EXHIBITION 36

MIXED-MEDIA
DEMONSTRATIONS
+ EXPLORATIONS

SUSAN TUTTLE

NORTH LIGHT BOOKS
Cincinnati, Ohio
www.mycraftivity.com

EXHIBITION 36 Copyright © 2008 by Susan Tuttle.
Manufactured in Singapore. All rights reserved. No part of this
book may be reproduced in any form or by any electronic or
mechanical means including information storage and retrieval
systems without permission in writing from the publisher,
except by a reviewer, who may quote a brief passage in
review. Published by North Light Books, an imprint of F+W
Publications, Inc., 4700 East Galbraith Road, Cincinnati,
Ohio 45236. (800) 289-0963. First edition.

12 11 10 09 08 5 4 3 2 1

Distributed in Canada by Fraser Direct
100 Armstrong Avenue
Georgetown, ON, Canada L7G 5S4
Tel: (905) 877-4411

Distributed in the U.K. and Europe by David & Charles
Brunel House, Newton Abbot, Devon, TQ12 4PU, England
Tel: (+44) 1626 323200, Fax: (+44) 1626 323319
E-mail: postmaster@davidandcharles.co.uk

Distributed in Australia by Capricorn Link
P.O. Box 704, S. Windsor, NSW 2756 Australia
Tel: (02) 4577-3555

Library of Congress Cataloging-in-Publication Data

Tuttle, Susan
Exhibition 36 : mixed-media demonstrations + explorations /
Susan Tuttle.
 p. cm.
 Includes bibliographical references and index.
 ISBN-13: 978-1-60061-104-9 (pbk. : alk. paper)
 ISBN-10: 1-60061-104-4 (pbk. : alk. paper)
 1. Handicraft. 2. Decoration and ornament. I. Title.
TT857.T97 2009
 745.5--dc22
 2008023309

www.fwpublications.com

EDITOR / Tonia Davenport
COVER DESIGNER / Geoff Raker
INTERIOR DESIGNER / Marissa Bowers
PRODUCTION COORDINATOR / Greg Nock
PHOTOGRAPHER / Adam Hand

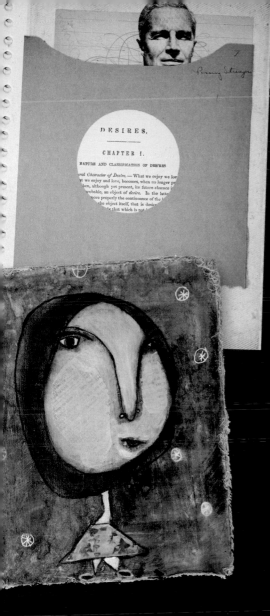

ACKNOWLEDGMENTS

A heartfelt thank you to my stellar editor, Tonia Davenport, who, like the perfect teacher, gave me direction and valuable tutelage, as well as the freedom to find and share my own, unique voice, both as an author and artist. The experience was one of sheer joy! Thank you to all those at North Light Books who have made the production of this book possible; your talents amaze me. For all of the artists who made contributions to this book, I am awe-inspired by your work. If it were not for you and your talents, this book could not exist.

To my very special husband, Howie, for all of the times you picked up the slack around the house while I chipped away at this book and, of course, for the time you were "Super Howie!" coming to my rescue when my computer crashed. If it were not for your technical genius, I would have lost nearly a year's worth of work on this book. Thank you to my sweet children, Elijah and Rose; you are both unending sources of inspiration and joy—you keep me young at heart and unafraid to try new things.

For my mom and dad, who supported and valued my musical endeavors from a very young age, and exposed me to the arts, so that I could begin my creative journey.

To Wendy Ifkovic, for believing in me as I set out on my artistic path—I really did write a book, just like you said I would! To my dear friends Jessica Theberge and Lisa West, for cheering me on and showing continuous support. Sheri Gaynor and Kate Cutko: Thank you for being my sounding boards. Thank you, Gloria, for providing me with fabulous finds with which to make art. For my friend and mentor, Nanette Jones, who somehow knew I'd be on this path even before I knew I would. Thank you to Suzanne Simanaitis for giving me a chance to contribute to your book; you opened a door for me, and I will be forever indebted. For Grace, my guardian angel, who has always encouraged me to "dance." A big thank you to you, the reader, who took a chance on me, on this book. I hope you will enjoy it. A sincere thank you to everyone aforementioned.

DEDICATION

FOR ELIJAH AND ROSE: YOU CAN DO ANYTHING YOU SET YOUR BEAUTIFUL HEARTS AND MINDS TO.

FOR HOWIE: I COULD NOT ASK FOR A BETTER LIFE PARTNER. THANK YOU FROM THE BOTTOM OF MY HEART FOR YOUR UNENDING LOVE AND SUPPORT.

FOR ALL MY FAMILY AND FRIENDS NEAR AND FAR: *I cherish you.*

CONTENTS

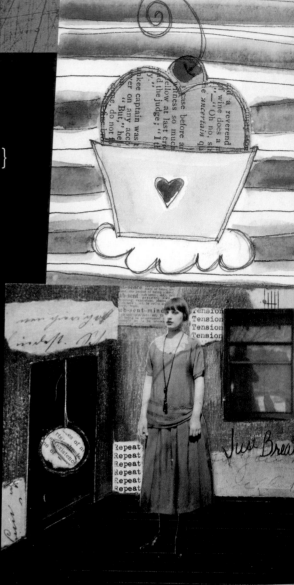

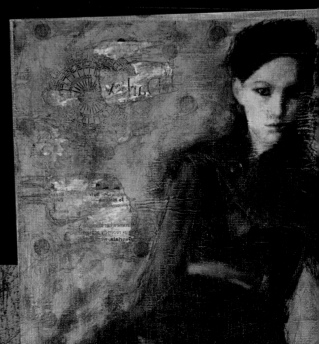

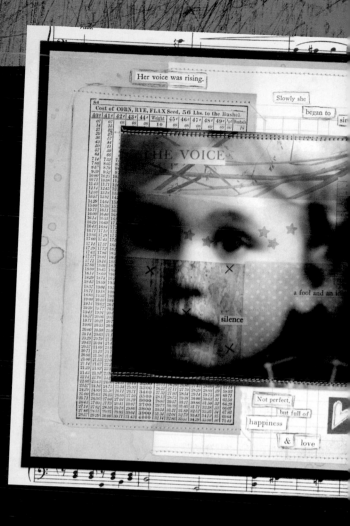

FROM MY LITTLE HOUSE IN THE MAINE WOODS

EARTH TO SUSAN

I was amazed to find an aerial view of my home on Google Earth. Zooming in the satellite camera from outer space, moving seamlessly—in three dimensions, no less — en route to planet Earth, to North America, honing in on the United States, getting closer . . . now to Maine, even closer. . . smack down in my rural town, moving along the dirt road that I live on, seeing what my backyard birds would see flying overhead . . . and finally, to my little white house surrounded by acres and acres of woods (which would seem in the middle of nowhere to most folks). That blows my mind!

I am a stay-at-home mom, living with my husband and young children in these beautiful Maine woods. It is such a gift to be surrounded by inspirations of nature, endless space and quiet—there is a sense of peace and contentment it brings that my family and I have not felt anywhere else. Even though there is no place I would rather be, the experience can be very isolating at times and a bit removed from artistic and cultural life. I have always thrived on culture and the arts and could access these essentials quite easily growing up. I had the benefit of living near New York City in my childhood, and lived in Boston as a young adult.

Today, use of the Internet helps us connect to the greater world—and the magic of Google Earth so perfectly demonstrates just how small a place the world is actually becoming. The Internet helped me create my own "cultural mecca," if you will, from the confines of my own home, right from the tips of my fingers—literally! Art enthusiasts, whether living in a yurt in a remote part of Alaska or in a flat in the middle of Paris, can visit virtual galleries online whenever they choose (for me, I love those late-night visits), connect with other artists via blogs and e-mails, and view artists' work and read about their creative processes via online publications and other digital venues. We can create and share our own art through these same avenues and be a part of collaborative projects via swaps and round-robin online groups. For many of us, our involvement and/or career in the arts would not be the same if it were not for all these amazing digital tools.

WHAT'S THIS BOOK ABOUT?

In essence, this book is a virtual art exhibit I've put together, right from my little house in the woods. It's my dream show come true—a gathering of thirty-six mixed-media artists, their collage, digital, assemblage, altered and repurposed art adorning the walls and pedestals of the gallery. The artists themselves are "present"— available to talk about their work and techniques and to share aspects of their creative lives with you.

I'll be your gallery guide throughout your visit, so let me start by giving you a map, so to speak, of the exhibit. Artwork in chapters one through four is organized according to particular creative approaches taken by the artists when creating their pieces, making for a nice mix of art in various mediums and dimensions throughout the gallery space. Be sure to attend our Guest Speaker Forum in Chapter Five, where we'll have the pleasure of hearing from some of the mixed-media art world's most notable artists.

You won't leave empty-handed, as our artists have donated some of their own personal imagery for use in your own art—a virtual collage pack to be scanned and used freely in your own work, just as you please. If you need some ideas for using the imagery, Chapter Six contains ten challenges that will fuel your own creative process. Plus, you get to see how several artists interpreted the challenges for themselves.

IF A TREE FALLS IN A FOREST . . .

. . . with no one to hear it, does it make a sound? It has been an incredible privilege to write this book. I have been inspired countless times by artist contributions to this creative endeavor and have learned a lot about myself and my art in the process. I've been humbled time and time again as I witnessed the book take on a life of its own—a magical unfolding, where the contributions inspired chapters that in some ways practically wrote themselves, and where the artwork magically distributed itself evenly amongst the sections of the book—perfect serendipity. There was a definite cosmic synergy going on, where common strands and themes emerged amongst the pieces. Staying out of my own way was my biggest challenge.

The birth of this book is not about me, and perhaps not even necessarily about the artists and their magnificent work within these pages—it is more about you and your experience with it. It is my great hope that you will find some form of inspiration within these pages that touches you in a meaningful way. You are an integral part of the experience of this book. It is because of you, the reader, that this book exists. Without you here to experience it, it could definitely not "make a sound."

Thank you for being a part of it.

Susan

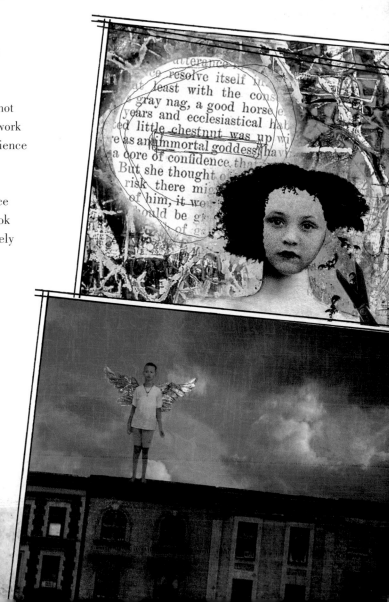

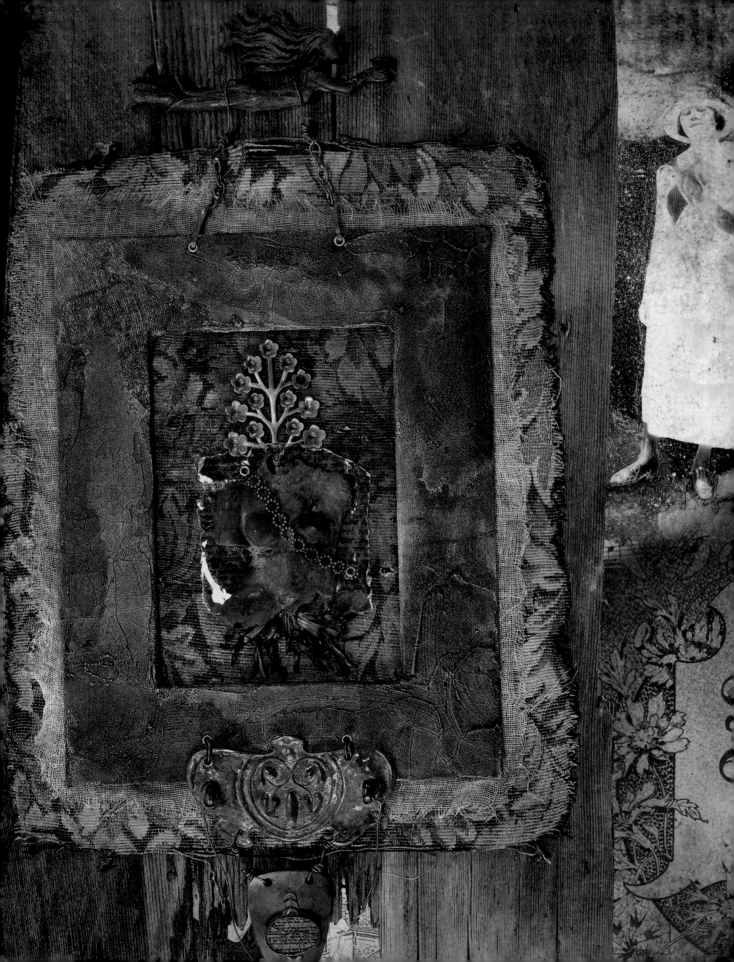

ARTIFACTS PRESERVED

Artifact is defined as an object made or produced for a certain purpose. To preserve means to protect or keep safe from decay or destruction, to keep intact or in a particular condition. We, as human beings, have such a deep-rooted, natural inclination to preserve artifacts—within our cities and towns, our homes, and within our hearts and minds—protecting the history of our world, as well as our own personal stories.

There are private collections of art, antiques, music and everything from antique cars to daguerreotypes. Just Google "The history of (you-fill-in-the-blank)." I'm willing to bet you'll be able to find a history of practically any word you choose to put in that blank. We snap photos of our children and our loved ones, preserving their memories and those precious moments in photo albums and scrapbooks; we keep safe those few treasured photos of our ancestors; we take movies of family vacations, birthdays and holidays; we create accounts of our thoughts and memories in our daily journals; we record "first" moments in our children's baby books; we save letters, postcards, ticket stubs, locks of hair, footprints, handprints, grandma's wedding ring . . .

Why? Why are we programmed to preserve our things, our thoughts, our memories, our histories? I think the answers may be simple. We need to honor our own personal paths and the lives of our loved ones, as well as the memories of those who came before us. Oftentimes we remember and revere the lives of those who have given of themselves and made sacrifices for our greater good; we are indebted to them for some of the privileges we enjoy today. We need to tell their stories, often for the betterment of ourselves, by encouraging understanding,

educating and providing awareness. We need evidence. We need to see where we came from in order to feel grounded in the present. Take this to mean whatever it means to you. I am not necessarily referring to religion, ancestors or cultural backgrounds, but maybe to something even greater, something that is not so tangible. This leads me to my next point: the extraordinary position artists are in when it comes to preserving and conveying our histories.

In this chapter, you will see the many ways artists can elevate historical and personal accounts to a whole new level through their artwork. In Richard Salley's contribution, *When Duty Calls*, the artist addresses "the ever-present reality" of war throughout human history. With artifacts of his family's "collective service," he constructed an assemblage paying homage to three generations of his family who have served in the armed forces.

Ancient myths, regarded as some of the earliest forms of history, are explored in the works of John Christopher Borrero. Through his artwork, he explores the female archetype, connecting her past to modern-day life and celebrating the strength and beauty of womanhood, both past and present.

Judy Wilkenfeld's powerful contribution, *The Last Photo*, documents her father's heart-wrenching, personal journey as a Jewish child living in Europe during the Holocaust. She tells his miraculous story through her art, honoring his experiences and sacrifices, revealing realities and truths so we may never forget.

USING COLLAGE TO TELL A STORY

Brandie Butcher-Isley

When approaching a blank surface with an idea, do you ever feel overwhelmed with the anticipation of how that idea will translate into a tangible piece of art? It happens to me often, but I find the process exciting because I get to not only express myself visually but am allowed to fulfill my lifelong desire of telling stories.

INSPIRATIONS

Inspiration, for me, comes from snapshots, particularly photos taken during the eras of the twentieth century. I prefer snapshots that have a spontaneous feel to them rather than the posed portraits of the nineteenth century. If you present me with a candid photo of an individual or group from any day in time, posed or caught in a captivating moment, there is a good chance I will be inspired to build a collage that tells a story about that person or group.

DESIGN TECHNIQUES

THE PHOTOGRAPH

Choosing the photo is always the first step. I have an extensive collection of old snapshots to rifle through. Because I often get a lot of creative ideas all at once, I record them in a journal, which contains a record of photographs and the descriptions and sketches of projects I intend to make with them. I will sometimes pass over a photo in my collection countless times before the story grabs me.

For preservation reasons, I don't recommend using original photos in your art. I make copies with a scanner and my inkjet printer. My particular printer uses archival, dye-based inks that do not bleed when glued or painted on. I use either matte photo paper or, one of my favorite techniques, I print images and text directly onto ephemera!

SETTING THE STAGE

When creating collage, it's fun to place subjects in intimate settings. Try setting them in a room and standing on a hardwood floor with walls of images behind them. Or place them outdoors, situated on solid ground, surrounded by painted trees and a sparkling atmosphere. Sometimes I surround the subject with private scripts and images. All these elements draw the viewer into the personal space of the character, where they are invited to look at the images and read the words that help build his or her story.

USING EPHEMERA AND IMAGES TO BUILD MEANING

I have a seemingly endless supply of ephemera, including snapshots, letters, postcards, old school IDs, bingo cards, railroad time cards, punch cards, countless shelves of old books, even an old railroad employee manual, and a program for a 1931 class reunion that includes all the students' names and their accomplishments. I turn to this supply when building the backdrops of my works.

Pieces of ephemera will become leaves on painted trees or leaves fallen to the earth. A piece of paper or imagery may become a photograph nailed to the wall, a heart hanging from a tree, a doorway or even a mouse hole. Here are some possible uses for ephemera:

- Clock to signify the passage of time
- Numbers to give order to things
- Calendar to emphasize an era
- Window to imply escape or that someone is watching
- Doorway symbolizing a pathway to a life change
- Sheet music to represent beauty
- Torn or out-of-focus image to suggest imperfection

OUTLINING FOR EMPHASIS

Outlining the perimeter of an image with graphite, ink, paint or even scratches made with an art knife, will define a specific part of your work you deem important.

FOREGROUND VERSUS BACKGROUND

Try layering the text and images. You can apply paint and gesso to "push" some further into the background and to bring others into the foreground (by use of highlights). This process creates a backdrop, setting the stage for the "lead character" of the piece.

SPATTER PAINTING

When working on an outdoor setting, I often use a spattering technique with white gesso. I load an old toothbrush with gesso, and I drag my thumb across the toothbrush, peppering the surface with the gesso. I repeat this between each layer of paint and paper and a final time on top of the last layer. This helps achieve a sparkling atmosphere around my subject. For areas I do not wish to spatter, I just loosely cover them with a piece of paper cut to fit the desired shape.

TWO PATHS

My art explores routes down both fictional and nonfictional paths.

FICTIONAL PATH

Often I have never met the person or people whose image(s) I choose as subjects. In these cases, I can create the fictional life of an individual whose photo has been discarded or forgotten. I like to think the stories told through my artwork breathe life back into these subjects.

The character will usually "speak to me" through my imagination. I may be thinking, "she looks strong," or, "he has been through a lot." Sometimes I get clues: for instance, writing found on the back of a photo, or a written entry below a snapshot in an old scrapbook.

I often write stories to accompany my fictional artworks. These stories are short and let me share with the viewer the thoughts that inspired the art. I view the subject(s) of the piece as the "lead character(s)," and through my work, I invite the viewer to take a peek through a little window and witness a tiny fraction of the character's life.

NONFICTIONAL PATH

I have acquired a few cherished family photographs. Some are of my parents as children, while others are baby photos of my brother and myself. I even have some photos of my ancestors. My most precious photos are of my grandparents, and I especially love the ones taken around the time that I was growing up and forming my earliest memories.

When I make art with these photographs, it is the personal stories that unfold—someone I know, or knew of, steps into the forefront and becomes the lead of the story. I still may not know the person(s) featured, but I have heard so many family stories about them, I feel like I do. I tend to write a lot more with these pieces, which makes them very special, as most of them will remain within my family and serve as beautiful documentation of the stories that have been passed down over the years.

BEFORE I GO, I'D LIKE TO SHOW YOU A FEW OF MY PIECES AND TELL YOU ABOUT THE INSPIRATION THAT WENT INTO EACH.

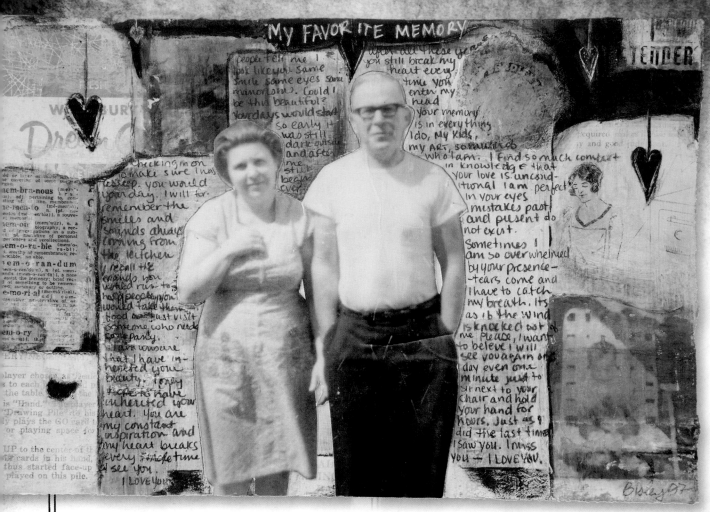

MY FAVORITE MEMORY

MY FAVORITE MEMORY

This piece contains a photo of my grandparents as they were when I was still very young—when I would spend summers at their house. I could explain the importance of my relationship with my grandparents, but am hoping this piece will tell the story for me. I have written letters to each of them, and these letters encompass their bodies as they stand next to each other. This piece was created on a vintage calendar page from 1979, and each and every piece of paper used is meaningful.

Just in case you couldn't make out the words, here they are in their entirety. These words were written as they came to mind; please excuse the childlike grammar.

There is a Grandma side and a Grandpa side.

Grandma,

People tell me I look like you, same smile, same eyes, same mannerisms. Could I be this beautiful? Your days would start so early, it was still dark outside, and after checking on me to make sure I was still asleep you would begin your day. I will forever remember the smells and sounds always coming from the kitchen. I recall the errands you would run to help people. You would take them food or just visit someone who needs company. I am unsure that I have inherited your beauty, I only hope to have inherited your heart. You are my constant inspiration and my heart breaks every single time I see you. I LOVE YOU.

Grandpa,

After all these years you still break my heart every time you enter my head. Your memory is in everything I do: my kids, my art—so much of who I am. I find so much comfort in knowledge that your love is unconditional. I am perfect in your eyes. Mistakes past and present do not exist. Sometimes I am so overwhelmed by your presence—tears come and I have to catch my breath. It's as if the wind is knocked out of me. Please, I want to believe I will see you again one day, even one minute just to sit next to your chair and hold your hand for hours. Just as I did the last time I saw you. I MISS YOU—I LOVE YOU.

I'M TAKING CARE OF ME

A very personal, tough time inspired this piece. She looks to me as if she is "done," absolutely finished. In this piece, I used ephemera that had handwritten text on it.

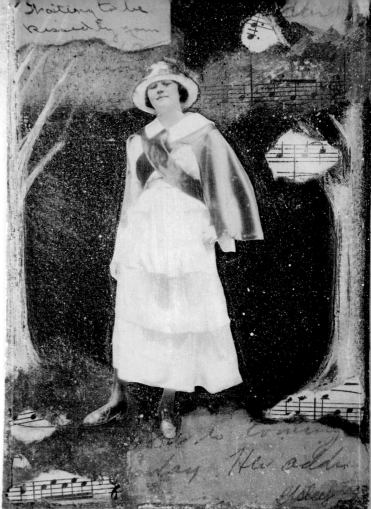

WAITING TO BE KISSED BY YOU

Her stance implies a dare. It's as if she's saying, "I dare you to come and kiss me. Come on . . . I'm waiting . . . but I won't wait forever."

I love this woman's presence. She is so confident and beautiful. She had to be the sole subject of this collage because she would absolutely overpower anyone else included.

The words "waiting to be kissed by you" were handwritten on the back of this photo. Did she write this thinking of someone? Did she write this on the photo and then give it to her lover? Maybe it was a surprise gift to someone who didn't know, prior to receiving this photo, that she wanted him to kiss her. How romantic is that?

This is one of my earliest pieces that uses the spatter paint technique for the background.

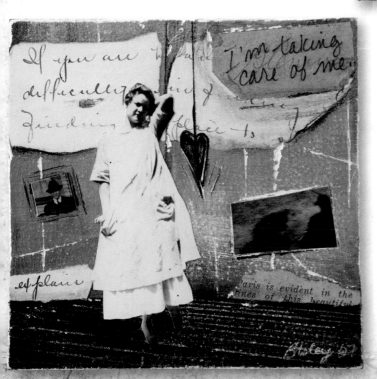

THE MOMENT OF RECOGNITION

John Christopher Borrero

NIKE

One of the inspirations for this piece is *Winged Victory*, a sculptural portrait of Nike that appears in the Louvre museum. In Greek mythology, Nike was a goddess who personified triumph. What I enjoy most about making art from found objects is the moment of recognition—the "a-ha" moment of coming across a piece of metal or fabric and recognizing that it is not just an umbrella but a flowing gown—and not just a flowing gown but the gown of a goddess.

This work began with a charred piece of driftwood; it forms the base at the center of the sculpture. I found it while walking along the beach and thought it looked like a person standing upright. The top of that piece of wood forms her chest. And so she was born. Her gown is an old umbrella, while her shoulders and neck are made from old fixtures I've found on walks over the years. (I do my part to keep New York City streets clean!) The base is the top of an old copper teakettle.

Next I attached the face and doll arm, both of which I thought gave her dignity—a sense of being strong and composed. Then came the wings. On one of my regular junk-shop runs, I was approached by the proprietor about a taxidermy bird. She said the bird had been sitting on the shelf for more than seven years and that it was much older than that. She was ready to just throw it away. Something clicked, and I took a good look at it; in truth, it was beautiful. But there was more than its beauty that struck me; its usefulness had passed. Seven years . . . no one wanted it . . . *A-ha.* I took it, turned it around in my hands and said—mostly to the bird—"So, how would you like to be a goddess?"

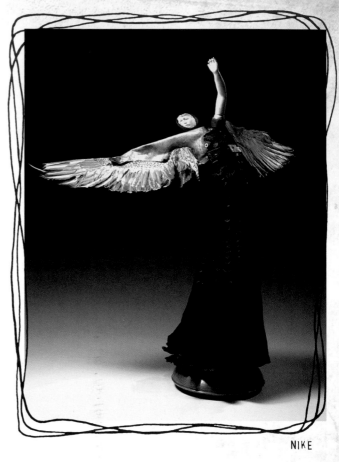

NIKE

ATROPOS

This piece began as a study on the concept of fate. In Greek mythology, Atropos was one of the three Moirae (the Fates)—daughters of Zeus and Themis. These female deities supervised fate rather than determined it. Atropos was the fate who cut the thread, or web, of life. She was known as the "inflexible" or "inevitable" and cut this thread with the "abhorred shears." She worked along with Clotho, who spun the thread, and Lachesis, who measured the length.

PANDORA'S JACK-IN-THE-BOX

(Accompanying chant to be sung to the melody of "Pop Goes the Weasel")

A tick, a tock, a moment in time
A step beyond retrieval
A trap once sprung, which can't be undone,
set for the feeble!

Warn them in the schoolhouse!
Fetch them in cathedral!
Curiosity, you see,
Brings forth the evil!

This is an ancient jack-in-the-box of unknown origins. It is, however, believed that when it was sprung for the first time by an unsuspecting little girl named Pandora, all sorts of evil was released into the world.

Although the evil has already been released and can't be returned to the box, the box plays the above tune when the curious turn the crank. Believe it.

ATROPOS

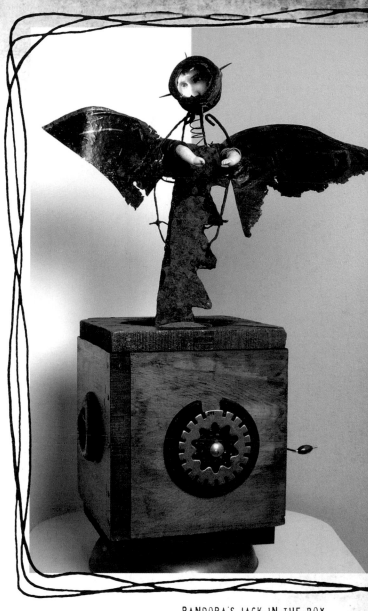

PANDORA'S JACK-IN-THE-BOX

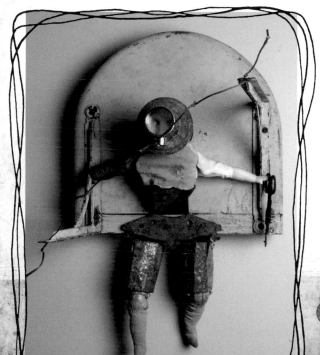

THE LAST PHOTO

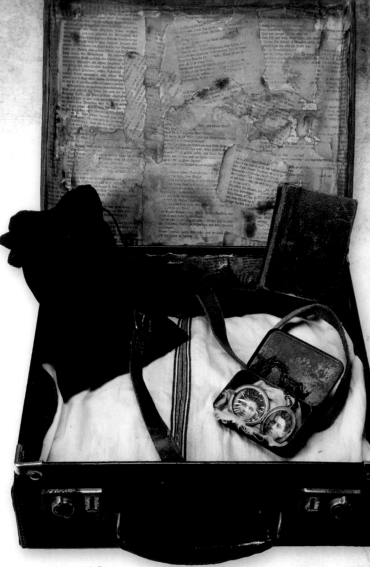

Judy Wilkenfeld

Stand up.
Grab your camera.
Imagine that your immediate family is standing in front of you on a sunny afternoon in your garden.
Imagine calling them to attention for a family portrait.
Your camera is a box brownie.
You only get to take one photo, so make it count.
Fast forward sixty years.
Your child is now writing about this photo taken in your garden.
That one photo.
That one photo that came to have so much significance. For that was the last photo that you, his/her parent, took of your family together.
Today, I am the daughter.
Today, you are viewing the story behind what was to become . . .
the last photo.

Tragedy, whether it takes the form of a natural or man-made disaster, is always heartbreaking. Interestingly, the inspiration for this piece is two-fold: It comes from my father's firsthand experience of the horrors of World War II and the crimes against humanity of the Nazi Regime, and it comes from Hurricane Katrina's devistation of New Orleans in 2005. Why New Orleans? Let me explain.

I was watching a program about families returning to their homes after the disaster to retrieve any semblance of family photos and memorabilia. The photos they found were almost beyond repair. They wished, in hindsight, that they had had more warning! They wanted their precious memories back in a tactile form.

HISTORY

In order to understand this Visual Anthology (a trademarked name I use to refer to my pieces of art), I must brief you on some of the history behind it.

It's Nazi Germany, and at twelve years old, my father, Gershon Wilkenfeld, was expelled from his hometown school. The reason? He was a Jew. He had no choice but to attend a boarding school, an hour from his home, for Jewish youth. One room in the school was always locked. Though all the boys were curious about the room, all were forbidden to enter. When any boy in the school turned thirteen, they left the school, never to return. Most people assumed the boys went back to their families. Given current affairs at the time, however, my father knew something more sinister was happening.

The boys, on a rotational basis, had to sit on the roof of the school building, and, should bombs fall close to the school, they were to run down and warn everyone. One day, while my father and his friend were on their watch, bombs began falling and were getting close. They ran down the stairs to find chaos. Amidst the chaos, they discovered that the door to the locked room had been left open. Their curiosities led them into the room, and they began to scour through the paperwork there. My father's instincts were confirmed—at age thirteen, the boys were taken to "work" for the Nazis.

My father, who had just turned thirteen, went with a group of boys to their madrich (a leader or teacher) to discuss their impending situation. After much discussion, the group of boys decided to escape. "But," said the madrich, "you must first seek the approval of your parents." There was no time to make the journey back home, so Gershon phoned his mother. Talking in code, they discussed "how bad the weather was," meaning the situation was very dire. Fortunately, his mother, Gittel, understood right away. Gershon told her he was going to visit Uncle Baruch. Gittel understood that to mean her son was going to try to escape to Israel. She gave her permission.

Can you imagine the bravery of this woman? In those days and times, mothers had to make extraordinary decisions—keep the children with them and pray for survival or let one go and hope they survived, knowing that the rest of the family might not make it. At least one of them would have a chance to one day tell the story of what happened.

THE SUITCASE

While searching high and low for just the right bag—a bag similar to those used at the time—I came across this vintage lawn-bowls case.

The green felt that lined the case would not suffice, so I altered it by covering the felt with vintage German text. After sanding the surface of the bag and applying distressing ink to it, I sealed it with matte medium. I then painted my father's former home address on the bag, mimicking the way bags were marked at that time.

THE PHOTO ALBUM

To house the subject matter of my project, I chose an 1880s photo album. When creating artwork, I try to keep things simple. For me, one element can say it all. The front cover of this album is an example. I could have covered the front with a lot of images or elements, but I think the inherent beauty of the aged leather, flowers and leaves speaks for itself.

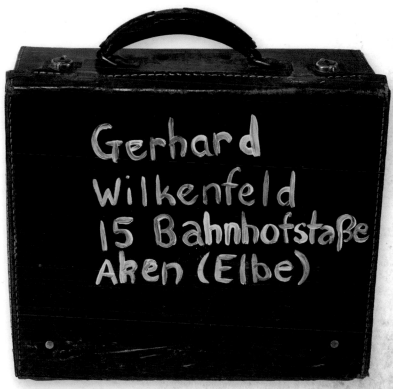

As with many of my Visual Anthologies, something mystical occurred with this album. I met a vendor (with a thick European accent) at a boot sale one day. After going through lots of her vintage jewelry, she pulled out this very album, filled with Victorian cabinet cards, but she would not sell the album to me that day. After explaining what I did as an artist, I felt it was the right time to ask her where she was from. She said she did not remember. I told her I had guessed she was either Hungarian or Czech—she went silent. She continued, "I don't remember, because I have blocked it out of my memory." I thought, "Oh, here we go" I just knew where this was heading. More silence—not uncomfortable for me, as I am used to that specific silence. I then saw the tears streaming from her eyes, her hands trembling while she tried to light up the next cigarette—before she had extinguished the last one. I put my hand on her arm, looked into her eyes and gently whispered, "You know, my father is a Holocaust survivor." Her robotic response, while she stared blankly, was, "I don't remember where I came from." Then she looked at me, almost like she came back to reality, and said, "You know those Nazi bastards took my mother away from me."

She rang me the next day to tell me I could buy the album from her.

PHOTO ALBUM SYMBOLISM

Three feathers from a broken bird, found on the cover, represent the three members of my father's immediate family who were killed in either the concentration camp Auschwitz or Thereszienstadt. The flowers and leaves on the cover represent the family tree.

A leather belt I found to hold the album together is the type of belt children used in those days to hold their books.

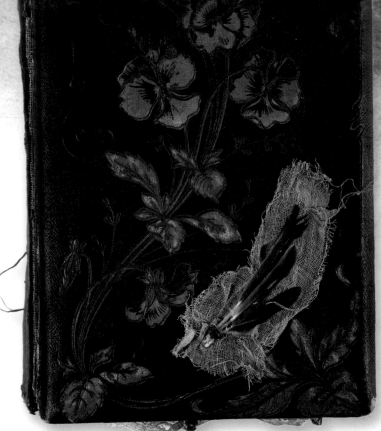

1880S PHOTO ALBUM

The black-and-white stripes on the piece of very old and stained fabric, surrounding the album, resemble a Tallit, or Jewish prayer shawl.

My father has always been a meticulous man. Whenever we traveled abroad, he always placed a towel at the bottom of the suitcase, which he wrapped around the clothing, securing it with straps. My gut instinct led me to wrap the album in the fabric, binding it all with the leather belt.

PAGE 2

I wanted to use a green book for the second page of the album. While perusing my collection of vintage books, I spotted this green-colored school reader. Its title was Book Six—perfect symbolically, alluding to the six million Jewish souls who perished.

I attached a brass ring around the photo and affixed it to a large, brass filigree. Behind the book cover, I layered vintage text. For me, the layering of fabrics and papers lets the viewer know there is a story to be told behind the cover.

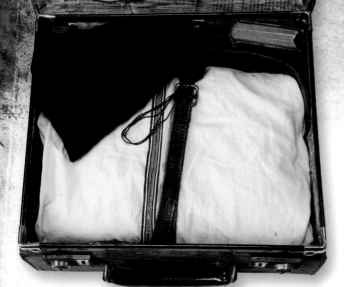

ALBUM WRAPPED IN PRAYER SHAWL

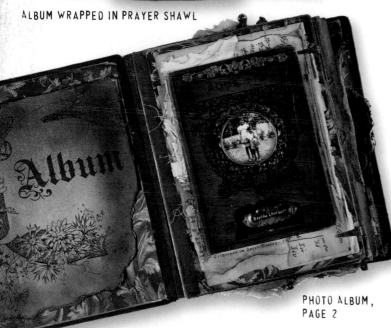

PHOTO ALBUM, PAGE 2

PHOTO ALBUM, PAGE 3

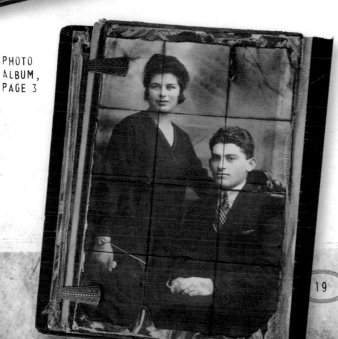

PAGE 3

At first glance, this page may look simple, but more went into it than meets the eye. I have actually re-created an old document. The intent was to re-create a photo that had been folded mulitple times and tucked away for safekeeping. Many Holocaust victims had photos or documents that resembled this.

I took a blank page from a book printed in the 1800s; I printed a photo of my father's parents, Gittel and Isador, onto the vintage paper and proceeded to score each section. While scoring, I was careful not to tear in the wrong places—the paper was extremely fragile. To give an aged appearance, I used distressing inks on and around the score lines and then made tiny cuts where the paper would have naturally torn over time. To anchor the photo, I adhered two pieces of vintage jewelry.

PAGE 4 (SEE NEXT PAGE)

This piece has particular significance to the assemblage as a whole, as it contains the *last photo*; four of the five members of the family were photographed together for the last time.

Elegant, vintage brass hardware adorns the piece. I backed the photo with a vintage cabinet card. The muslin adds a dynamic flow.

PAGE 5 (SEE NEXT PAGE)

Through the use of symbolism, this page tells the story of what happened to Bertha and Norbert, my father's younger siblings.

The vintage book, with its Nazi insignia, was found while scouring an old bookshop I frequent. The striped fabric symbolizes the uniforms worn in the concentration camps. The wood frame surrounding the children is from an antique-sewing-machine drawer. The fine copper mesh,

sandwiched between the frame and photo, represents the fact that they were eventually fenced in behind the walls and barbed wire of both the Warsaw Ghetto and the concentration camps. Finally, the plank of wood, used to secure the cover to the wood, mimics the plank the siblings are standing on in the photo.

PAGE 6

The photograph in this piece is probably the last photo taken of my father with his siblings. I find it interesting that in the photo my father was looking in one direction—his siblings the other!

The vintage book cover says Volume 2; the author's last name, Young. A brass "2" is placed on a copper embellishment. The two vintage hardware pieces I chose from my stash were placed as left and right elements.

As you can see, nothing is placed by chance in my art pieces. I wanted to express that they were too young and also that two of the three siblings were killed.

The internal part of the window hardware reminded me of a broken heart—clearly, my father's broken heart over the loss of his family members.

THE FINAL PAGE

The final page of the album exhibits an image of a person, my father, walking alone. The photo was taken in Palestine, five years after he had escaped from Germany. He was eighteen.

I received two pieces of green glass a few months before creating this piece and almost threw them away. Only after placing the glass over this photo did I realize just how effective it was against the sepia-toned image.

This image tells us that my father walked alone—metaphorically—as he did not know the whereabouts of his family. The piece spoke for itself; hence, I left the elements surrounding it very simple. Life becomes much more simple when what really matters is taken away.

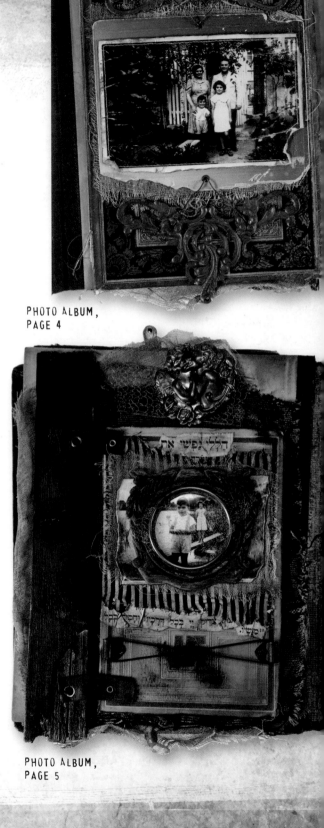

PHOTO ALBUM,
PAGE 4

PHOTO ALBUM,
PAGE 5

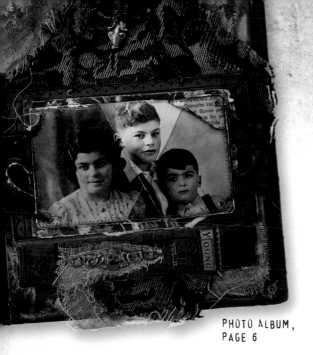

PHOTO ALBUM,
PAGE 6

My father took few possessions with him on his escape. Just before leaving, he had celebrated his Bar-Mitzvah, for which he was given a gold watch from his parents; the watch was being repaired in a shop in town. It was one of the only items he had from his family. While retrieving the watch, he missed the very last train out of Germany—the Nazis were in the next town over; he somehow managed to join the train again. A bag of his possessions was placed in Carriage Three of this train, along with the possessions of other children. His prayer book and his Tefillin (Jewish prayer items) were inside, placed within a purple velvet bag. The Nazis were getting closer; the third carriage had to be released.

PHOTO ALBUM, FINAL PAGE

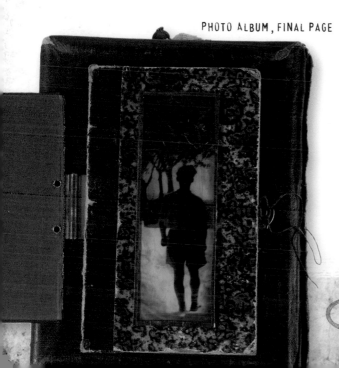

Each child watched, mortified, as all their belongings disappeared down the track and out of view.

I just had to leave the piece almost bare, for my father did not have much. To create an anthology of the life of any Holocaust survivor at that time, one must try to understand that barren feeling inside. Yet, on the other hand, that eerie, green glow spoke to me. It said, "Behind even the darkest of days, there is light!" That light shone a few years later. But that is where I must leave you now. What happened to my father next is part of another Visual Anthology.

PURPOSEFULLY USED MATERIALS

According to Jewish mysticism, the materials one uses creatively have some influence on the power of their creation, or the message being conveyed. I believe if all the energies going into the piece are a match, the final result ought to yield a strong and good energy.

I backed the photos in green book covers because the color green corresponds to the Sefirah (level) of beauty. Green represents the color of the heart, with which we seek completion to mend our brokenness.

The Hebrew text used is, for me, significant to what occurred. For example, above the photo of the children the Hebrew text states, *Halleli nafshi et.* Loosely translated, it means "Glorify the souls of." For me, that meant glorify the souls of Bertha and Norbert—children, innocent victims, part of the mass slaughter of two million Jewish children. Below the photo are the words, *Tzadik Adonay bechol drachav, vechassid bechol ma'asav.* Loosely translated, this means "G-d is righteous in all His ways, and He is compassionate in all that he does." This particular text, which comes from a daily prayer, is something I question— something that leaves me perplexed. If a person is religious, they are meant to believe with blind faith that everything G-d does is righteous and compassionate. I have always found myself questioning the righteousness and compassion in this context and the broader context of any child dying so young.

TREE OF LIFE

Judy Wilkenfeld

SYMBOLISM

Symbolism is a form of unsaid expression—the telling of a message one attempts to convey. This piece is based on the biblical story "The Tree of Life," as it relates to Jewish mysticism, or Kabbalah. First mentioned in Genesis 2:9, the Tree of Life is a mystical symbol used to understand G-d's creation of the universe and the nature of G-d. There are ten spheres related to the tree, so I used ten basic elements to reflect the ten Sephiroth (spheres).

As creation is the key focus here, the female form was chosen as a primary element, for without woman, there can be no further creation of humans. The fruit of the Tree of Life was purported to give everlasting life. The woman, in creating one life, can potentially, with the birth of a child, create a family line that continues for generations, if all goes according to plan.

G-d, according to the teachings of Judaism, has both feminine and masculine qualities, hence a further reason to add the female form to the artwork.

Emanating from the form, we find the roots, representing both the tree and the lower levels of the Sephiroth. The branches of the tree and the reason for their placement speak for themselves.

Behind the female form you will notice what looks like Hebrew text; the text is not actually Hebrew but Rashi. Rabbi Solomon Ben Isaac, better known by the acronym Rashi, was a rabbi from France, a scholar and the first author of comprehensive commentaries on the oral law of Judaism. Briefly, there is an oral law (the Talmud) and a written law (the Torah, or Bible). The written portion is his writing. So why the inclusion of the commentary on the Oral Law? Because the mystical explanations related to the Tree of Life are oral in nature, not written.

"It is a tree of life to those that take hold of it" comes from a Jewish Proverb. This proverb relates to the Tree being the Torah and the taking hold of it, meaning adhering to the Jewish laws. To finish the piece, I needed an an element that would serve as a hanging device. I chose a casting of a female who almost looks like she is flying and who is grasping on to something in her hands—a perfect fit for the proverb, and a nice way to bring the whole art piece together, at least in my mind.

PUTTING IT TOGETHER

For one layer of the assemblage, I used a piece of upholstery fabric with a "forest" look to it. I aged it with washes of paint and ink.

I glued the quote from Genesis into a brass bezel with matte medium and covered it with a crackle glaze. To add to the flow while keeping with the theme, I chose to add tiny copper leaves, both above and below the bezel. I attached all hardware elements with aged copper wire, which I knotted to secure the elements into place.

To create the textured frame surrounding the female body form, I began by adhering a piece of muslin to a paper frame mat. For interest, I added a crackle texture paste to random areas of the substrate. I then applied light washes of paint to build up color over the texture. (Sometimes it takes twenty or more washes of paint to achieve this effect.)

I built up the frame by adding some cardboard to the back side of the mat. Then I adhered the completed frame to the upholstery fabric piece and set eyelets in the top of the frame.

The brass casting of the female figure is anchored to the top of the piece with lengths of copper chain, copper findings (hooks) and copper wire (knotted for security).

Finally, I added a piece of painted muslin behind the frame to give the piece a more dynamic feel and flow.

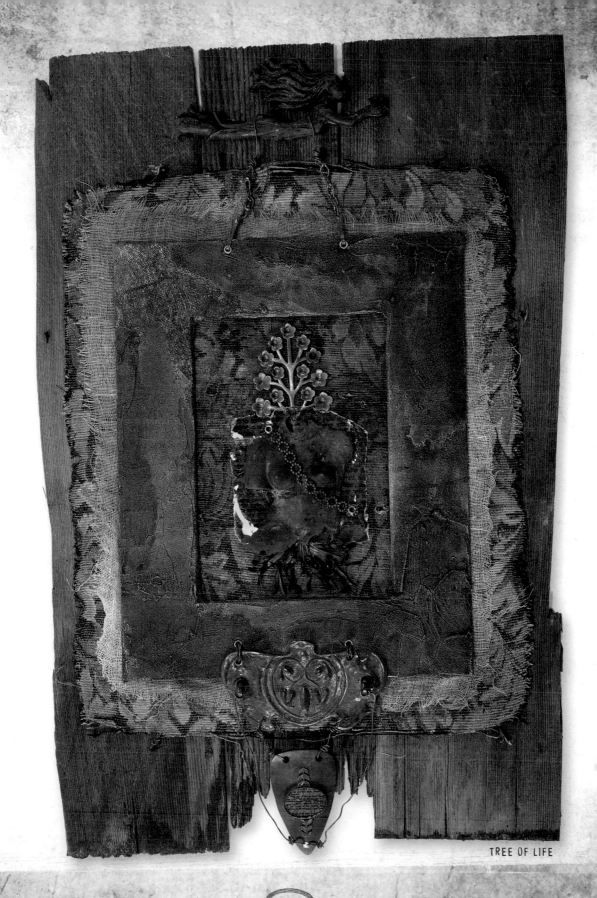

TREE OF LIFE

AN ALTERED SELF-PORTRAIT

Karen Michel

I took this "self-portrait" as I was canoeing down the Delaware River with my husband while I was pregnant with our son. It was such a beautiful day, and the water was so smooth; it relaxed every ounce of my body and spirit. It was a perfect moment of escape from the world. This is the spirit I tried to capture in this piece: rowing gently through the world.

Manipulating a Color Photo

Materials

- PHOTOGRAPH
- BUCKET OF WATER
- FINE-GRIT SANDPAPER
- BOOK AWL
- WATER-BASED FELT-TIP MARKERS
- ACRYLIC PAINTS
- GEL PENS AND MARKERS
- RUB-ON LETTERS
- ALUMINUM TAPE
- CANVAS BOARD
- MUSIC PAPER
- GEL MEDIUM (GOLDEN)
- PHOTO CORNERS
- HANDCARVED STAMP

METHOD

-1- BEGIN WITH AN ACTUAL PHOTO PROCESSED ON A PHOTO-DEVELOPING MACHINE (THE KIND YOU FIND AT MOST SUPERSTORES). BEWARE OF PHOTO KIOSKS, AS SOME USE PHOTO PAPER THAT CANNOT BE ALTERED.

-2- DIP THE PHOTO IN WATER TO SOFTEN THE EMULSION, AND THEN SAND AWAY THE CLEAN EDGES WITH A FINE-GRIT SANDPAPER. YOU CAN ALSO USE THE SANDPAPER TO REMOVE ANY UNDESIRED AREAS. USING A BOOK AWL, SCRATCH INTO THE PHOTO TO EMPHASIZE THE SHAPE OF THE MAIN FOCAL POINT (IN MY CASE, THE CANOE). WHEN SCRATCHING INTO DARK AREAS, YOU'LL NOTICE THE AREA TURNS A WONDERFUL GOLDEN COLOR.

-3- WHEN YOU'RE DONE SCRATCHING AND SANDING, RINSE THE SURFACE OF THE PHOTO TO CLEAN OFF THE BITS OF REMAINING EMULSION.
WHILE THE PHOTO IS DAMP BUT NOT WET, COLOR INTO THE SURFACE WITH WATER-BASED FELT-TIP MARKERS. TRY USING YOUR FINGERS TO BLEND THE COLORS INTO THE SURFACE FOR INTERESTING EFFECTS. ACRYLIC PAINTS ALSO WORK WELL FOR ADDING COLOR. ONCE THE SURFACE IS COMPLETELY DRY, GEL PENS AND MARKERS WORK NICELY FOR FINER EMBELLISHMENTS AND DETAIL WORK. IN THIS PIECE I ALSO USED RUB-ON LETTERING AS A DESIGN ELEMENT AND CUT OUT A STAR FROM A ROLL OF ALUMINUM TAPE.

-4- PREPARE THE CANVAS BOARD FOR MOUNTING YOUR PHOTOGRAPH. I TOOK A PIECE OF VINTAGE SHEET MUSIC AND ADHERED IT TO A CANVAS BOARD USING ACRYLIC GEL MEDIUM. APPLY THE GEL MEDIUM ALL ACROSS THE BOARD USING AN OLD CREDIT CARD TO HAVE A NICE EVEN COAT. (FOLLOW SAFETY PRECAUTIONS ON PRODUCT LABEL.) ALSO USE THE CREDIT CARD TO SMOOTH THE PAPER ONTO THE BOARD. IF YOU LIKE, ADD SOME PHOTO CORNERS, AND THEN APPLY GEL MEDIUM TO THE BACK OF THE PHOTOGRAPH AND STICK IT TO THE CANVAS BOARD. YOU CAN NOW WORK THE REST OF THE BOARD WITH SOME ACRYLIC PAINTS, GEL PENS AND MORE RUB-ONS. NEXT, EMBELLISH THE PIECE WITH A HAND-CARVED STAMP TO PULL IT ALL TOGETHER.

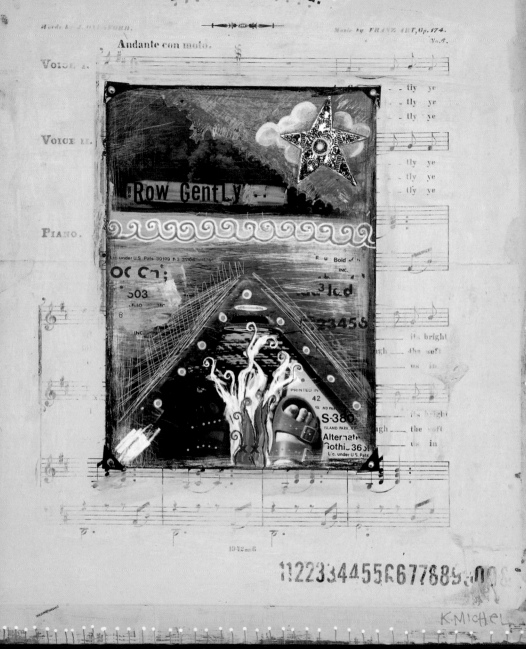

I feel photo altering offers endless possibilities. Working from memories and real-life experience can fuse your art with more mojo than you may realize. Try playing, using some old photos and some of your favorite art materials. You may be surprised by what comes forward!

WHEN DUTY CALLS: AN ASSEMBLAGE

Richard Salley

WARS AND RUMORS OF WARS

It is an unpleasant fact of human history that war has been an ever-present reality. From biblical times to the present, there has been a war going on somewhere on the planet. In recent years the unpopularity of war has led artists, working in every medium, to decry the military effort. I have often felt that to make a piece of "protest" art is simply too easy, too obvious. Being negative seems to come readily. I think it is a greater challenge to make art that is positive and affirming—art that stands for something, not merely against. While I am not an advocate of violence or war by any means, I do think there is honor in military service. The artwork I present here pays homage to three generations of men in my family who served in the armed forces during their youth. My grandfather served in WWI, my father in WWII and I served during the Vietnam years. The artifacts of our collective service have been removed from their dusty storage boxes and brought into this assemblage. This work stems directly from a "Shrines and Icons" workshop I took with my friend and mentor Keith LoBue.

ARTIFACTS BECOME ART

The basic "stage" for the piece is part of an old metal opaque projector given to me by one of my students when I taught high school photography. You are looking at what was the bottom of the projector—you can make out the feet it stood on in each of the four corners. The opening in the center once held a mirror that reflected the light up into the projection lens. The tubular light bulbs on both sides of the opening are partially visible.

In the center of the stage is a photo of my grandfather, framed on each side by bullet souvenirs he brought back from France. From the bullets hang his dog tags on the left, and those that I wore on the right. Above his head is a uniform button bearing the U.S. Army insignia. On the left side of the stage is a picture of my father surrounded by some of the ribbons and medals he received during his twenty years of active duty in the Air Force. His pilot wings fly over center stage and serve as a bridge to the right side of the assemblage where my photo and service medals hang.

The backdrop of the stage is made from a photograph that belonged to my grandfather. It had been folded and placed in his uniform pocket (a wonderful, wool WWI uniform I have in my closet). When I opened the photo it fell apart into several pieces. I decided to reassemble the photo by carefully adhering it to a 1918 *New York Times* newspaper segment that was also in one of the uniform pockets. I then gently tore the two pieces along the original fold lines of the photo. Small eyelets were put in the top of each panel, and a jump ring was inserted. They hang on a length of twisted rebar wire to serve as a curtain behind the central stage of the assemblage.

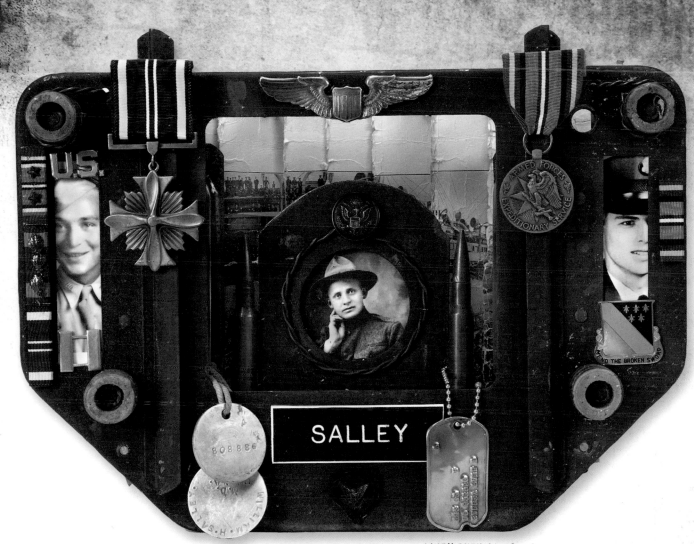

WHEN DUTY CALLS

A NOTE ABOUT TECHNIQUE

The assemblage is held together entirely with cold connections—screws, bolts, rivets, etc. This was done to preserve the integrity and natural patinas of the individual components of the piece. The piece could be disassembled and the parts returned to their storage boxes and still be in their original condition. Working with only cold connections is a challenge unto itself. There are many times when the easy solution would be to glue, weld or solder parts together. It requires much more thought, planning and engineering to rely only on cold connections. That said, I did use epoxy in one instance—to hold the bullets in place. I was just not brave enough to drill holes into them and secure them with screws, even though I knew they were no longer live rounds. All the ribbons, medals and insignia are held in place by way of drilling holes in the metal base and then securing them with their original fastening hardware, just as they were worn on a uniform.

For Elijah and Rose:
A MOTHER'S TREASURE BOX

Susan Tuttle

"Here ya go!" my daughter Rosie says at least three dozen times a day. She's a toddler, exploring every nook and cranny of her environment, relishing all her discoveries, and bringing Mama, Daddy and Big Brother all her little found treasures. My four-year-old son, Elijah, enjoys bringing me flowers, leaves, nuts and pebbles found during one of his backyard adventures. I accumulated quite a collection of these treasures but had no suitable place to store the beautiful mementos.

Creating a Keepsake Box

Materials

ANTIQUE METAL CIGARETTE BOX
OR SIMILAR CONTAINER

MEDIUM-GRADE SANDPAPER OR SANDING BLOCK

WATERCOLOR PAPER

IMAGERY

SMALL SCRAP OF TULLE

EPOXY (E6000)–PLEASE READ SAFETY INSTRUCTIONS,
ON PRODUCT LABEL

COSTUME JEWELRY, FAUX PEARLS

BROWN ACRYLIC PAINT

FINE- AND MEDIUM-BRISTLE PAINTBRUSHES

TWINE

RUSTY, METAL PARTS

NONTOXIC VARNISH (APPLY WITH A PAINTBRUSH)

My creative process, more often than not, seems to take the long and winding back-road journey—can you relate? It takes me a while to reach the final destination, but I must admit there are many surprises and delights along the way, in spite of quite a few wrong turns and blown-out tires. Working in 3-D is not my forte, and I often seem to have trouble with balance and design when I'm out of my comfort zone of working on a flat surface. I'll spare you the gory details, but let's suffice it to say that my initial attempt yielded nothing more than a piece that looked mismatched, thrown together and a bit contrived.

I put the piece aside (note: I did not trash it, even though I wanted to) and called upon my muse for insight. Within a few days, and after collecting a few seemingly random objects (ones I just had to have) on my various "thrifting" quests, I had one of those "a-ha!" moments: the kind that electrifies your brain and flutters your heart—that instant, inner knowing you learn to trust and follow. I did just that, and within twenty minutes—no joke—I chiseled apart my original piece, combined pieces of it with my newfound treasures and had my new piece nearly completed. I marveled at just how perfectly the objects fit together and at how well the faux jewelry captured the sentiment of the outdoor flora treasures from my kids.

By following our instincts, we can transform parts of our first failed attempts into something quite special—in my case, an heirloom piece. Metal scraps, including an old, rusty car part I retrieved from what I call "the tetanus bin" at our local dump (wear thick working gloves if you attempt this), faux pearls from my mother-in-law's First Communion necklace (that I salvaged after the necklace broke) and imagery from an old photo were all combined to form a mini treasure box, made to house gifts given to me by my precious children. This cherished collection will help me keep these sweet, innocent memories of their childhood alive. And by the way, I think taking the back road is the much better route, don't you?

METHOD

-1- FIND A RUSTY, METAL PART THAT RESEMBLES THE APPEARANCE OF A DRESS. SAND THE BACK OF IT WITH MEDIUM-GRADE SANDPAPER OR SANDING BLOCK (THIS WILL ALLOW FOR BETTER ADHESION TO YOUR SURFACE).

-2- ON WATERCOLOR PAPER (THIS PAPER GIVES A NICE TEXTURE FOR IMAGERY), PRINT OUT THE GIRL'S HEAD (SIZE IT TO BE IN PROPORTION WITH THE METAL DRESS BODY BEFORE PRINTING IT OUT).

-3- CREATE A VEIL FOR THE HEAD BY GLUING A SMALL SCRAP OF TULLE TO THE BACK OF HER HEAD (GATHER THE MATERIAL A BIT TO REPLICATE THE LOOK OF AN ACTUAL VEIL).

-4- ADHERE THE HEAD TO THE METAL BODY AND ATTACH FAUX PEARLS TO HER NECKLINE.

-5- GLUE DOWN THE LEAF COSTUME JEWELRY PIECE TO ONE EDGE OF THE BOX, AND THEN ADHERE YOUR GIRL TO THE BOX, KEEPING THE LEAF IN THE BACK, CENTER OF HER HEAD.

-6- ADHERE THE FAUX ROSE PIN TO THE CENTER OF HER CHEST AND ALLOW THESE ELEMENTS TO DRY FLAT FOR AT LEAST TWENTY-FOUR HOURS (FOLLOW DRYING-TIME DIRECTIONS ON GLUE PACKAGE FOR BEST RESULTS).

-7- TO COVER UP ANY CLEAR, DRIED GLUE THAT MAY HAVE SEEPED OUT FROM UNDER THE METAL DRESS, PAINT IT WITH BROWN PAINT (TRY TO MATCH IT TO THE COLOR OF YOUR METAL), USING A FINE-BRISTLE PAINTBRUSH.

-8- USING A PIECE OF TWINE, TIE A TARNISHED, METAL HEART TO THE CENTER OF A CIRCULAR PIECE OF METAL (THE CIRCLE ACTS LIKE A GREAT FRAME FOR THE HEART TO "FLOAT" IN).

-9- TURN THE BOX ON ITS SIDE (SO THE FRAME CAN DRY FLAT) AND ADHERE THE CIRCULAR FRAME TO THE MIDDLE OF THE BOX. LET DRY COMPLETELY BEFORE TURNING UPRIGHT (FOLLOW DIRECTIONS ON GLUE).

-10- USING A MEDIUM-BRISTLE PAINTBRUSH, SEAL RUSTY METAL PARTS WITH A NONTOXIC VARNISH.

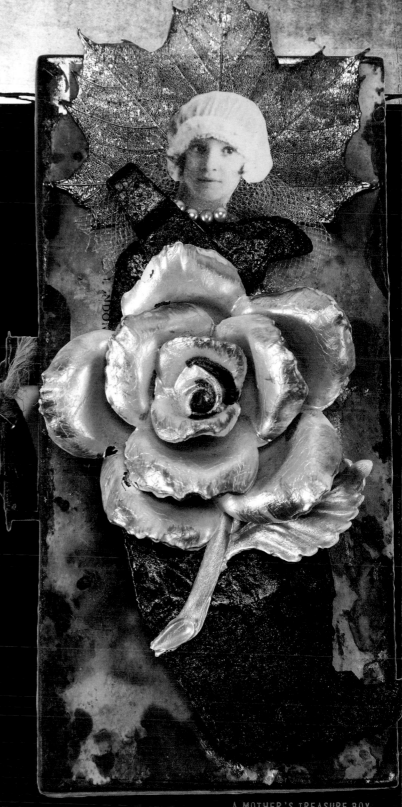

A MOTHER'S TREASURE BOX

GUARDIANS, KEEPERS AND PROTECTORS

Terry Garrett

These days, at my age of fifty-five, if I don't write down ideas I have for art-making as they come to me, they are lost forever. I was sitting having coffee before the sun rose, and I thought about how nice it would be if there were protectors, guardians and keepers to help with keeping track of these things. As I pondered this, it seemed the next logical step for me would be to bring these characters to fruition. This started a series of art pieces for me, and I'd like to share four pieces from the series with you.

I wanted these figures to have some personal authenticity for me, and I decided to use old photographs of my family as well as of my partner's. While I have not met these people, they are a part of my heritage. I altered all the portraiture with a photo-editing program, using a "poster edges" filter along with some mild use of a "posterizing" feature to give the portraits an edgier look.

The first piece, *Guardian of the Unborn Ideas*, is about wanting someone to be a guardian of all the ideas I have for artwork. The woman I used here had such a nice look in her eyes. I cut through her photograph and inserted a box containing a nest with eggs, representing the unborn ideas. I covered papier-mâché eggs with dictionary definitions and gave them a wash

of blue acrylic paint. The other objects present in the piece all have some personal significance—an abacus for counting ideas, an old watch to represent the idea of time ticking away, a wooden ruler for the construction of these ideas into actual form and a window with a scene from the land where I live.

The Protector of the Words Thought but Not Spoken illustrates the thoughts I often have when I am sitting through university department meetings, wanting to say things that might be too honest for my colleagues to hear. The box in this woman contains words in a nest of dictionary definitions.

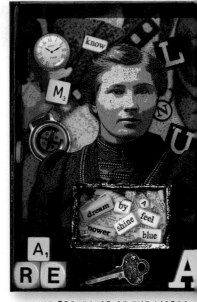

THE PROTECTOR OF THE WORDS THOUGHT BUT NOT SPOKEN

The Keepers of the Family Secrets comes from the whole experience of having some family members who don't want the truth about each other to be known. This piece includes a box filled with a key and tiny letters/postcards, representing communication (in this case family may discuss "family issues" among family only—sometimes in letters), a keyhole where prying eyes may stray and praying hands yearning for things that will never happen.

The final piece, which may seem like the odd one out in this series, is *A Cloudy Day for Icarus*. I have always been attracted to the mythological story of Icarus, and I used my partner's great-grandfather's image to represent him. What would things have been like if Icarus had had a cloudy day for his flight? To fly away on one's own power is very appealing—especially when things aren't going so

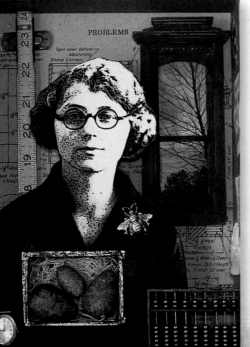

GUARDIAN OF THE UNBORN IDEAS

well in life! Perhaps it's the cloudy times in life that may very well allow ideas to "fly" freely! Of course, I love it when the viewer can make connections to their own experiences in life when viewing my work.

PUTTING IT TOGETHER

I start by selecting background papers for the box frame that will contain the work. Sometimes I use a photograph relating to the theme. I adhere these to the back and sides of the interior of the box with adhesive (I prefer Xyron).

After selecting the family photograph, I scan it and experiment with altering the image by using filters from photo-editing software to create a more graphic, outlined appearance. Then I print out an enlarged version unless I'm working with a small box.

I cut out my figure and mount it on a piece of acid-free mat board, and then cut the shape from the board. Next, I cut an opening for a jewelry box and tape it to the

A CLOUDY DAY FOR ICARUS

figure from the back. I like to cover this junction with copper tape on the front of the piece to hide the seam. From here, it's really a matter of selecting elements to tell my story. I enjoy adding things like dollhouse windows with various scenes "outside" of them and objects that hold symbolic meaning.

After experimenting with various options for placement of the found objects and other photographs, I adhere everything to the background with epoxy. I achieve a variety of depths by gluing small wooden blocks (in a variety of sizes) to the backs of the photos and objects before gluing them into place.

After the epoxy has set, I attach Plexiglas to the front of the frame, using washers and screws.

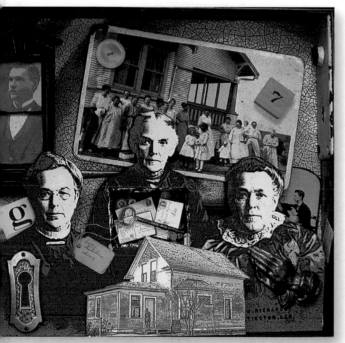

THE KEEPERS OF THE FAMILY SECRETS

ARTIST'S TIP

I like to use Xyron because it is a dry adhesive and doesn't warp.

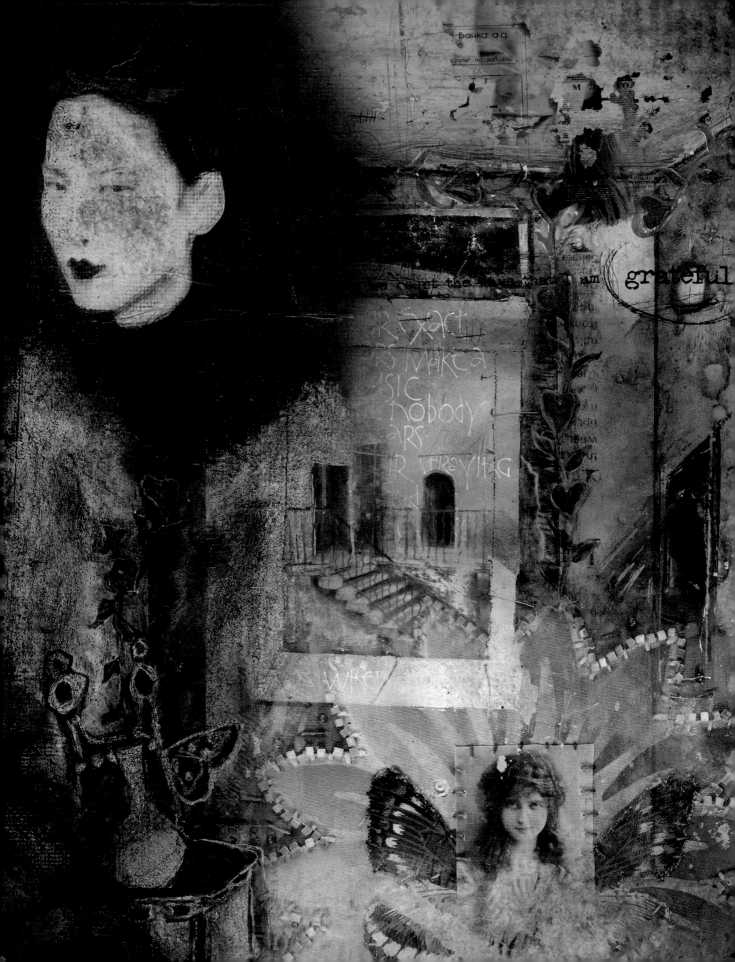

PERFECT IMPERFECTION

How do you handle "imperfection" in your art? In your life? Do you embrace it? Do you run from it? Or do you try to "fix" it, in an attempt to make it "perfect" or close to perfect? Do imperfections fill you with dread and frustration? Or do they bring a sense of excitement and possibility? Do you believe that true perfection even exists?

A few years ago, I would not have been comfortable with any of those questions. Here was me: Type A personality, pretty much an overachiever, everything in its place, ultra-clean house, didn't like change, had to have just the right job in my field, wished I would have done or said this or that differently, hair and makeup just right, my life was my date book and my lists. Way too high expectations of myself (and even others at times), trying to be everything to everybody—HOW EXHAUSTING! And guess what? In my attempts to achieve happiness by trying to attain what I thought was "perfection," I was actually missing out on my own life. And I was stressed and unhappy to boot. My face is a bit inflamed with embarrassment as I write this . . . but, hey, admitting the problem is the first step toward recovery, right? If you want to read more about my adventures as a recovering perfectionist, you can do so in this chapter's *The Art I Almost Threw Away*. Not to say that we shouldn't have high standards for ourselves as we reach for those stars—that's not what I'm saying, of course—it's more of a matter of how we choose to get there.

There is a wisdom in embracing the imperfect. Some people know this innately. My friend Katie Kendrick welcomes "mistakes" in her art, referring to them as "unexpected happenings and surprises that keep me coming back to the studio each day." You can tap into her insights by reading her contribution *Serendipitous Solvent Papers*. And in *Your Exact Errors Make a Music*, Laurie Doctor states with brilliance, "We, as we are, with our exact errors, is what leads our straying feet [to] find the great dance."

In Nathaniel Hawthorne's short story *The Birthmark*, written in 1843, Georgiana is a most beautiful woman who is perfect in all regards except for the birthmark upon her face. Her husband, Aylmer, a scientist, becomes obsessed with the birthmark and its removal in order to attain perfection. In the end, he does remove the birthmark with a special potion, only to have his beloved wife die from the treatment, the author's symbolic message being that absolute perfection can never be attained in earthly form. Instead, to achieve happiness and contentment in our lives (thus, in our art-making), we need to embrace the things we love . . . imperfections and all . . . and come to realize that, as Thomas De Quincey said, "Even imperfection itself may have its ideal or perfect state."

EVEN IMPERFECTION ITSELF MAY HAVE ITS IDEAL OR PERFECT STATE.
—THOMAS DE QUINCEY

Freestyle Art Quilts

BELINDA SCHNEIDER

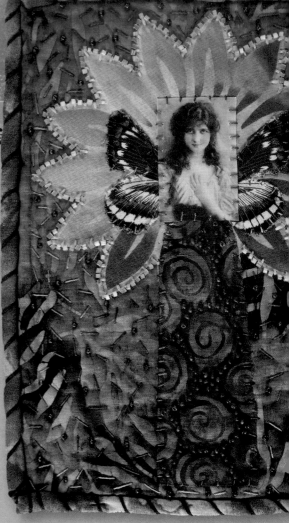

SUMMER FAIRY

Since childhood I have explored and expressed my creativity through various media, including paper, wood and clay. A few years ago, upon discovering contemporary art quilts made by artists such as Keely Barham and Susan Shie, I was immediately charmed by their handstitching and the freestyle look of their compositions. In a world where perfection is often expected, I found it liberating to discover this new way of creating fabric collages.

Making art that requires you to stitch by hand can give you the freedom to create in practically any location. I have made art quilts traveling by train, airplane, car, in hotels and visiting with family and friends. I have a joyful recollection of making art quilts for nieces and nephews during a family reunion several years ago. Prior to the reunion, I had selected recent photos of their faces and printed them onto fabric. I gathered various suitable embellishments ahead of time—choosing these fabrics and threads and anticipating my relatives' excitement was pure joy for me. I was able to visit and mingle with family members at the reunion while piecing and stitching the mini art quilts together at the same time. The children enjoyed observing the progress of their quilts and were delighted to see their faces on these little pieces—some even expressed specific wishes for designs, colors and embellishments. Inspired by these "reunion" quilts, I proceded to create four Haiku mini quilts for a group project. I enjoy working with today's commercial fabrics, as they are so colorful and offer a wide variety of patterns and designs from which to choose.

WHERE DOES A SUBJECT COME FROM?

Most of the time, my art quilts are based on something I experienced in my everyday life—an image I saw or some words I overheard during a conversation or read somewhere. I begin by selecting appropriate images and then printing them on white fabric. The images dictate which types of coordinating fabrics I will use—this can often be the most difficult part of the process for me. I then pin my fabric background together and cut out my images. I enjoy moving the images around on the fabric as I attempt to find a pleasing look. The final steps require stitching all elements together and adding embroidery stitches and embellishments.

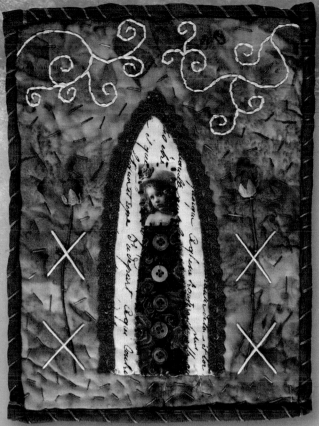

ROSE GIRL

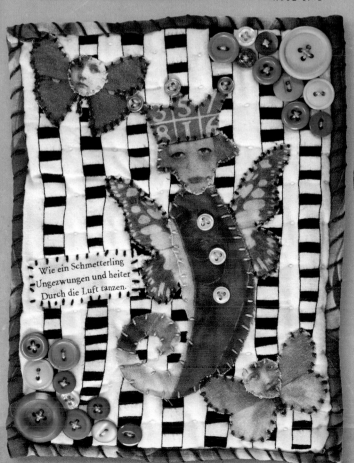

Wie ein Schmetterling
Ungezwungen und heiter
Durch die Luft tanzen.

ERRATIC FLIGHT

PRINTING TRICKS

THERE ARE A VARIETY OF WAYS YOU CAN PRINT AN IMAGE ONTO FABRIC (WORKS WELL ON MUSLIN AND COTTON). THESE ARE MY FAVORITE METHODS:

• PRINT THE IMAGE DIRECTLY ONTO A SHEET OF FABRIC SUPPORTED WITH IRONED-ON FREEZER PAPER.

• USE T-SHIRT TRANSFER PAPER.

• USING PRINT BLOCKS OR RUBBER STAMPS, STAMP DIRECTLY ONTO THE FABRIC WITH STAZON PERMANENT INK.

• PRINT YOUR IMAGE ONTO A TRANSPARENCY, AND TRANSFER THE IMAGE ONTO FABRIC, USING GOLDEN FLUID MEDIUM (PLEASE READ SAFETY PRECAUTIONS ON THE PRODUCT LABEL). (TIP: COAT THE IMAGE AND RECEIVING SURFACE WITH THE MEDIUM, PLACE THE IMAGE FACEDOWN, BURNISH, LET DRY A FEW MOMENTS, AND PEEL AWAY THE PAPER TO REVEAL THE TRANSFER.)

• PRINT YOUR IMAGE ON GLOSSY PAPER AND TRANSFER IT ONTO FABRIC WITH WATER. (SPRITZ THE IMAGE AND RECEIVING SURFACE WITH WATER, PLACE THE IMAGE FACEDOWN, BURNISH, AND PEEK TO SEE IF THE IMAGE IS TRANSFERRING. IF NOT, BURNISH SOME MORE. FINALLY, PEEL AWAY THE PAPER TO REVEAL THE TRANSFER.)

Serendipitous Solvent Papers

KATIE KENDRICK

The uncontrollable element of surprise and mystery—unexpected happenings some might call mistakes—are what bring me back to my studio each day. This is the part of the creative process that interests me most.

When Susan asked me to be a contributing artist in her book, I was particularly delighted by the opportunity to experiment with altering old *National Geographic* magazine pages using Citra Solv® natural cleaner, followed by incorporating the newly created paper into my artwork. A few years ago, a friend shared some of her altered magazine paper along with a brief tutorial, and I've been hooked ever since. Making the paper is as much fun as finding ways to use it.

I've tried this technique with several different magazines but have had success only with *National Geographic*. I have had the best luck using magazines printed in the past ten years; ones older than that didn't work as well.

Because of the cleaner's strong citrus odor (and because the process is messy), I set up my workstation on my picnic table outdoors. And unless you don't mind ink-stained hands, you'll want to wear latex gloves.

Altering Magazine Pages

Materials

PLASTIC SHEET

CITRA SOLV NATURAL CLEANER
(AVAILABLE AT SPECIALTY GROCERY STORES THAT SELL NATURAL FOODS)

RECYCLED GLASS JAR OR SIMILAR CONTAINER

LATEX GLOVES

ISSUE OF *NATIONAL GEOGRAPHIC MAGAZINE*

CHIP BRUSH OR SPONGE BRUSH

THIN TISSUE PAPER

METHOD

-1- PUT A PIECE OF PLASTIC DOWN TO WORK ON, AND POUR SOME CITRA SOLV INTO YOUR CONTAINER. (PLEASE FOLLOW THE MANUFACTURER'S PRECAUTIONS.) OPEN UP YOUR MAGAZINE TO THE SECOND PAGE SPREAD.

-2- LIBERALLY BRUSH ON THE CITRA SOLV, COATING BOTH SIDES OF THE PAGE. TURN THE PAGE AND REPEAT THE PROCESS ON THE REMAINING SPREADS. YOU DON'T WANT SO MUCH LIQUID THAT MOST OF THE INK RUNS OFF THE PAGE AFTER LOOSENING, BUT NOT SO LITTLE LIQUID THAT THE PAGES DRY AND STICK TOGETHER DURING THE STEEPING PROCESS. I USE EIGHT TO TEN OUNCES OF CITRA SOLV TO COVER AN ENTIRE MAGAZINE.

-3- LAYER THIN TISSUE PAPER BETWEEN THE WET PAGES. THE TISSUE ABSORBS MOST OF THE BLACK INK, LEAVING THE MAGAZINE PAGES WITH PASTEL COLORS. (PLUS, YOU END UP WITH SOME INTERESTING TISSUE PAPER!)

-4- TEAR OUT THE PAGES AND REARRANGE THEM IN THE MAGAZINE, WITH THE FOLLOWING PARAMETERS IN MIND: IF TWO TEXT PAGES ARE FACING ONE ANOTHER IN A SPREAD, I TEAR OUT A COLORED PHOTO SOMEWHERE ELSE IN THE MAGAZINE AND PLACE IT ACROSS FROM ONE OF THE BLACK-AND-WHITES.

-5- SOME OTHER THINGS TO EXPERIMENT WITH ARE:
• PLACING A STENCIL BETWEEN TWO PAGES,
• LAYING A WET PAGE ON A BIG GARBAGE BAG: THE INK WILL POOL AND MAKE INTERESTING PATTERNS ON THE BACK SIDE.
• PLACING A PAPER DOILY, CORRUGATED CARDBOARD OR ANYTHING THAT MAKES A PATTERN ON TOP OF THE PAGE.
• LAYING WET PAGES ON GRAVEL. STEPPING ON A PAGE AND SQUISHING IT INTO THE GRAVEL A BIT.
• WRITING INTO THE WET INK WITH A WOOD SKEWER.

-6- NOW LET THE MAGAZINE SIT UNDISTURBED FOR A COUPLE HOURS. WHEN THE PAGES ARE "DONE," THE INK WILL LOOK BEAUTIFUL, SMEARED ALL OVER THE PAGES. GENTLY PULL THE PAGES OUT, ONE AT A TIME, AND SPREAD THEM OUT TO DRY.

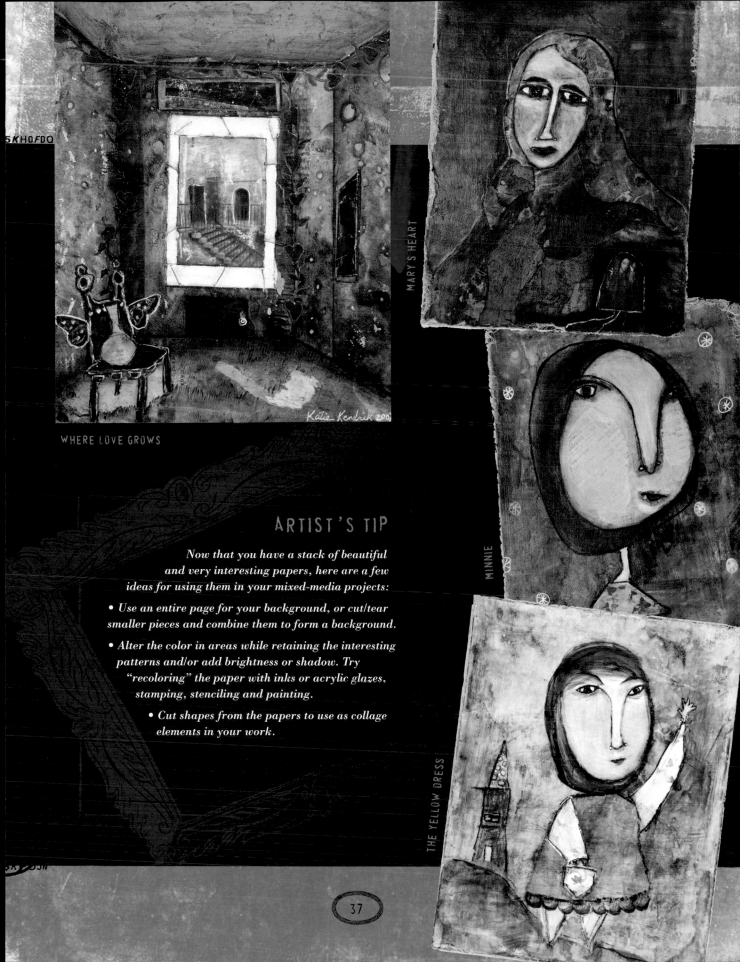

WHERE LOVE GROWS

Katie Kendrick 2007

MARY'S HEART

MINNIE

THE YELLOW DRESS

ARTIST'S TIP

Now that you have a stack of beautiful and very interesting papers, here are a few ideas for using them in your mixed-media projects:

• *Use an entire page for your background, or cut/tear smaller pieces and combine them to form a background.*

• *Alter the color in areas while retaining the interesting patterns and/or add brightness or shadow. Try "recoloring" the paper with inks or acrylic glazes, stamping, stenciling and painting.*

• *Cut shapes from the papers to use as collage elements in your work.*

Your Exact Errors Make a Music

LAURIE DOCTOR

Often the most difficult part of a creative project for me is: Where do I begin?

Just looking around my studio, it seems there are infinite possibilities: baskets of paper, paints, pencils, brushes, shells, feathers, magazines, sketchbooks and unfinished projects, all offering me contradictory advice. So I have to reel myself in and just begin somewhere! For me, the way into my work is often with words. *Your Exact Errors* comes from a poem by William Stafford called "You and Art." It is a strong poem that mentions nothing in particular about art and yet says everything one needs to know. For now, I will take only the first line, "Your exact errors make a music that nobody hears." This speaks to the part of ourselves that believes if we could just amend this one thing about ourselves, change this or that detail of our history, well, then, all would be well. Yet there is the experience that comes from the kind of forgiveness and openness alluded to in this poem, that confirms the last line of the first stanza, ". . . and you live on a world where stumbling always leads home."

Incorporting a Poem Into Your Art

Materials

- TEXT OR POEM TO USE AS INSPIRATION
- TEXT WOVE PAPER (ARCHES)
- .05 PERMANENT BLACK FELT-TIP PEN
- RUBBER STAMPS AND WATERPROOF INK (OPTIONAL)
- ACRYLIC PAINTS IN TUBES
- ASSORTMENT OF SPONGE BRUSHES
- ASSORTMENT OF POINTED BRUSHES
- SUMI INK
- JAPANESE PAPER, UNBLEACHED
- WHITE GEL PEN
- METHYL CELLULOSE (PLEASE READ SAFETY PRECAUTIONS ON PRODUCT LABEL)

ARTIST'S NOTE

A lot of what went into this piece (most of which was not mentioned in the project steps) was either covered up or not used. For example, I have sheets of blind contour drawings I made of snowflakes and feet (images from the poem) that were never integrated into the final product; this is an important part of the process, nonetheless. Art does not seem to have much to do with perfection; beginning with a phrase like "your exact errors" gave me permission to consider all my mistakes a part of this work.

METHOD

-1- FIND A POEM THAT SPEAKS TO YOU. BEGIN WITH JUST ONE LINE. DETERMINE THE SIZE OF PAPER(S) YOU WILL WORK ON. I CHOSE ARCHES TEXT WOVE PAPER (IT WILL TAKE ALL KINDS OF MEDIA), AND I TORE MY PAPERS TO 14" X 18" (36CM X 46CM).

-2- USING A PERMANENT BLACK FELT-TIP PEN, WRITE OUT THE LINE OR POEM IN YOUR OWN HANDWRITING, OR USE A SET OF RUBBER STAMPS (WATERPROOF INK IS PREFERABLE). DON'T FRET OVER HOW IT LOOKS: IT CAN GET PAINTED OVER IN THE PROCESS OF WORKING (WHICH I ACTUALLY DID WITH MY INITIAL WRITING, ADDING THE POEM AGAIN LATER IN THE PROCESS). WRITING OUT THE POEM HELPS INFUSE THE MEANING INTO YOUR MIND AND INTO THE PIECE.

-3- MIX EQUAL PARTS ACRYLIC PAINT FROM THE TUBE AND WATER. MIX AS FEW OR AS MANY COLORS AS YOU LIKE. APPLY THE COLORS TO YOUR PAPER WITH A WIDE SPONGE BRUSH, USING LARGE STROKES, JUST TO GET PAINT ON THE PAPER. TRY DOING THIS WITH YOUR EYES CLOSED TO HELP GET OUT OF LEFT-BRAIN THINKING AND LEAVE ROOM FOR SURPRISES!

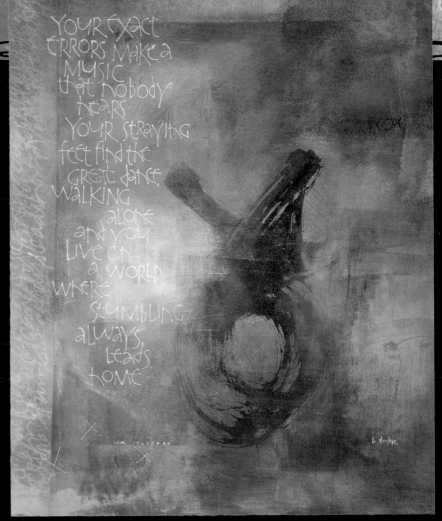

YOUR EXACT ERRORS

-4- LEAVE THE SHEETS OUT WHERE THEY CAN BE SEEN, AND LET THEM CATCH YOU BY SURPRISE WHEN YOU WALK BY AT A LATER TIME. I DID THIS, AND WHEN I CAME BY MY PAINTING, I TOOK OUT A BIG POINTED BRUSH, DIPPED IT IN SUMI INK, AND MADE AN X THAT GREW INTO A CIRCLE ON MY PAPER. I HAD BEEN THINKING ABOUT ERRORS AND HOW MISTAKES ARE INDICATED WITH AN X, AND THEN HOW CIRCLES REPRESENT WHOLENESS.

-5- WRITING THE POEM BECOMES A KIND OF MEDITATION. WRITE IT AGAIN, OVERLAPPING THE LINES, WITH A POINTED BRUSH ON A PIECE OF JAPANESE PAPER. YOU COULD ALSO USE A WHITE GEL PEN OR A FINE-POINT PERMANENT PEN. THE OVERLAPPING LINES CREATE PATTERN AND TEXTURE AND ARE NOT MEANT TO BE LEGIBLE.

-6- ONCE THE PIGMENT ON THE JAPANESE PAPER IS DRY, MIX UP SOME METHYL CELLULOSE (A PRODUCT AVAILABLE UNDER VARIOUS NAMES, BUT ESSENTIALLY, A POWDER THAT YOU MIX WITH COLD WATER TO CREATE A PASTE) TO BE USED AS AN ADHESIVE. THE TYPE OF COLLAGE TECHNIQUE I USED IN THIS PIECE IS CALLED CHINE COLLÉ. USING A BRUSH, APPLY THE PASTE TO A SECTION OF THE PAPER YOU HAVE PAINTED ON: PLACE THE JAPANESE PAPER ON TOP OF THE ADHESIVE, AND PASTE OVER THE TOP OF THE JAPANESE PAPER WITH YOUR SPONGE BRUSH, REMOVING ANY WRINKLES. JAPANESE PAPER HAS AN ADVANTAGE OVER MOST OTHER PAPERS: IF YOU DO NOT LIKE THE WAY IT LOOKS ON YOUR SUBSTRATE, YOU CAN DAMPEN IT AND TAKE IT OFF.

-7- INCORPORATE THE COLLAGE INTO THE PAINTING BY PAINTING ON TOP OF IT WITH THE COLOR PREVIOUSLY MIXED. CONTINUE MAKING MARKS HOWEVER YOU ARE MOVED TO DO SO.

Portraits Reinvented

SUSAN TUTTLE

As a self-taught artist, I am constantly looking for ways to practice skills I have not yet fully formed. Painting and drawing in the realist style have proven to be some of my greatest artistic challenges. I was thrilled to come across a wonderful exercise in Karen Michel's book, *The Complete Guide to Altered Imagery,* where she recommends altering magazine photography as a great way to practice working with lights and shadows. Karen suggests working with gesso, water-soluble oil pastels and gel pens.

I began leafing through a fashion magazine and chose photographs of women who seemed to have a story to tell behind their soulful eyes.

These projects became not only excellent teaching tools for painting portraits in the realist style, but evolved into a variety of mixed-media pieces that yielded some satisfying artistic results. Below is a general materials list that covers all the projects, and then a synopsis of how I went about creating each individual piece. Please refer to safety warnings on all product labels.

Altering Magazine Portraits

Materials

CANVAS BOARD, 8" x 10" (20CM x 25CM)	NONTOXIC VARNISH
MAGAZINE PAGE	MASKING TAPE
GEL MEDIUM, MATTE (GOLDEN)	BRISTLE PAINTBRUSH
DECOUPAGE MEDIUM	PAPER TOWEL
GESSO	EMBELLISHMENTS
ACRYLIC PAINTS, ASSORTED COLORS	GLITTER
CHARCOAL PENCILS	DISTRESSING INK
GRAPHITE PENCILS	INKPAD OF YOUR CHOICE
WATER	RUBBER STAMPS
	RED CHALK

METHOD
{A BIT GOTH}

-1- FLIP THROUGH A FASHION MAGAZINE AND FIND A PICTURE OF A MODEL THAT APPEALS TO YOU. CUT THE PAGE TO FIT THE CANVAS BOARD. (I LIKE TO PLACE THE CANVAS ON THE PAGE, TRACE AROUND IT, THEN CUT ALONG THE LINES.)

-2- COAT THE CANVAS BOARD WITH A GENEROUS AMOUNT OF GEL MEDIUM IN REGULAR STRENGTH AND ADHERE THE PAGE TO THE BOARD, SMOOTHING OUT ANY BUBBLES WITH YOUR FINGERS AND/OR BRAYER.

-3- APPLY A LAYER OF GESSO TO THE BACKGROUND OF THE PAGE, BEING CAREFUL NOT TO PAINT THE MODEL. WHILE THE GESSO IS SLIGHTLY DAMP, TAKE A PIECE OF MASKING TAPE AND PRESS AND PULL IT OFF THE CANVAS IN A RANDOM FASHION TO CREATE A DISTRESSED LOOK.

-4- NEXT COMES THE FUN PART! PAINT THE MODEL'S COAT WITH RED ACRYLIC PAINT (OR A COLOR OF YOUR CHOICE). LET IT DRY. ADD SHADOWS AND EMULATE FOLDS IN THE MATERIAL, USING A BLACK CHARCOAL PENCIL.

-5- PUT A LIGHT COAT OF GESSO ON HER FACE, BLENDING IT WITH A DROP OF WATER: DAB THE EXCESS WATER AND GESSO WITH A PAPER TOWEL. BE VERY CAREFUL NOT TO COVER UP HER FACIAL FEATURES WITH TOO MUCH GESSO: YOU SHOULD BE ABLE TO SEE GLIMPSES OF HER FACIAL FEATURES THROUGH THE MEDIUM. ONCE THE GESSO DRIES, ALTER HER FEATURES WITH ACRYLICS, GRAPHITE AND CHARCOAL PENCILS.

-6- ALTER HER HAIR BY PAINTING IT WITH YELLOW ACRYLIC PAINT, ADDING MORE WISPS AROUND HER FACE AND HIGHLIGHTING THE DRIED PAINT WITH BOTH GRAPHITE AND CHARCOAL PENCILS. TO MAKE HER STAND OUT FROM THE BACKGROUND, OUTLINE HER BODY WITH BLACK CHARCOAL PENCIL AND SMUDGE IT WITH EITHER YOUR FINGER OR A PAPER TOWEL. SEAL WITH VARNISH.

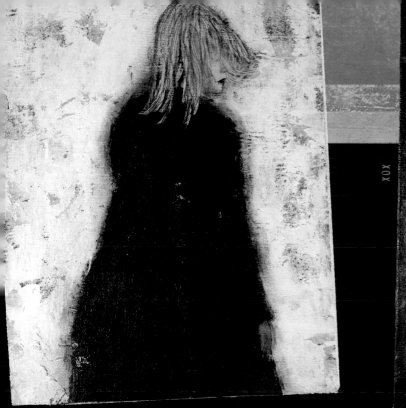

A BIT GOTH

XOX

METHOD
{xox}

-1- ADHERE A MAGAZINE PAGE WITH A PRETTY FLORAL BACKGROUND TO YOUR CANVAS AS PREVIOUSLY DESCRIBED. MIX SOME PAINT INTO THE COLORS OF THE BACKGROUND. (HERE, I MIXED SOME HOT-PINK ACRYLIC PAINT WITH A FEW DROPS OF WATER.) GIVE THE BACKGROUND A WASH WITH YOUR SELECTED COLORS.

-2- TO ADD SOME DEPTH AND INTEREST, ADD A FEW SPOTS OF WATERED-DOWN PAINT. BLOT ANY EXCESS MOISTURE FROM THE PAGE WITH A PAPER TOWEL. AGAIN, USE SOME MASKING TAPE TO PULL UP SOME OF THE PAGE WHILE IT IS SLIGHTLY DAMP TO ADD A DISTRESSED LOOK.

-3- ONCE THE PAINT IS DRY, DISTRESS IT FURTHER BY COATING IT WITH BROWN ACRYLIC PAINT THINNED WITH WATER. LET IT SIT FOR ABOUT THIRTY SECONDS AND THEN RUB IT OFF WITH A PAPER TOWEL. YOU'LL NOTICE THAT THE BROWN PAINT STAYS IN THE CROOKS AND CREVICES OF YOUR PAGE AND GIVES AN OVERALL SEPIA TONE TO YOUR BACKGROUND. THE FRICTION FROM THE CLOTH WILL ALSO REMOVE SOME OF THE MAGAZINE INK, GIVING IT A MORE WARN, VINTAGE APPEARANCE.

-4- PAINT HER GLORIOUS MANE WITH BLACK ACRYLIC PAINT TO CREATE A JET-BLACK EFFECT. GIVE IT SHEEN BY ADDING HIGHLIGHTS WITH A WHITE CHARCOAL PENCIL.

-5- GIVE HER DELICATE FACE A LIGHT WASH OF GESSO (THINNED WITH A DROP OF WATER), BEING CAREFUL NOT TO COVER UP HER FEATURES. IF YOU ACCIDENTALLY COVER THEM UP, ADD A DROP OF WATER AND GENTLY BLOT IT OUT. DON'T RUB TOO HARD, OR YOU WILL REMOVE HER FEATURES. ONCE DRY, ENHANCE HER LIPS WITH BLACK ACRYLIC PAINT, TRACE OVER HER EYES AND EYEBROWS WITH GRAPHITE PENCIL AND ADD SHADOWS AND HIGHLIGHTS WITH BOTH GRAPHITE AND BLACK CHARCOAL PENCILS.

-6- PAINT HER DRESS WITH A LIGHT COATING OF GESSO AND ADD RED ACRYLICS TO HER CUFFS, COLLAR AND STOCKINGS.

-7- ONCE DRY, COAT HER DRESS WITH DECOUPAGE MEDIUM AND SPRINKLE ON ULTRA-FINE RED GLITTER. USING A BLACK CHARCOAL PENCIL, ADD SHADOWS, SHADINGS AND RANDOM SCRIBBLES. ADD EMBELLISH-MENTS AND SEAL WITH VARNISH.

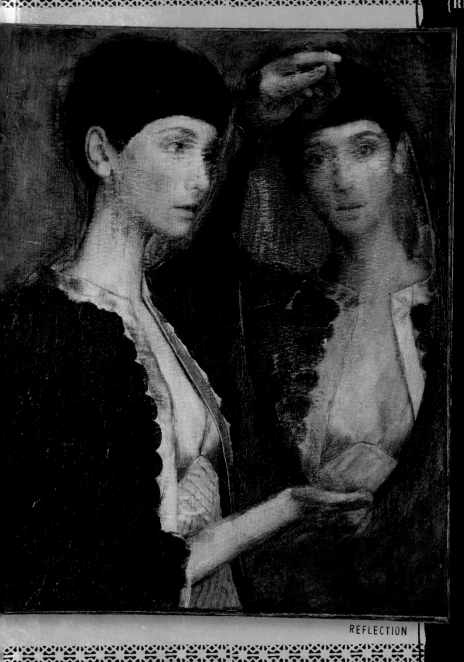

REFLECTION

METHOD
{REFLECTION}

-1- ONCE YOU'VE ATTACHED THE MAGAZINE PAGE TO YOUR SUBSTRATE AS PREVIOUSLY DESCRIBED, PAINT THE BACKGROUND WITH A COMBINATION OF GREEN, AQUA BLUE AND ROBIN'S-EGG BLUE PAINTS TO ACHIEVE A PAINTERLY EFFECT.

-2- ONCE DRY, ANTIQUE THE BACKGROUND BY APPLYING A WASH OF BROWN ACRYLIC PAINT AND RUBBING IT OFF WITH A PAPER TOWEL ABOUT THIRTY SECONDS AFTER APPLICATION.

-3- PAINT THE WOMAN'S SKIN WITH A LIGHT COAT OF GESSO THINNED WITH A FEW DROPS OF WATER. USE A BLACK CHARCOAL PENCIL TO TRACE OVER HER FACIAL FEATURES AND ADD SHADOWS AND SHADINGS TO HER SKIN. COLOR HER LIPS WITH A PEACHY/PINK PENCIL. DUST HER CHEEKS WITH RED CHALK AND A SOFT-BRISTLE BRUSH TO ACHIEVE A SUBTLE EFFECT.

-4- PAINT OVER THE CIRCLES OF THE SWEATER WITH BLACK ACRYLIC PAINT, AND WHEN DRY, OUTLINE EACH CIRCLE WITH BROWN PENCIL: IT'S BARELY VISIBLE AGAINST THE BLACK, BUT ADDS A BIT OF CONTRAST. WITH GRAPHITE AND CHARCOAL PENCILS, ADD SHADINGS AND SHADOWS TO THE FIGURE, BLENDING THE EDGES WITH A PAPER TOWEL.

-5- FOLLOW A SIMILAR PROCESS WITH THE WOMEN'S REFLECTION, BUT WHEN YOU ARE FINISHED, RUB THE SURFACE OF THE MIRROR WITH A PAPER TOWEL, USING A BIT OF PRESSURE TO RUB OFF SOME OF THE COLOR, AS ONE'S REFLECTION IS NEVER QUITE THE SAME AS HER ACTUAL PRESENCE. SEAL THE PIECE WITH VARNISH.

METHOD

{CINDERELLA}

-1- YOU KNOW THE DRILL ON PREPARING THE SURFACE, SO WE'LL MOVE ON TO THE NEXT STEPS. GIVE THE BACKGROUND A THICK WASH OF GESSO, BEING CAREFUL NOT TO GET ANY ON THE FIGURE. NO WORRIES IF YOU DO, AS THE PAINT WILL WIPE OFF EASILY WITH A PAPER TOWEL. PAINT HER DRESS WITH A LIGHT PINK ACRYLIC, AND WHEN DRY, ADD A WASH OF BRONZE METALLIC PAINT.

-2- COAT HER SKIN USING GESSO THINNED WITH A LITTLE BIT OF WATER. ENHANCE HER LIPS WITH RED AND WHITE ACRYLICS, ADD GRAPHITE AND CHARCOAL PENCIL TO HER EYES AND EYEBROWS, AND GIVE HER FACE A LIGHT DUSTING OF RED CHALK.

-3- ADD YELLOW CHARCOAL PENCIL TO HER HAIR AND FINALIZE THE PIECE BY ADDING SHADINGS, SHADOWS AND SCRIBBLES WITH YOUR BLACK CHARCOAL PENCIL. BLEND ANY THICK LINES WITH A PAPER TOWEL. ADD EMBELLISHMENTS. SEAL WITH VARNISH.

BLUE ON A GREEN DAY

METHOD

{BLUE ON A GREEN DAY}

-1- ONCE THE PAGE IS ATTACHED, PAINT THE BACK-GROUND WITH A YELLOW/GREEN ACRYLIC. WHILE IT'S SLIGHTLY DAMP, REMOVE AREAS OF THE PAGE BY PRESSING DOWN ON THE SUBSTRATE WITH MASKING TAPE AND THEN PULLING THE TAPE UP, GIVING IT A DISTRESSED LOOK.

-2- USING A FAVORITE RUBBER STAMP AND SOME DISTRESSING INK, STAMP AN IMAGE ONTO THE UPPER LEFT-HAND CORNER OF THE CANVAS.

-3- WITH GRAPHITE PENCIL, SCRIBBLE CIRCLES AND DOODLES IN A RANDOM FASHION AROUND YOUR BACKGROUND.

-4- RUB BROWN DISTRESSING INK INTO YOUR BACKGROUND AND BLEND WITH A PAPER TOWEL.

-5- ALTER THE FIGURE'S DRESS WITH BROWN AND BLUE ACRYLICS. WHEN DRY, ADD SHADINGS WITH WHITE CHARCOAL PENCIL.

-6- DECORATE HER FACE IN A FASHION SIMILAR TO THAT MENTIONED IN THE PREVIOUS WORKS.

-7- COMPLETE YOUR WORK BY ADDING FURTHER SHADOWS AND SHADINGS, BLENDING ANY ROUGH EDGES IN ORDER TO BETTER INTEGRATE THE FIGURE WITH THE BACKGROUND. SEAL WITH VARNISH.

CINDERELLA

The Art I Almost Threw Away

SUSAN TUTTLE

"The Perfectionist." That is what I used to strive to be. All the furniture in my dollhouse was placed just so; I spent hours decorating it, striving for symmetry, neatness and a polished appearance—I was definitely more than a bit obsessive. Everything from the pages of my school notebooks, to my physical appearance, to my bedroom décor reflected my need and desire for perfection—whether innate, learned or both. In some ways this striving served me well as a high-achiever, but in other regards it hindered me and kept me from seeing and experiencing the truths and beauty inherent in life's imperfections.

These days, I am striving to be "The Imperfectionist," though it's something I still struggle with. Slowly, over time, I have sloughed off many of those desires and needs for perfection, both through conscious decision-making and with little pushes from life's circumstances. I learned a lot through making art and raising kids—both are quite messy! Speaking of little nudges from life's circumstances, I must tell you about how I came to art-making, or, rather, how it came to me. I have a musical background as a flutist and music educator and did not explore the visual realm of the arts until my late twenties, after a serious car accident. While my body rested and healed, my soul became energized and seemed to have new life. During my respite I began to explore with charcoals on paper, which led to refurbishing furniture I found on the curbside in my old neighborhood in Boston with paint and found objects. As I continue to explore my artistic side today through collage, abstract painting, assemblage and digital art, it's becoming very clear to me that when we truly allow ourselves to play, explore and follow our muse implicitly during the creative process of art-making, things are never neat, linear or predictable—never perfect. We can lose ourselves in the flow of the creative process; some artists refer to it as being in "the zone." The feelings we get while in the zone can be exhilarating, even if what we are exploring is emotionally difficult. We find ourselves returning to this place again and again—this magical place where we can tap into joy so readily. Not a bad reward for embracing the imperfect.

JUST SURRENDER

I started to realize that in striving for perfection, I was reaching for something that did not exist. My efforts yielded feelings of exhaustion, disappointment and a sense that I was missing out. What I have learned—and am continuing to learn—is that there is a beautiful perfection in embracing the imperfect, and that to embrace it, all we have to do is surrender to it.

So what does that mean for your creative process? Well, if we give ourselves permission to get messy, take risks and let go of expectations, we can then create art that is real, raw—maybe even powerful—and exciting. The constant element of surprise is thrilling, the uncovering of truths is enlightening and even spiritual. This creative process is a form of meditation for me I can no longer live without.

I do not mean to totally mislead you; embracing this imperfect process can also be difficult and frustrating. We have all felt those feelings of futility and the urge to crumple, destroy and toss art pieces in progress because we just can't seem to get them to work. I have felt this sensation more times than I can count. The voices in my head chant, "This is so awful, where can you possibly go with this? Just throw it out now if you know what's good for you. How can you call yourself an artist?" etc. But, if I listen carefully, I hear another little voice in the background coaxing me on, providing me with choices and artistic alternatives I hadn't previously thought of. I have learned over time that these very pieces that seem to be going nowhere often turn out to be my best works.

I want to share with you a couple of Artist Trading Cards (ATCs), as well as some digital collages I struggled with—works I felt the need to toss at one time or another.

SWEEPINGS OF THE MOON

I adhered paper to a playing card and then trimmed it to fit the card. I coated it with gesso, let it dry and randomly adhered torn pieces of decorative paper.

I applied distressing ink randomly over the card and adhered an image of a woman I took from a magazine. Next, I brushed a thin layer of aqua acrylic paint around the woman.

I added a bit of ochre acrylic paint, blending with a paper towel and then repeated the process with purple acrylic paint.

Using a small bristle brush coated in red acrylic paint, I dipped it into a cup of water and flicked the watered-down paint randomly over the card.

Using gesso and acrylic paints, I altered the imagery of the woman, starting by painting her face, neck and arms with watered-down gesso and blending it in gently with a paper towel. I then traced over her facial features with a graphite pencil and scratched away part of her face to symbolize imperfection. I painted her dress with red acrylic paint. After it dried, I scratched away some of the red paint to create texture.

With charcoal and graphite pencils, I added shadows and highlights. Finally, I adhered text and traced the text strips with graphite pencil for added dimension.

SWEEPINGS OF THE MOON

with charcoal and graphite pencils.

Using sharp scissors, I scratched away at the substrate, revealing lower layers and creating a distressed appearance. I scratched quite a bit just around her body to reveal the gesso layer underneath; the white outline highlights and accentuates her body.

Finally, using graphite pencil, I doodled a swirling string and attached text to it, highlighting the text pieces with graphite pencil.

OUTSIDE THE BOX

I began this card the same way, layering vintage paper on top of a playing card. I then added a layer of gesso, followed by pink acrylic paint. I then continued to drybrush layers of paint, blending and wiping with a paper towel as I went, to reveal some of the lower layers of color.

After adhering the image of the ballerina, I altered her with acrylic paints and gesso and then used colored chalks to highlight areas of her skin and dress. I added shadows

OUTSIDE THE BOX

GRATEFUL, PORTALS AND DANCING SHADOWS

These three digital pieces started out basically in the same manner. I took them several steps further by playing around with my digital imaging software.

DIGITAL COLLAGE—THE BASICS

All digital editing programs work more or less in the same way; the more expensive ones have more advanced options for professional use. I recently upgraded from Adobe Photoshop Elements™ to Adobe Photoshop CS3™. I have a friend who uses Microsoft Digital Image Suite™ and another who uses Corel Paint Shop Pro™. Although the ways of navigating through each program are unique, and the tools offered by each program have different names and approaches, they do more or less the same things. If you don't have any background knowledge on these types of programs, I recommend going online for a trial version prior to purchasing anything. In addition to the user manuals that come with each program, the Internet is full of user-friendly tutorials to help get you started with your specific program.

To create digital artwork you need two things: a photo-editing program and imagery you can scan and save onto your computer.

There are a few basic things you need to know about working with a photo-editing program. You work in layers, and each element of your design is a new layer; that way you can click on individual elements (layers) and move them around, alter their size, color and opacity, and move them in front of or in back of other layers. If you want, you can create many layers for each element as well. For instance, if you want to "age" an object, you can create a "faux patina" out of several colors and texture layers. The wonderful thing is that you can easily delete layers you don't like, and you can always "undo" moves you are not satisfied with. Layers can also be replicated, so if you want the same object or effect somewhere else in your piece, you can just copy and paste it.

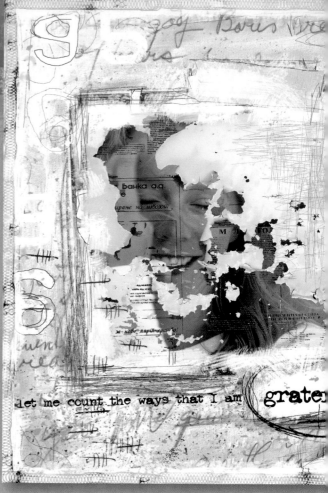

GRATEFUL

Hues and color depth can be altered with your "hue and saturation" tools. You can alter the entire piece or only alter colors of selected elements.

There are a variety of brushes available with each program, all in different sizes and shapes, some softer than others. Some are straightforward, and others have special effects (some make stamped images, for instance). I like to use a soft brush called "granite flow," which gives a speckled effect. I often choose brown paint in my digital palette and use this brush to spread it around the edges of my digital collages—a great distressing effect.

HOW TO CREATE YOUR OWN DIGITAL BRUSH:

To create a "Pencil Doodle" brush for *Grateful*, I started by making a few doodles on a blank sheet of paper—circular and oval scribbles, as well as some tally-mark symbols. I scanned the sheet into my computer and opened the file in Photoshop. I decided to make a brush out of a circular doodle, so I selected the doodle with my lasso tool. Then I moved it into a new blank, transparent document, selected the entire entity (control/apple A) and defined it as a brush (this maneuver can be found if you scroll down under the "edit" option). You then name and save the brush, and it automatically appears in your brushes file. You can then select it, resize, colorize and adjust its opacity before "stamping" it onto your digital collage. Easy, instant gratification!

CREDITS:

The poem utilized in *Portals* is called "The Layers" by noted American poet Stanley Kunitz. It is published in *The Collected Poems of Stanley Kunitz*, W. W. Norton & Company; 1st edition (October 2000).

The imagery of the two children featured in *Portals* is extracted from a photograph by Lori Vrba.

PORTALS

DANCING SHADOWS

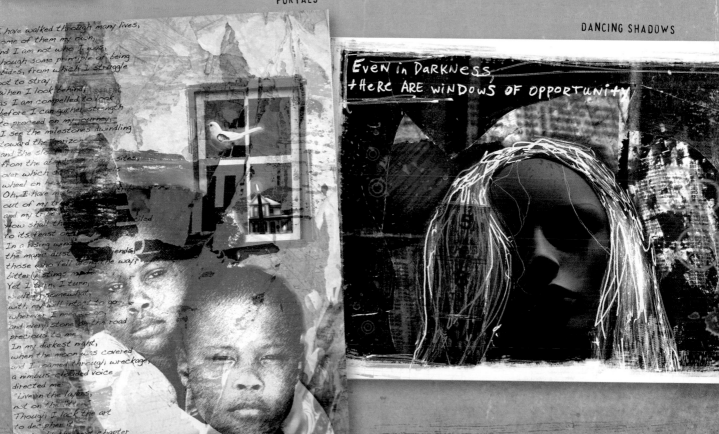

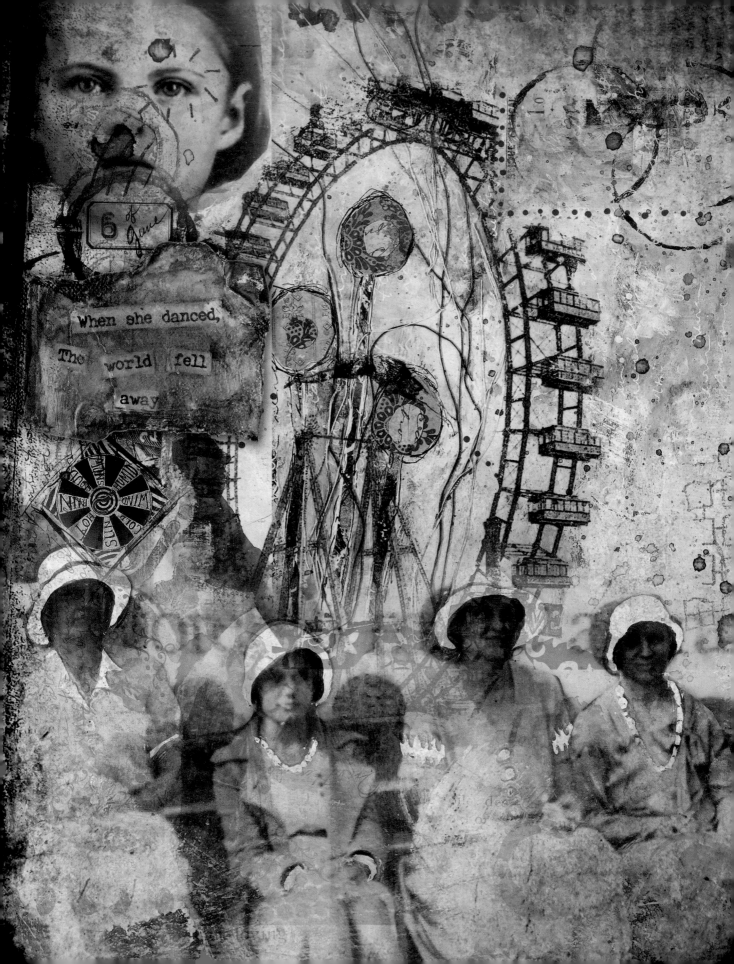

When she danced,
The world fell
away

THE ART OF PLAY

ALMOST ALL CREATIVITY INVOLVES PURPOSEFUL PLAY.
—ABRAHAM MASLOW

When we witness children at play, there is a part of ourselves that resonates with their laughter—a laughter emanating from uninhibited states of freedom, creativity and joy that once came so easily to us, and that we long to connect to. I actually read somewhere that children laugh an average of three hundred times a day, compared to most adults, who only laugh about fifteen times a day! Play comes naturally to children. It's something they are intrinsically motivated to do— the sheer enjoyment of play for play's sake! It's how they learn about their world, make sense of things, experiment, practice skills and develop physically, emotionally and even spiritually. And let's not forget the most important reason for play: It's just plain fun!

So, would it not make sense that art-making is really a form of play? The creative process is a form of self-expression replete with experimentation, development of ideas, the practicing of techniques and skills, and exploration on a variety of levels. Often, it is through their art that artists attempt to make sense of their experiences and that of the greater world. I think many of us are attracted to the idea of play (and the idea of art-making as play) because it's all about the freedom to make choices of our very own, using our imaginations to make new discoveries and finding novel and unique ways of doing things without feeling restricted by rules or conventions. As a parent of young children, I know play is essential for healthy child development and growth, but I argue it shouldn't be limited to that population alone. I think purposeful play, in whatever form it takes, is essential for all human beings, young and old, for we should never stop learning, and we should never stop growing.

In this chapter we will find artists who embrace the notion of art as purposeful play, whether they are exploring an artistic medium or combination of mediums with childlike enthusiasm, creating in what is often referred to as the "creative zone," or engaging in an artistic, collaborative project. Let's go play!

IT IS A HAPPY TALENT TO KNOW HOW TO PLAY.
—RALPH WALDO EMERSON

A Hand-Drawn Touch
Jeannine Peregrine

My personal collection of vintage photographs is a bottom-less source of inspiration for me. I use them frequently in introspective mixed-media pieces.

Recently I began exploring the possibilities of these photos and their capacity for whimsy and lightheartedness. As I am not trained in drawing and prefer a carefree look to a realistic one, I decided to experiment with simple hand-drawn "doodled" shapes. The results inspired me and opened up a whole new way of working and playing!

ARTIST TRADING CARDS

I began my experiment using Artist Trading Cards (ATCs) made from cardstock as my canvas. The small size—2½" × 3½" (6cm × 9cm)—allowed me to work quickly and experiment with different shapes, color combinations and collage applications. The cardstock offered a less expensive alternative to prestretched canvas—great for experimenting.

My first designs were made by coating thin cardstock with three or four layers of Absorbent Ground medium—a base that will accept watercolor crayons. After letting the ground dry, I drew a simple cupcake and then added design elements like polka dots or stripes with a pencil. I then painted in the color using a wet paintbrush and watercolor crayons. Once these elements were dry, I drew around the pencil lines with a black pen.

PRESTRETCHED CANVAS

After experimenting with the small Artist-Trading-Card size, I moved on to 5" × 7" (13cm x 18cm) prestretched canvas. This size is "just right"—not too big, not too small. The technique I used on this canvas involves many layers of wet paint and medium. If you are impatient like me, I highly recommend having a hair dryer or heat tool handy, so you can speed things along.

CUPCAKE NO. 6

CUPCAKE NO. 7

50

I used a paintbrush to apply a light coat of matte medium to the entire surface and then adhered torn pieces of buff-colored tissue paper over the wet medium. I used additional touches of matte medium over the top to completely adhere the tissue paper to the canvas. Once dry, I applied two layers of gesso. When the gesso dried, I used the edge of a credit card to scrape acrylic paint across the canvas, using random strokes. Once the paint dried, I applied three or four coats of Absorbent Ground with a paintbrush, letting each layer dry thoroughly before continuing; don't worry if it covers up some of the paint from the previous layer, because this just deepens the time-worn, weathered look.

Next, I used matte medium and a paintbrush to adhere imagery to the canvas and used a pencil to draw the scenery (cupcakes, hearts, stripes, polka dots, lines and arrows). I applied color using a wet paintbrush and watercolor crayons, just as I did with the Artist Trading Cards, and used my black pen to outline the pencil marks on the drawings and accents. For the final step, I added more random strokes of acrylic paint to increase the depth of the weathered look, and used layers of gesso to add highlights inside polka dots and lines.

CREDITS

Images in the ATCs are from Paper Whimsy.

CUPCAKE NO. 5

OFFERING

Running an Adoption Agency

JoAnnA Pierotti

Living in the middle of a forest (five hundred miles away from loved ones), I find myself lonely at times. One day, in a lonely state, I created an "art doll," and somehow she made my heart dance; it felt like I had made a new friend.

Creating an Art Doll

Materials

PLASTIC DOLL HEAD OF ANY SORT (OPENING MUST BE LARGE ENOUGH TO ATTACH TO A SPOOL)

ACRYLIC PAINTS

SMALL BRUSH TO PAINT HER FACE COLOR

VERY FINE LINER BRUSH

LIQUID VARNISH
(READ PRODUCT SAFETY PRECAUTIONS)

EPOXY (E6000)
(READ PRODUCT SAFETY PRECAUTIONS)

VINTAGE SPOOL/BOBBIN FOR THE BODY

SANDPAPER

WOOD BASE, 4" X 4" (10CM X 10CM)

DECOUPAGE MEDIUM

FABRICS, LACES, FIBERS, FLOWERS, FOUND OBJECTS

HAND DRILL

HAMMER

THREE-INCH NAIL

WHITE GLUE

NEEDLE AND THREAD

METHOD

{PAINTING THE FACE}

-1- REMOVE ALL OF THE DOLL'S HAIR.

-2- CLEAN THE FACE TO REMOVE ANY DIRT OR OIL AND THEN PAINT IT WITH CREAMY WHITE ACRYLIC PAINT. LET THAT DRY. REPEAT THIS PROCESS UNTIL YOU NO LONGER SEE ANY DETAIL FROM THE ORIGINAL DOLL FACE.

-3- USING A VERY THIN LINER BRUSH, PAINT THE EYES. I KEEP MINE VERY SIMPLE, BUT YOU MIGHT WANT TO GRAB A FASHION MAGAZINE AND LET THOSE PRETTY FACES INSPIRE YOU. ADD EYELASHES AND EYEBROWS IF YOU DESIRE.

-4- PAINT THE LIPS A SOFT PINK, AND ADD SOME LITTLE, ROSY CHEEKS. I LIKE TO DAB THE PAINT WITH MY FINGERS TO SOFTEN THE EDGES. IT'S YOUR DOLL, AND THERE ARE NO RULES—MAKE HER YOUR OWN STYLE. LET DRY OVERNIGHT.

{GLAZING THE HEAD}

SEAL THE DOLL'S FACE WITH A COUPLE COATS OF HEAVY VARNISH TO GIVE THE HEAD A GLOSSY, PORCELAIN FEEL. ALLOW COMPLETE DRYING BETWEEN COATS.

{ATTACHING THE HEAD}

-1- USE EPOXY ON THE TOP OF THE SPOOL, AND FIT THE HEAD OVER THE TOP OF THE SPOOL.

-2- GLUE SOME FIBERS AROUND THE NECK WHERE THE HEAD AND SPOOL MEET, TO MAKE THE POINT OF CONTACT EVEN STRONGER. (THE FIBERS CAN BE COVERED UP LATER, WHEN EMBELLISHING YOUR DOLL.)

ARTIST'S T

Remember when you were a child, playing with your dolls? There was no rush, no rules, just simple play. Do the same with this d Simply play with her, and enjoy the process!

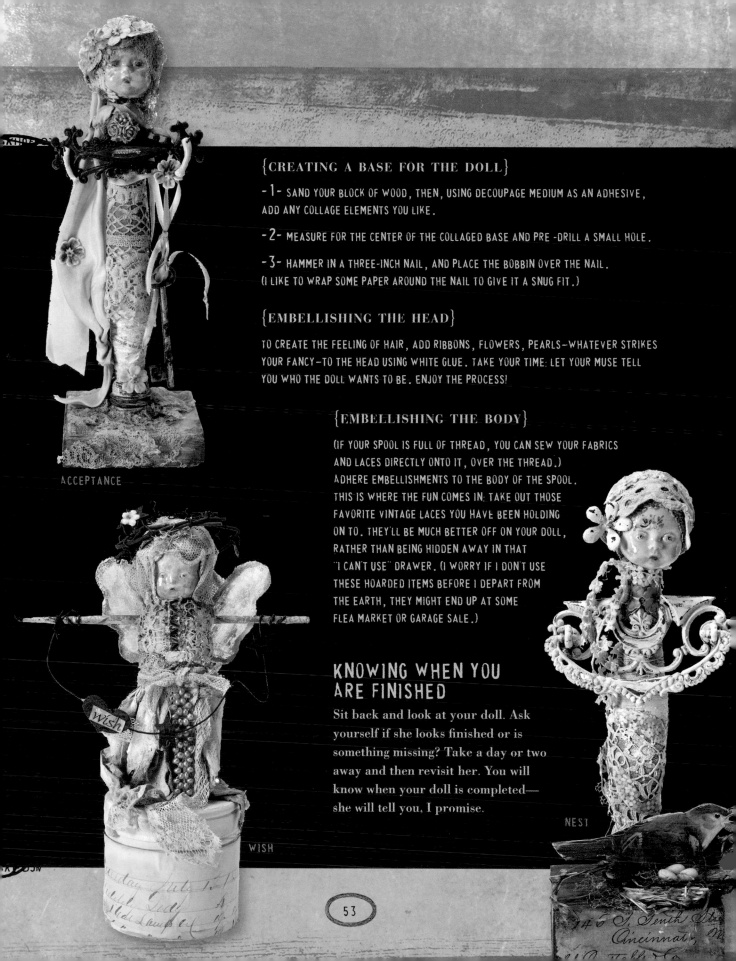

ACCEPTANCE

{CREATING A BASE FOR THE DOLL}

-1- SAND YOUR BLOCK OF WOOD, THEN, USING DECOUPAGE MEDIUM AS AN ADHESIVE, ADD ANY COLLAGE ELEMENTS YOU LIKE.

-2- MEASURE FOR THE CENTER OF THE COLLAGED BASE AND PRE-DRILL A SMALL HOLE.

-3- HAMMER IN A THREE-INCH NAIL, AND PLACE THE BOBBIN OVER THE NAIL. (I LIKE TO WRAP SOME PAPER AROUND THE NAIL TO GIVE IT A SNUG FIT.)

{EMBELLISHING THE HEAD}

TO CREATE THE FEELING OF HAIR, ADD RIBBONS, FLOWERS, PEARLS—WHATEVER STRIKES YOUR FANCY—TO THE HEAD USING WHITE GLUE. TAKE YOUR TIME: LET YOUR MUSE TELL YOU WHO THE DOLL WANTS TO BE. ENJOY THE PROCESS!

{EMBELLISHING THE BODY}

(IF YOUR SPOOL IS FULL OF THREAD, YOU CAN SEW YOUR FABRICS AND LACES DIRECTLY ONTO IT, OVER THE THREAD.) ADHERE EMBELLISHMENTS TO THE BODY OF THE SPOOL. THIS IS WHERE THE FUN COMES IN: TAKE OUT THOSE FAVORITE VINTAGE LACES YOU HAVE BEEN HOLDING ON TO. THEY'LL BE MUCH BETTER OFF ON YOUR DOLL, RATHER THAN BEING HIDDEN AWAY IN THAT "I CAN'T USE" DRAWER. (I WORRY IF I DON'T USE THESE HOARDED ITEMS BEFORE I DEPART FROM THE EARTH, THEY MIGHT END UP AT SOME FLEA MARKET OR GARAGE SALE.)

KNOWING WHEN YOU ARE FINISHED

Sit back and look at your doll. Ask yourself if she looks finished or is something missing? Take a day or two away and then revisit her. You will know when your doll is completed— she will tell you, I promise.

WISH

NEST

Encaustic Collage

Sandy Lupton

People say I'm a little bit hyper. I admit I can't sit still for long and I need constant artistic stimulation; so when I had the chance to take an encaustic painting class at a local museum, I jumped at it. I'm always looking for something to take my mixed-media art to the next level. After a full day surrounded by encaustic's sweet smell, rich colors, unlimited texture, transparency and finish, I was addicted!

Encaustic medium is a mixture of beeswax and a resin hardener. Encaustic paints combine these elements with intensely colored pigments. Encaustic medium can be combined with any oil-based medium. Wax is a great adhesive, so you can embed just about anything into it. You can scrape away layers to reveal hidden treasures beneath, or add more layers to conceal them.

Creating an Encaustic Painting

Materials

- RIGID SUBSTRATE SUCH AS WOOD OR PLEXIGLAS
- FREEZER PAPER
- PALETTE (INEXPENSIVE PANCAKE GRIDDLE WITH THERMOSTAT)
- ENCAUSTIC MEDIUM (READ SAFETY PRECAUTIONS ON PRODUCT LABEL)
- SMALL METAL BOWLS
- ASSORTED NATURAL BRISTLE BRUSHES
- ENCAUSTIC PAINTS (PLEASE READ SAFETY PRECAUTIONS ON PRODUCT LABEL)
- HEAT GUN
- SCRAPING TOOLS
- PARAFFIN WAX FOR CLEANUP (FROM THE CANNING AISLE OF THE GROCERY STORE)
- OPTIONAL: DEEPLY ETCHED RUBBER STAMPS, COLLAGE ITEMS, OIL PASTELS, OIL PAINTS, OIL STICKS

METHOD

WHEN WORKING WITH ENCAUSTICS, MAKE CERTAIN YOU ARE IN A WELL-VENTILATED SPACE, AS VAPORS FROM MELTED WAX ARE HARMFUL.

-1- FIRST, CHOOSE YOUR SUBSTRATE. YOU'LL WANT SOMETHING RIGID, SUCH AS 1/4" (6MM) PLYWOOD. COVER YOUR WORK TABLE WITH FREEZER PAPER TO PROTECT IT. HEAT UP YOUR PALETTE TO ABOUT 200° FAHRENHEIT (168° CELCIUS).

-2- MELT YOUR ENCAUSTIC MEDIUM IN A SMALL METAL BOWL ON THE PALETTE. USING A WIDE FLAT BRUSH, COVER YOUR SURFACE WITH THE MEDIUM. TO FUSE THE LAYER TO YOUR BACKGROUND, HEAT WITH A HEAT GUN UNTIL THE SURFACE IS SLIGHTLY SHINY.

-3- LET THIS COOL A FEW MOMENTS AND THEN ADD AS MANY LAYERS AS YOU WISH. AS LONG AS YOU FUSE EACH LAYER, YOU CAN BUILD UP YOUR SURFACE TO UNBELIEVABLE DEPTHS. YOU CAN EMBED OBJECTS INTO YOUR CREATION AT ANY TIME DURING THE PROCESS, FOLLOWED BY MORE LAYERS OF ENCAUSTIC MEDIUM AND SPECIAL ENCAUSTIC PAINT.

-4- TO ADD COLOR, MELT A SMALL AMOUNT OF ENCAUSTIC PAINT ON YOUR PALETTE, MIX THE COLOR, AND PAINT JUST LIKE YOU WOULD WITH ANY OTHER PAINT. KEEP YOUR BRUSHES SOFT AND PLIABLE WHILE YOU'RE WORKING BY LAYING THEM ON THE HEATED PALETTE WITH THE HANDLES OVER THE SIDE. THIS WILL KEEP THE PAINT IN THE BRISTLES MELTED AND THE HANDLES COOL.

{SPECIAL EFFECTS}

AS FOR HAVING SOME REAL FUN, THE POSSIBILITIES ARE ENDLESS! SCRAPE, PAINT, STAMP, EMBED, CARVE, COVER AND LAYER UNTIL YOUR MASTERPIECE REVEALS ITSELF. YOUR ADDICTION TO ENCAUSTIC COLLAGE HAS JUST BEGUN!

- CREATE AMAZING MARBLED EFFECTS BY MELTING THE WAX AND BLOWING IT AROUND WITH YOUR HEAT TOOL.

- SCRAPE AWAY LAYERS OF WAX TO REVEAL WHAT'S HIDDEN UNDERNEATH.

SUMMER DREAM

- BUILD UP A FEW LAYERS OF WAX, FUSING BETWEEN EACH LAYER, AND STAMP INTO IT WITH A RUBBER STAMP WHILE IT IS STILL SLIGHTLY WARM. LET THE STAMP COOL COMPLETELY BEFORE TRYING TO REMOVE IT. IF YOU JUST CAN'T WAIT, PUT IT INTO THE FREEZER FOR A FEW MINUTES.

- CARVE LINES INTO THE WAX WITH ANY CARVING TOOL. RUB OIL PAINT INTO THE LINES AND REMOVE THE EXCESS WITH A SOFT CLOTH. USE OIL-BASED RUB-ONS, OIL PASTELS, OIL PAINTS OR OIL STICKS TO ADD COLOR AND DEPTH TO THE SURFACE. YOU CAN ALSO CARVE LINES INTO THE WAX AND THEN ADD A LAYER OF DARK-PIGMENTED ENCAUSTIC PAINT. WHEN IT COOLS, USE A SCRAPING TOOL TO REMOVE THE EXCESS. THE DARK WAX STAYS IN THE LINES TO CREATE OUTLINES OR SURFACE TEXTURE.

- USE A GREASE PENCIL TO DRAW A PICTURE, PATTERN, OR WORDS ON YOUR SUBSTRATE.

- USE GOLD LEAF ON THE SURFACE FOR SOME "BLING!"

- IMAGE TRANSFERS ARE EASY TO DO ON AN ENCAUSTIC COLLAGE. JUST LAY THE TONER-BASED PHOTOCOPY FACEDOWN ON A WARM, WAXY SURFACE AND BURNISH DOWN COMPLETELY. WHEN THE WAX IS COOLED, WET THE PHOTOCOPY AND GENTLY RUB OFF THE PAPER. CONTINUE WETTING AND RUBBING UNTIL ALL THE PAPER IS GONE, AND THERE IS NOTHING LEFT BUT THE IMAGE.

{CLEANUP}

CLEAN YOUR BRUSHES BY DIPPING THEM IN MELTED PARAFFIN WAX AND RUBBING THE EXCESS COLOR ONTO PAPER TOWELS. CLEAN YOUR GRIDDLE AND TOOLS WITH PARAFFIN TOO, THEN WIPE CLEAN WITH PAPER TOWELS. YOU NEED TO CLEAN WHILE THE GRIDDLE IS STILL HOT.

{SAFETY}

- NEVER LEAVE A HOT GRIDDLE UNATTENDED. IF YOU TAKE A BREAK, UNPLUG THE GRIDDLE AND LET IT COOL DOWN.
- KEEP A CHECK ON YOUR TEMPERATURE: IF YOUR PAINTS AND MEDIUM ARE SMOKING, THEY ARE TOO HOT—THE SMOKE IS BAD FOR YOUR LUNGS (USE ENCAUSTIC PAINTS AND MEDIUM IN A WELL-VENTILATED AREA).
- SUPERVISE CHILDREN AND WATCH OUT FOR PETS ON THE TABLE TOO!
- NEVER USE YOUR GRIDDLE FOR FOOD ONCE YOU HAVE USED IT FOR ENCAUSTICS.
- REMEMBER, EVERYTHING IS HOT!

CREDITS

All clip art by Dover Publications:

Rooster and vine: *3,800 Early Advertising Cuts* by Carol Belanger Grafton

Dragonflies, Neptune, horse, bird, leaves: *Decoupage, the Big Picture Sourcebook* by Eleanor Hasbrouck Rawlings

RESOURCES

The Art of Encaustic Painting by Joanne Mattera

R&F Paints: The source for buying encaustic supplies (www.rfpaints.com)

Karen Eide—an incredible artist and teacher (www.kareneide.com)

Jeff Schaller—my favorite encaustic painter (www.pinkcowstudio.com)

Dover Publications—my favorite source for clip art (www.doverpublications.com)

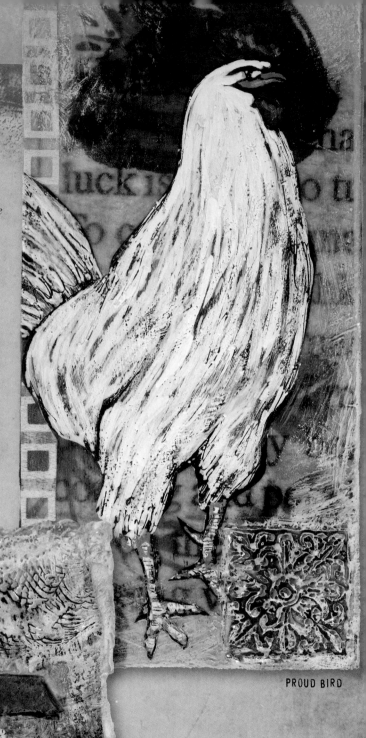

BILL'S FAMILY

PROUD BIRD

ARTIST'S TIP

Here are some of my HOT tips!

• *Griddles can be found at thrift stores and discount stores for under $20. Be sure to get one with a thermometer. The flat ones work best, but an electric skillet will work too.*

• *Use old paintbrushes (once they go "waxy," they can't go back!).*

• *Crayons will work too, but they don't have the intensity or longeveity of encaustic paints.*

• *When your encaustic art has cooled, polish it with a soft cloth to make it "glow." Polish anytime to remove dust and regain that shine.*

• *Encaustic works can withstand regular temperatures, but don't leave them in the sun or the trunk of your car in the summertime.*

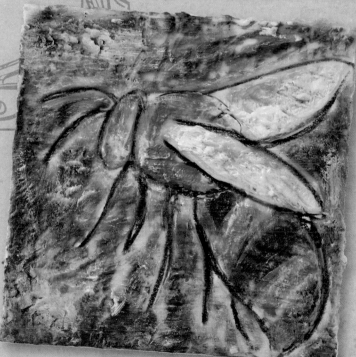

HONEY BEE

Felted Adornments

Linda Koch

As an artist, I started solely as a primitive doll maker—sewing and creating dolls with vintage baby clothes. I evolved into a mixed-media artist—incorporating my love of fabrics, fibers, papers and beadwork into varied creations. I then began knitting and even spinning my own yarns—a new addiction that has started me on another playful adventure! I enjoy finding ways to incorporate many artistic interests into one project. For the projects featured here, I used knitting, found objects, paper, beads and sewing to create a fun and easy process!

Making Felted Jewelry

Materials

- 100% WOOL YARN (I PREFER NORO)
- SCRAP PIECES OF ALREADY FELTED WOOL
- FOUND OBJECTS (E.G.: SMALL BEADS, TINY KEYS, WATCH PARTS, VINTAGE BUTTONS AND PIECES OF JEWELRY, WASHERS, SMASHED BOTTLE CAPS, ETC.)
- DIAMOND GLAZE (OR GLOSSY ACCENTS)
- SMALL IMAGES AND TEXT FROM VINTAGE BOOKS
- HAND DRILL OR DREMEL TOOL
- SILAMIDE THREAD (OR ANY WAXED THREAD)
- OLD BUTTON OR LARGE SNAP FOR CLASP
- MICA
- JAPANESE HOLE PUNCH
- EYELETS
- EYELET SETTER
- FINE NEEDLE TO APPLY OBJECTS—I USED SHORT SHARPS NO.10 OR NO.12, BUT ANY THIN NEEDLE WILL WORK
- SEED BEADS
- BEADS IN A VARIETY OF SIZES AND STYLES (BUGLE, HEX, ETC.)
- SEQUINS
- PIN BACKS
- LARGER UNUSUAL BEADS FOR ACCENTS OR CLASP

METHOD

{CUFF}

-1- TO MAKE THE BODY OF THE BRACELET, YOU HAVE TWO OPTIONS. YOU CAN EITHER KNIT WOOL YARN TO FORM THE BAND (AS I DID FOR THIS PARTICULAR PIECE), OR CUT A STRIP FROM AN OLD 100% WOOL SWEATER AND "FELT" IT IN THE WASHING MACHINE (PROCESS DESCRIBED IN STEP 2). I KNIT THE BAND LONGER AND WIDER THAN THE FINISHED PIECE, BECAUSE IT SHRINKS DURING THE FELTING PROCESS (EACH YARN SHRINKS DIFFERENTLY IN TERMS OF SIZE, SO YOU WILL HAVE TO EXPERIMENT TO GET YOUR DESIRED SIZE).

-2- "FELT" OR "FULL" YOUR PIECE IN ONE OF TWO WAYS: (1) IN THE WASHING MACHINE USING HOT WATER AND THE HARSHEST CYCLE (DON'T CHOOSE THE "DELICATE" SETTING). IT'S BEST TO FELT SEVERAL PIECES AT A TIME, SO YOU WON'T THROW YOUR MACHINE OFF BALANCE. FIRST PLACE THEM IN A MESH "DELICATES" BAG OR PILLOWCASE, TO CONTAIN THE STRAY FIBER BITS THAT WILL COME OFF YOUR PIECES DURING THE FELTING PROCESS (THEY CAN DAMAGE YOUR WATER PUMP OTHERWISE). (2) IN THE SINK USING HOT WATER. RUN YOUR TAP AS HOT AS IT WILL GO (YOU MAY NEED GLOVES), AND USING A BIT OF SHAMPOO OR DAWN DISH SOAP, "WASH" (SCRUB) YOUR BRACELET UNTIL YOU ACHIEVE THE DESIRED FELTED EFFECT, AND THEN LET DRY. (THERE ARE LOTS OF GREAT FELTING TUTORIALS ONLINE.)

-3- CREATE A TINY COLLAGE OR USE A SMALL IMAGE OR FOUND OBJECT AS THE FOCAL POINT OF YOUR BRACELET. USING DIAMOND GLAZE, ADHERE YOUR IMAGERY IN OR ONTO A WASHER OR BOTTLE CAP, OR ANYTHING THAT WILL HOLD AN IMAGE/COLLAGE, AND THEN SEAL IT WITH THE GLAZE. ONCE COMPLETELY DRY, DRILL HOLES AROUND THE BOTTLE CAP, WHICH YOU WILL STITCH THROUGH WHEN ATTACHING YOUR OBJECT TO THE BRACELET (WITH THE WASHERS, YOU CAN JUST STITCH THROUGH THE DIAMOND GLAZE).

CUFF

-4- NOW YOU CAN APPLY YOUR IMAGERY AND FOUND OBJECTS! I USED SILAMIDE, A WAX-COATED THREAD, TO STITCH ALL MY FOUND PIECES INTO PLACE ON THE BRACELET (I RECOMMEND USING A DOUBLE STRAND TO GIVE IT BETTER HOLD).

-5- DETERMINE WHAT YOU WANT TO USE AS A CLASP. TRY USING A LARGE SNAP EMBELLISHED WITH A VINTAGE BUTTON. YOU MIGHT TRY KNITTING A BUTTON HOLE IN THE BRACELET (PART OF STEP 1), USING AN OLD BUTTON AS THE "CLASP."

HAPPINESS

{"HAPPINESS" BROOCH}

-1- CHOOSE A SMALL IMAGE TO SERVE AS THE FOCAL POINT OF YOUR PIN. CUT TWO PIECES OF MICA, SIZED TO COVER THE IMAGE. SANDWICH THE IMAGE BETWEEN THE TWO PIECES, PUNCH HOLES IN THE FOUR CORNERS WITH YOUR JAPANESE HOLE PUNCH, AND SET EYELETS IN THE HOLES WITH YOUR EYELET SETTER.

-2- CUT THE WOOL LARGE ENOUGH TO ACCOMMODATE YOUR IMAGERY (BE SURE TO LEAVE ENOUGH ROOM ALONG THE SIDES FOR THE SEQUINS AND SEED BEADS). USING SILAMIDE THREAD, STITCH YOUR MICA EMBELLISHMENT TO THE WOOL (STITCHING THROUGH THE HOLES YOU CREATED). I ADDED BEADS TO MY THREAD FOR FURTHER DECORATION. STITCH SEED BEADS AND SEQUINS ALONG THE SIDES, AND FOR FURTHER EMBELLISHMENT, ADD A FEW BEADS (INCLUDING A FOCAL HEART BEAD) TO THE BOTTOM AND A SMALL BEAD TO THE TOP.

-3- ADD A PIN BACK, AND YOU ARE FINISHED!

{BROOCH OF GIRL}

-1- KNIT AND FELT A SQUARE OF WOOL—OR CUT A STRIP FROM AN OLD 100% WOOL SWEATER AND "FELT" IT IN THE WASHING MACHINE (PROCESS DESCRIBED IN STEP 2 OF THE BRACELET PROJECT).

-2- CHOOSE AN IMAGE THAT WILL FIT IN THE OPENING OF YOUR WASHER. ATTACH IT TO THE WASHER WITH DIAMOND GLAZE AND SEAL YOUR IMAGERY WITH THE GLAZE.

-3- ONCE DRY, STITCH YOUR IMAGERY EMBELLISHMENT TO THE TOP OF THE WOOL PIECE AND SEW ON FURTHER EMBELLISHMENTS LIKE THE EARRING PIECE, FOX BEAD AND "DANGLY" AT THE BOTTOM OF THE PIN.

-4- ATTACH A PIN BACK. DONE!

BROOCH OF GIRL

Where Time Stands Still

Stacie Rife

I have thrived on being creative ever since I was a little girl—an only child—having to entertain myself. This created a yearning to escape to a place where time has no beginning and no end—a creative zone that made (and still makes) me extremely happy and relaxed. Thinking too much can inhibit the creative process, so when I have the time to create, I try to just do whatever comes to mind first, with no plan of action, accompanied by some inspirational music and a lit scented candle.

More recently, the birth of my daughter Audrey (my best creation yet) makes me want to take heed of everything beautiful in my everyday life and create from that inspiration. Creativity is an endless process—one which we will never fully master, but, if we can thrive in the moment and learn as we grow, we can reap its abundant rewards.

Incorporting a Poem Into Your Art

Materials

- 140-LB (300GSM) WATERCOLOR PAPER
- MASKING TAPE
- VINTAGE BOOK TEXT
- PHONEBOOK SHEETS
- GESSO
- ACRYLIC PAINTS
- WATERCOLOR PAINTS
- DOILIES
- VINTAGE WALLPAPER
- VINTAGE IMAGERY
- TISSUE PAPER
- BLACK PERMANENT PEN AND/OR GEL PEN
- TEXTILES AND BUTTONS
- VINTAGE HARDWARE
- RUB-ONS (7 GYPSIES)
- GERMAN FOIL (WWW.ARTCHIX STUDIO.COM)
- CHARCOAL PENCILS
- COLORED CHALK
- SPRAY FIXATIVE (READ PRODUCT SAFETY PRECAUTIONS)
- MEDIUMS: FLUID GEL AND MATTE (GOLDEN) (READ PRODUCT SAFETY PRECAUTIONS)
- BRAYER

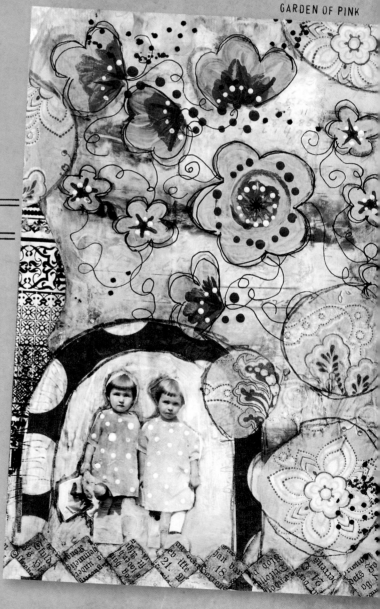

GARDEN OF PINK

METHOD

-1- ADD TEXTURE TO WATERCOLOR PAPER BY ADHERING STRIPS OF MASKING TAPE IN A VARIETY OF SIZES AND RANDOMLY GLUING ON MISCELLANEOUS PIECES OF PAPER, SUCH AS VINTAGE WALLPAPER OR SCRAPBOOKING PAPER.

-2- COVER ENTIRE PIECE WITH WATERED-DOWN WHITE GESSO, ALLOWING SOME OF THE BACKGROUND PAPERS TO SHOW THROUGH. LET DRY.

-3- PAINT A BACKGROUND WITH VARIOUS WASHES OF DIFFERENT COLOR ACRYLIC AND WATERCOLOR PAINTS.

-4- USE GEL MEDIUM TO ADD MORE PAPERS FOR TEXTURE, SUCH AS PAPER DOILIES, VINTAGE WALLPAPER, TISSUE PAPER, TEXTBOOK PAPER—ANYTHING YOU HAVE ON HAND.

-5- ADD MORE COLOR WASHES WITH WATERCOLOR, GESSO AND/OR ACRYLIC PAINTS TO ENHANCE THE DETAILS OF THE LAST ADDED PAPERS.

-6- ADD DESIRED PHOTOS (YOU MIGHT EVEN WANT TO TRY IMAGE TRANSFERS—SEE TECHNIQUE BELOW) OR HAND-DRAWN OBJECTS, AND ENHANCE WITH GEL PENS OR PERMANENT BLACK MARKER.

-7- ADD EMBELLISHMENT DETAILS WITH GLITTER, RUB-ON LETTERS OR PICTURES, VINTAGE OBJECTS, CHARMS, WIRE OR ANYTHING YOU HAVE ON HAND TO MAKE IT "YOUR OWN."

-8- HIGHLIGHT AND SHADOW AREAS OF COLLAGE WITH CHARCOAL AND/OR CHALK USING A SPRAY FIXATIVE TO SEAL (PLEASE READ SAFETY PRECAUTIONS ON SEALER LABEL).

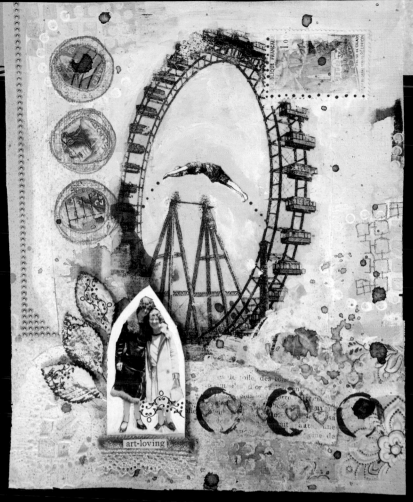

FRIENDS AND FAIR

{IMAGE TRANSFER TECHNIQUE}

-1- PRINT OUT THE IMAGE (COLOR INK JET) YOU WANT TO TRANSFER, KEEPING IN MIND THAT IT WILL TRANSFER AS A MIRROR IMAGE (THUS, YOU MAY WANT TO "FLIP" YOUR IMAGE IN A PHOTO-EDITING PROGRAM PRIOR TO MAKING THE TRANSFER).

-2- APPLY FLUID MATTE MEDIUM BOTH OVER THE IMAGE (ENOUGH SO IT'S HARD TO MAKE OUT THE IMAGE UNDERNEATH) AND TO THE SUBSTRATE ON WHICH YOU WOULD LIKE TO ADD THE TRANSFER.

-3- PLACE YOUR IMAGERY FACEDOWN ON THE TRANSFER AREA, AND IMMEDIATELY ROLL A BRAYER OVER IT (WIPE OFF ANY EXCESS MEDIUM THAT COMES OUT ON THE SIDES).

-4- WAIT A FEW MINUTES UNTIL IT IS SOMEWHAT DRY, AND THEN PEEL THE TOP LAYER OF PAPER OFF. THIS METHOD LEAVES A BIT OF PAPER ON THE IMAGE, WHICH YOU WILL NEED TO CAREFULLY RUB OFF WITH YOUR FINGER (RUB AS IF YOU WERE PETTING A BIRD—GENTLY, SO THE INKED IMAGE DOESN'T COME OFF WITH IT). IF THIS EXCESS PAPER BECOMES TOO DRY TO REMOVE, WET YOUR FINGER JUST A BIT BEFORE RUBBING IT AGAIN. CONTINUE TO RUB UNTIL YOU CAN SEE THE ENTIRE IMAGE.

Glazed Over: Creative Blends for Layering

Roben-Marie Smith

Holidays were times of elaborate celebration in our home while I was growing up. In fact, each holiday was an occasion for my mom to decorate and liven up our home, and sometimes our yard, with colorful and festive decorations. Her favorite, by far, was Christmas, and, for her, one of the highlights of that time of year was driving around popular neighborhoods looking at the lights. I loved it when the family jumped into the car on those chilly evenings to take in the brilliance of the lights. For me, the real pleasure came from the mysteries that lay beyond the outside layers of the houses. The mystery of the unknown intrigued me. I longed to get a better look into each window or front door—I had such a curiosity for what other people's homes looked like on the inside. The facades of those houses were simply a layer to me, one to look beyond—to go through to see more, a revealing.

I am still drawn to the mystery of the unseen. I'm intrigued by layers used in artwork, and I enjoy studying pieces to see what I can find below the surface. As I began pursuing creative endeavors in mixed media, I wanted to achieve a transparent, layered appearance in my personal art journals and collages. I love to use acrylics in my work but found that many times the paint covered too much and didn't leave enough area showing through. In addition to using sandpaper to scratch off surfaces, or even using baby wipes to rub off areas of paint, I turned to glazing medium and began experimenting with this versatile art supply.

Glaze is available in clear and in many colors and can be mixed with acrylic paints. The medium creates a thin, fairly transparent layer on your substrate that just slightly alters the color of the surface. The drying time of glaze is dependent upon the amount of medium used. Glaze medium tends to dry more slowly than acrylics; the advantage to a slower drying time is having time to manipulate the color. The disadvantage is simply waiting for the glaze to dry

before moving on to the next layer. I'm a little impatient, so I utilize a heating tool to speed this process along. Once layers are dry, the end result is a transparent surface where certain layers of color show through. In addition to using glazes to build multiple layers in my work, I also use them to tone down areas that might be too bright. I like to use premixed glaze colors or glaze medium to create my own colors with acrylics. I also discovered that watercolors mixed with glaze create some interesting effects. Sometimes the most satisfying discoveries come when I make the decision to try something unconventional or to use products in a way that might seem a little unusual at first.

ALWAYS BE HAPPY

I began on this page with a handful of new stencils and rubber stamps. I selected colors from my favorite color palette of greens and went to work. As the piece evolved, I noticed that it felt like I was creating what looked like a garden. I looked at this piece later and was amazed to find how much the white dots at the top resembled a hydrangea, and the red punchanella pattern moving down the page reminded me of a garden path! (Punchanella is a plastic ribbon with holes punched in it that comes in different widths. Originally, this was the waste from which sequins were punched, but now it is sold expressely as a collage element or a stenciling tool.)

CREATING THE BACKGROUND

After applying gesso to my page and letting it dry, I began with Umber glaze, dabbing some of it off with a paper towel.

I mixed glazing medium in four small cups with green-gold fluid acrylic, dark forest green acrylic craft paint, teal liquid watercolor and celery acrylic craft paint. Using bristle brushes and working from the lightest to darkest colors, I randomly brushed the mixture over parts of the page.

ADDING STENCILS AND IMAGES

I randomly stamped circles in various sizes onto the bottom left and bottom right edges of the page and then used a flourish stencil with ivory spray paint. (If you decide to use spray paint, remember to always use it in a well-ventilated area.)

After brushing a little more of the glaze mixture with green gold over part of the stencil, I rubbed a bit of it off with a paper towel. This gave the illusion that part of the stencil was on the top layer and part was on the bottom.

At the top of the page, I placed a large-sized punchanella, and with a bristle brush, randomly stippled black acrylic paint over it. Next, I repeated this with a small-sized punchanella and stippled white gesso. I repeated this process on the bottom right corner of the page.

With a bristle brush, I stippled white gesso over the letter stencils and dried it with a heating tool. Then I used a black poster-paint pen (Sharpie) to write the word *always* repeatedly within the letter A, the word *be* within the letter B and *happy* within the letter H. I outlined the stencil letters with black pen to make them "pop" off the page.

I placed a large flower stencil on the page at the top left and small flower at the bottom right. Using a bristle brush, I stippled a glaze mixture of medium and celery acrylic paint over these stencils in a random fashion. To the right side of the page, I adhered old book papers using a glue stick.

ALWAYS BE HAPPY

FINAL TOUCHES

With a small sized punchanella, I stippled Quinacridone Red Orange acrylic (Liquitex). When that was dry, I added rub-on dots to the bottom right of the page.

Using black dye ink, I randomly stamped circle stamps onto the left side of the page. Then, using a black pen, I pressed the tip into each of the small white circles on the top right of the page. I used a craft stick dipped in black paint to create texture around my white dots.

Using the end of a round ear plug as a stamp, I printed with Quinacridone Red Orange acrylic (Liquitex) in the center of two stencil flowers and again dried everything with a heating tool.

I outlined some petals with a black pen and, using a white gel pen, outlined additional flower petals. Under the stenciled letters, I wrote the words *Always Be*, first with the black pen and then with the white pen. Finally, using a glue stick, I adhered the word *Happy* to the page after the words *Always Be*. I outlined the text with a circle made from black-and-white pens.

REFRESH

I often spend time in my art journal as a means to refresh, which simply means to make fresh again—to reinvigorate or cheer a person, the mind or the spirit.

On this page, I experimented with mixing glazing medium with liquid watercolors and was ultimately pleased with the results. Doodling around the stamped images made them stand out more and added to the random feeling I was aiming to achieve.

My Words: *I am truly in need of refreshing; down time, think time, reflect time, purpose time, me time, breath time, away time, get-it-together time . . . rest for the soul time!*

PREPARING IMAGES

I began by opening up a photo of myself in PhotoFrame Pro™ and chose a filmstrip edge. Next, in Adobe Photoshop™, I converted a photo of a flower to gray scale and printed it out onto transparency film. Note: The ink side will be adhered to the page, so if you are using a photo with text, reverse/mirror the image before you print it. I ran the images through a Xyron laminator loaded with adhesive and set them aside.

Next, I printed out a color image of a different flower and trimmed it to size.

CREATING THE BACKGROUND

I placed photocopied text pages facedown onto each side of my journal spread. Working with a mask over my mouth and nose, I began vigorously rubbing a cotton ball soaked with acetone on the backs of the copies to transfer the text to the journal.

In two plastic cups, I created two different mixtures: One of glazing medium and fuchsia liquid watercolor and one with glazing medium and white gesso. Working with the gesso mixture first, I randomly brushed over parts of the page, dabbing some areas with a paper towel to leave the text showing through. I then repeated the process with the fuchsia mixture and created a few more layers of each, drying the pages between layers.

With a bit of water in a spray bottle, I added a small amount of fuchsia liquid watercolor and spritzed the pages while I held the journal up so some of it would drip down.

ADDING VISUAL ELEMENTS

Using a small circle stamp and white gesso, I randomly stamped along the top of the left page and used a swirl stamp three times along the right side of the right page.

With a detail brush and white gesso, I painted flowers freehand on the right page. Using a glue stick, I adhered a personal photo, an image of a flower, lace, old papers and a piece of a handwritten letter to the right page. I also added masking tape to a few edges for effect.

After cutting small strips from book pages, I placed each strip randomly on the left page. I ran a flower transparency through the Xyron laminator and adhered it to the page over the strips.

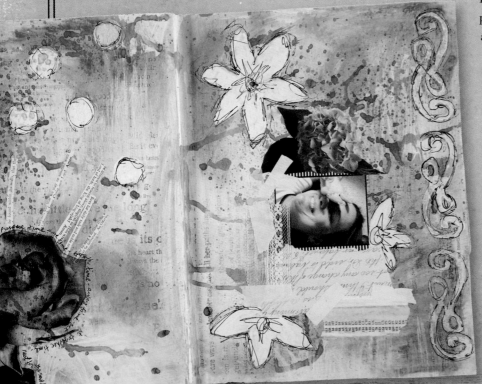

FINISHING TOUCHES

With a black, fine-point paint pen, I doodled around the white stamped circles on the left page and also around the edges of the swirl and hand-painted flowers. I then journaled around the transparency flower to finish the layout.

6 OF JUNE

After loading my shopping cart at the local home improvement store with what seemed about twenty-five cans of spray paint in a rainbow of colors, I hurried home to begin working. (When the warning label on the product reads to use in a well-ventilated area, that doesn't mean to just turn on the ceiling fan!) This page utilizes one of my favorite colors of glaze, Fresco Cream by Golden. It's a tan/cream color perfect for toning down bright areas. When you have a blank page staring up at you, squeeze Fresco Cream glaze onto the page and move it around with a brush. Now you are ready to start!

6 OF JUNE

CREATING THE BACKGROUND

After placing pieces of small punchanella across the page and spraying with black spray paint, I lightly sprayed with paprika spray paint. I then placed a letter stencil on top of the page and stippled it with gesso.

Using a glue stick, I adhered a piece of old paper to the center of the page and then pieces of an old check to the lower right side of the page.

I placed a flourish stencil on the right side of the page and painted it with black acrylic paint, then randomly brushed gesso onto the page.

Next, I placed a large piece of punchanella at the top of the right of the page and stenciled with apricot acrylic paint. I sprayed over a piece of small punchanella at the top of the left and bottom right of the pages with paprika spray paint.

ADDING VISUAL ELEMENTS

I used circle stamps and black acrylic paint horizontally across the left page; then, using the same stamps, I stamped vertically at the center. I stamped over the first impressions using the same stamp covered with gesso.

Using medium circle stamps and apricot paint, I stamped at the top left and bottom right of the pages. When that was dry, I brushed a thin layer of white glaze over the bottom left side of the page. Then I brushed a thin layer of Fresco Cream glaze over the entire page to tone down the white and blend everything together.

FINISHING TOUCHES

I adhered a label sticker to the top center of the page and used a medium circle stamp and black acrylic paint around the label.

I loaded the side of a popsicle stick with black acrylic paint. Then I made impressions around the black-stamped circles, dragging the stick to make some lines longer. Go over an area more than once to make some lines thicker.

I cut numbers from scrapbook paper and adhered them using a glue stick. I scribbled around both with a black pen. Finally, I journaled on the page with black pen and adhered a bubble number to label and date the page.

THRIVE

Paul Boese said, "Nature thrives on patience; man on impatience." Armed with a stack of wallpaper samples, a new bottle of Instant Age Varnish glaze and Paul's words on my mind, I went to work. Setting aside my impatience and need for immediate results, I glued down a floral piece of wallpaper and began adding layer upon layer of acrylic and glaze to create the background for this collage. I was pleasantly surprised by how much I liked the effect of blending the varnish glaze with acrylics. I had considered varnish glaze to be a product primarily used on wood; don't assume a product won't work just because it was meant for another purpose. Sometimes the best and most unexpected results come from experimentation.

CREATING THE BACKGROUND

I began by adhering a piece of floral wallpaper to the page using soft gel medium on a paintbrush. Then I painted a light coat of gesso over the page, leaving some of the wallpaper pattern showing though.

To create the rest of the background, I started by brushing a light coat of black acrylic paint randomly on the page. Then, combining a small amount of gesso with some Instant Age Varnish glaze, I randomly rubbed the mixture over the page and let it dry.

I used black acrylic paint and circle stamps to make circles on the right side of the page. Next, I placed a medium-sized piece of punchanella across the top of the page and stippled black acrylic paint through one row of holes. When that was dry, I randomly brushed gesso over the page. Using a detail brush and a mixture of a small amount of gesso and water, I spattered white marks across the page. Next, I put a small amount of walnut ink into a spray bottle with about eight ounces of water and lightly sprayed that across the page. I sealed the entire page with a coat of matte medium.

ADDING VISUAL ELEMENTS

With a white gel pen, I randomly wrote vertically across the page. Next, I cut round shapes for flowers and strips for stems out of scrapbook paper and adhered them to the page with a glue stick.

I added a torn piece of scrapbook paper to the bottom of the page below the flowers. I then used a dark red ink pad to stamp the word *thrive* onto the bottom of the collage. I traced around the letters with a black pen and colored in the letters with a dark red pencil to make them stand out more.

FINISHING TOUCHES

Using a black pen, I scribbled around the flowers and stems and, using a white pen, I scribbled just around the stems.

I frayed a piece of red fabric and cut several pieces of black thread. Using a small paintbrush, I added soft gel medium to the page and placed them onto the collage, lightly brushing over them with gel medium.

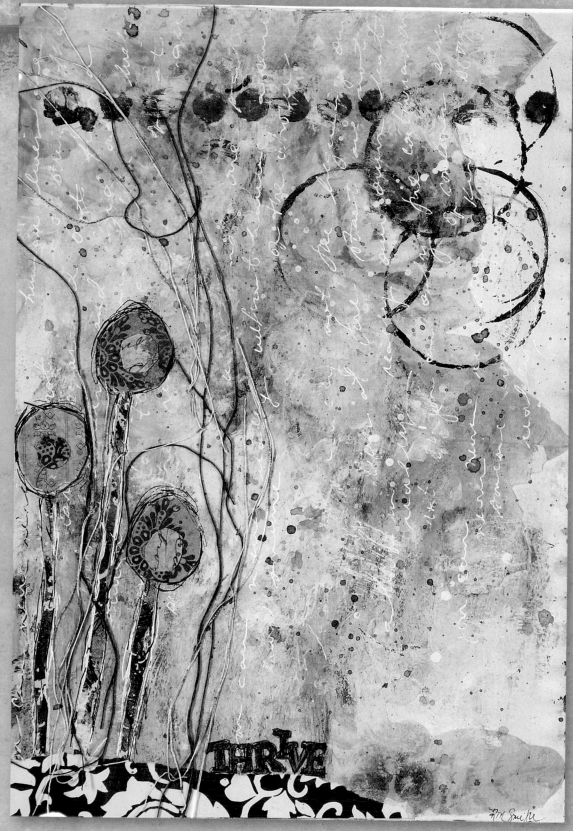

THRIVE

Soul Synergy: An Art-Making Collaboration

Susan Tuttle
(with excerpts by Lori Vrba)

One morning, early, while the house was still quiet and the sky was just beginning to show signs of light, I sat down with my laptop, coffee in hand, ready to check my e-mail, just as I do every morning before the kids wake up. I received a flattering e-mail from a woman I did not yet have the privilege of knowing—Lori Vrba. She had stumbled across my Web site, Ilka's Attic, and sent me the kindest e-mail after her visit. Lori explained she was a photographer and invited me to view her Web site. I wasn't prepared for what I would see: a slideshow of the most soul-stirring, artistic, black-and-white photographs of families, set to beautiful music. I distinctly remember going to the bathroom for a handful of tissues, all of which I saturated while perusing her site. Even though I had never met this woman in my life, my instincts told me I must connect with her. I could feel in my heart we were meant to collaborate together on a special project. I decided to take a risk and tell her about my feelings.

I am so happy I did, as we have since come together, fusing our art, to create something greater than either of us ever imagined: a true synergism—a collaborative dance of sorts. Lori provides me with imagery I use to make collages. She trusts me with her work, and allows me complete creative license in utilizing her breathtaking photographs in any way I feel moved to. What an incredible gift! She also gave me a few copies of her own family heirloom photographs to make art with. It was an honor and a pleasure and an endeavor I took very seriously. It was not at all difficult to create collage pieces with her imagery; the pieces flowed from me very quickly and with such ease.

After the moving experience of viewing her work at her site, I immediately wanted to get an inside view of Lori's creative process; I wanted to know more about her gift for photography and wondered, "Who is the woman behind these incredible photographs?" I want you to get to know Lori too, and as you read her journaling in the next few paragraphs regarding what a photo shoot with a family is like for her, you'll come to understand why her artwork pulls at so many heartstrings.

THROUGH THE LENS, BY LORI VRBA

The world looks different through the lens: Not everything gets in. Oftentimes at photo shoots there is chaos, clutter, crying babies; but in an instant I turn around, and there, in perfect light, is a little boy lining up his favorite toy cars. Click. Magic. I was able to capture a moment of peace, reflection, joy, pride, serenity. In today's world, if we look around, we will find countless moments of beauty.

While driving to a shoot, I listen to strong music that pulls up strength in me, a wisdom to know that I have the skills to accomplish everything needed. I arrive and am greeted by old friends, new friends, family members. We take a tour through our space (usually someone's home or yard; sometimes a park). I really only spend about five minutes looking for light; I can always find it. I start to put together in my mind how to begin. There may be very young children who feel shy, so I ask the parents to be in some of the initial shots—make it safe for baby; then the magic begins. In no time, we're past the poses and on toward art. If I am open to it, art shows up in all kinds of ways.

Here's the scenario: I enter the master bedroom and see a beautiful old guitar. Executive-looking Daddy plays the guitar. So, we've got Daddy sitting outside gently strumming the guitar. Baby girl climbs up the back of Dad; arms wrap around his shoulders. Mom curls in around the other side. The love the parents have for the child is obvious from the moment I walk in the door. But slowly, melodically, the love of the couple becomes crystal clear. I can see it through the lens; just a sweet kiss, but they don't pull away, staying very close for just another second or two. I hold my breath

and push the shutter. I almost feel guilty for being a part of something so deeply personal. The people don't even know how beautiful they are.

I leave photo shoots with a deep connection to everyone I've photographed. The privilege of photographing people in their own homes offers many tiny moments that add up to one big life. It's the guitar, a kitty, a little girl's room—the art in every family. If I show up with a strict agenda, my images in the end might as well have been taken at the mall—that's not for me. Invite me into your world, and I will find the magic. I will capture it, take it away with me, put those magic moments to music in the form of a custom slideshow and then make magic prints that will hang on your wall. Then every day as you pass through that room, you'll be deeply touched by something in that image that beautifully captures your family; the image leaves out the chaos, the Cheerios, the barking dog, the pile of laundry—all the noise. The image very quietly and safely holds the perfect light, the content mother, the gentle father, the sweet baby, the precious child, the magic treasures that say who they are. That one magic image.

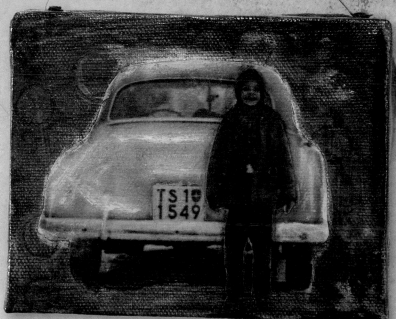

RAYMOND

LORI'S TIPS FOR TAKING BETTER PICTURES

The first two basic rules for better pictures:
1. *Take lots of pictures.*
2. *Get closer.*

Let's start with the first rule. If you are taking photos with a digital camera, click away; what's stopping you? Every time you press the shutter, you increase the odds of getting an image you'll love. Film is a little more complicated, of course, but worth the investment. In my opinion, if you want black and white, shoot with film. There is a grain and softness to film that has yet to be duplicated in the digital world.

Now for rule number two: Get closer. Think about what you want the focus of your picture to be and get rid of the "noise" by physically moving closer to your subject. If you develop an image and find that perfect expression or gesture, but the rest of the picture is unimportant, just crop it out.

Now for the fun stuff. Once you've mastered the basics, you can start to play. Here are a couple of fun, easy things to get you started:

1. *Turn off the flash!* You must hold the camera very still, but you won't believe how different your images will look. If movement produces blurred images—cool! That's what movement looks like! Stop making people smile. Please do not ever say "cheese" again. If you're looking for authenticity, just shoot.
2. *Turn around and look behind you.* There have been moments in my shoots where everything is working; subject

is engaged, setting is fabulous and then a little voice tells me to turn around, and BOOM . . . there it is—the moment I've been waiting to capture. It's magic when that happens.

3. *When you are ready to print your pictures, get the biggest print you can afford.* If you love the image, 4" × 6" (10cm × 15cm) will not do. My favorite size is 16" × 20" (41cm × 51cm), and I only print images in this size when I absolutely love them.

4. *Do not get discouraged.* Even the pros hope only for one great image for every roll of film; that's one in thirty-six. So get busy taking pictures and have fun! Isn't that what it's all about anyway?

COLLABORATIVE PIECES

Lori provided me with copies of imagery from her collection that I used in several collage works. The images were either ones she shot herself or photographs of family members taken from her own personal collection. I must admit it was a little scary at first. I did not want to destroy the original character and flavor of the photos. I hoped to do them justice with my art, and I hoped Lori would be pleased. I took a deep breath and dove right in. I was surprised at how easily the ideas came and how quickly the pieces emerged. Thankfully Lori was happy with the results, and we found our collaboration to be a positive one—dare I say, even a magical one!

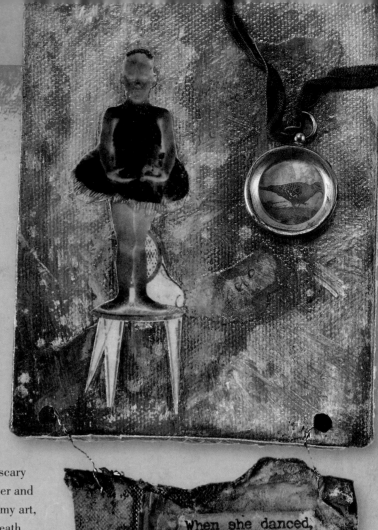

WHEN SHE DANCED

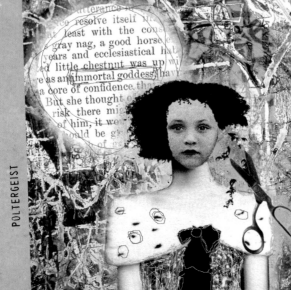

POLTERGEIST

(Please note that some basic information on creating digital collage and making your own digital brushes is present in another article in this book titled *The Art I Almost Threw Away* on page 44.)

CREDITS:

The imagery of the scissors featured in "Poltergeist":
©iStockphoto.com/Rouzes

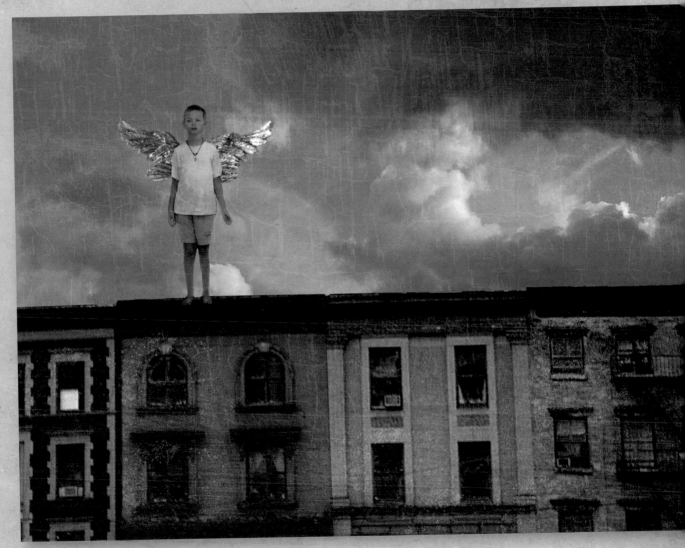

ANGELS AMONG US

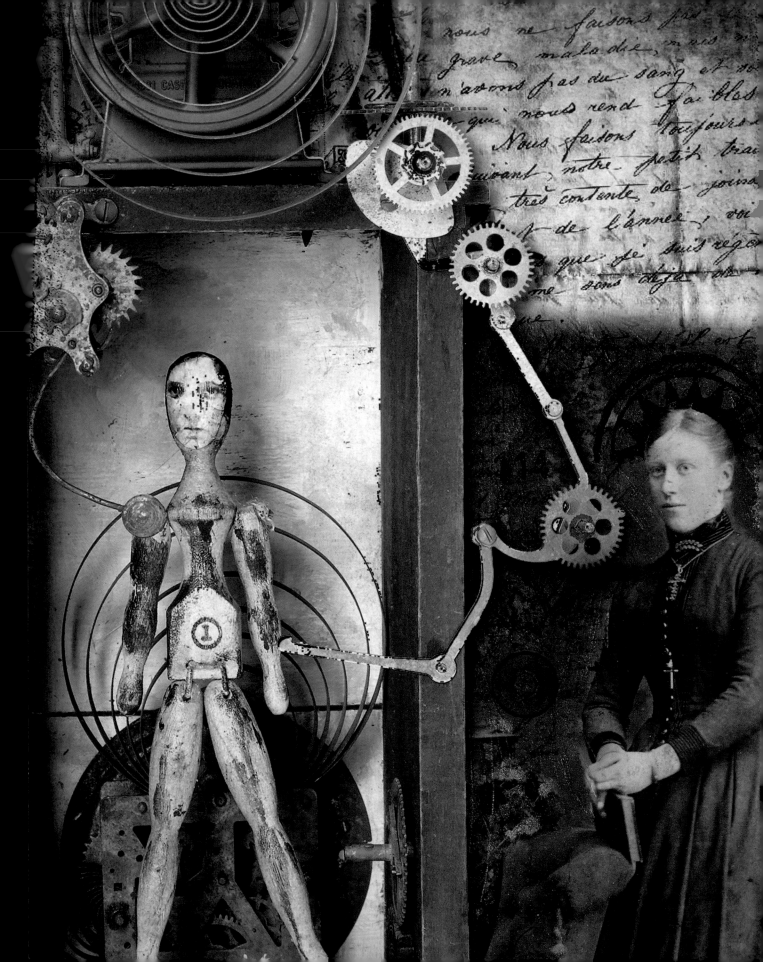

LOST AND FOUND

Vintage photos, an old dictionary page, a crystal from an antique lighting fixture, doll parts, natural finds from the forest floor, broken china, rusty metal scraps. Discarded, unwanted objects—some old, some new—tossed into the junkyard, baking in the hot sun at your local flea market or yard sale, sitting on the dusty shelves of thrift and antiques stores, waiting on the curbside for trash pickup, even strewn across city sidewalks. Some of these tossed objects served utilitarian purposes, while others held personal significance and sentimental value. To the found-object artist, these items are truly diamonds in the rough. With a bit of "polishing," their surprising potential and exceptional character as repurposed objects will shine through, promoted to the level of art!

When I was four, my preschool teacher asked me what I wanted to be when I grew up. I told her I wanted to be a garbage man. I didn't expound on why, but looking back, I think it was because I thought it would be neat to ride on the back of the truck, free in the open wind, like being on some kind of wild carnival ride. Or maybe, as I'd like to think, it was my budding interest in found-object art: my inclination and readiness to turn one person's trash into something I had deemed treasure. I am certain found-object artists and enthusiasts have similar stories to share—what's your story?

It has been almost ninety years since Marcel Duchamp's *The Fountain* (repurposed from a urinal) was accepted into the broader spectrum of the fine-art world—not without protest, of course. Found art, by definition, involves infusing an otherwise mundane object with personal meaning—meaning that is sometimes revealed by the artist or left open for interpretation. This type of art invites you to actively participate in the viewing experience, and oftentimes you become an integral part of the experience. In looking at found art, you cannot help but be introspective and reflective and bring your own personal stories to the table. The found-object artist asks you to think about the unconventional relationships between objects that ordinarily would not be put together. Ultimately, this coaxes us to open up our minds and see other possibilities in all aspects of our world—to find the adventure inherent in new ways of seeing and in new ways of doing.

I will never forget, at age nineteen, my first visit to the Museum of Modern Art in New York City. In particular, I remember being attracted to an installation piece of crocheted dolls, placed seemingly haphazardly around a defined space. At first I wondered if I was really looking at art. As I stood there and let the experience wash over me, I was surprised by the inner churnings that began to occur—the long-forgotten memories of playing with my own crocheted doll as a little girl. This led to other powerful thoughts and feelings that eventually brought me to tears—good tears. On that day I became forever changed in the way I view art and in terms of what I deem as art. I share this story with you to illustrate this point: When viewing found-object art, we can't help but feel we are being invited into the artwork—a place where our own personal stories and truths can be revealed to us, if we let them—a place where we can learn about ourselves and begin to form questions that will lead us in new directions. So, are you ready for the journey? All right then . . . turn the page!

FINDING ART ALL AROUND YOU

David Wallace

Starting a collage is always daunting to me. When I enter my studio (my one-car garage) and look at the empty worktable, I'm often filled with dread.

I fear not being able to come up with anything. Some days that is the case, but on other days, I can make four or five pieces in one creative spurt.

Most of my work begins with the materials. I never set out to make a piece "about" anything, although sometimes it becomes "about" something as I go along. I'm inspired by the effects of nature and time, and I love finding examples of what I call "accidental" art—peeling paint, rusting metal, stained paper and fading photographs. My materials tend to have a layer of grit or a little dirt, and they all have a mysterious and unknown history. This aesthetic is similar to the Japanese concept *wabi-sabi*, which states that nothing lasts, nothing is finished and nothing is perfect. The imperfections in something add to its appeal and charm and give it character.

Every piece of paper I see is a potential piece of a future collage. When I first started making collage, I imagined I was saving the material from some kind of image landfill. As an avid gardener and environmentalist, I am aware of the amount of waste in the world, so I enjoy taking old, beat-up and forgotten images and remaking them into something I hope is artful.

MY PROCESS

I start with the backdrop, which could be anything from a page torn out of an old dictionary to a piece of wallpaper. Because I tend to think of my collages as portraits, I next look for a central figure—a point of focus for the piece. From there, the work proceeds as trial and error, with me moving pieces of paper on and off the background until something resonates. A story begins to be told—a loose but

DEEP END

THAT VERY THING

THE SEXUAL EMBRACE.

Your gift of manhood is to make you a great er, broader thinking power than you have ever co you have a special taste for anything, so that w

probably obscure narrative begins to form, and the collage begins to take shape.

For example, in the piece titled *Deep End*, the color and shape of the record sleeve looked like water to me. The numbered sleeve reminded me of a marker indicating the water's depth. The stained paper looked like a cloudy sky, and the tilt of the woman's head in this environment could look like she was straining to stay above the waves. It's all about context and proximity. The image of the woman's head was actually cut from an old panty-hose ad, and her head tilt probably signaled her extreme joy at wearing such a fine product.

So this piece tells a story, at least in my mind. You may have a completely different interpretation. But a story is not the only thing that gives a piece direction. Other times, there is no narrative. Sometimes everything just fits together, and it feels right.

This juxtaposition of seemingly unrelated photos, textures and words into a unified whole is what keeps me coming back to collage. I never get bored with it. I don't remember exactly why I started making collages, but it is something I believe I'll always do as long as I make art.

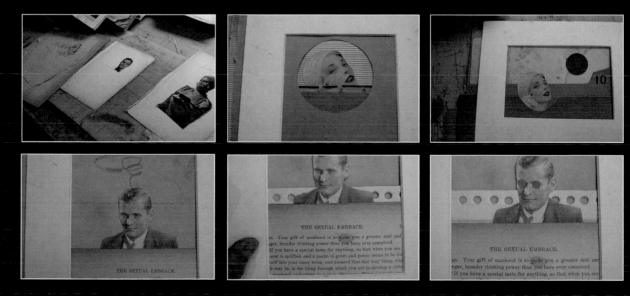

THE ALTERINGS OF AN ECLECTIC COLLECTOR

Deryn Mentock

For as far back as I can remember, I have been a collector of . . . well . . . things—some strange, some not so strange. My grandfather was an auto mechanic who worked out of his home garage, and I recall spending many happy hours as a kid rummaging through the dirt of his driveway for all manner of interesting junk—things like rusty washers and mysterious-looking valves and pins.

Treasure hunting is still one of my favorite pastimes. There is a distinct feeling of satisfaction for me when I discover the perfect, unique element to use in my artwork. My collections have changed over the years as my artwork and interests have changed. My treasure trove now includes crusty metal hardware and "doo-dads," porcelain teeth, old flatware, vintage religious medals, wooden nickels, a large collection of vintage prayer cards and, of course, vintage cabinet cards.

Cabinet cards were made beginning in the mid 1800s until around 1900, when they fell out of favor. Fortunately, cabinet cards were extremely popular, which makes them widely available today.

I love the time-worn look of these cards, and the fact that they are castoffs makes them even more appealing. I can't help but wonder how these photos ended up in a dusty box in my favorite junk store!

Creating Art From a Cabinet Card

Materials

- CABINET CARDS
- COARSE AND FINE SANDPAPER
- TWINKLING H$_2$OS PAINTS (LUMINARTE)
- PAINTBRUSHES (CHEAP ONES WORK BEST!)
- HEATING TOOL
- DYE INK
- RUBBER STAMPS
- FOAM STAMPS
- EPHEMERA (POSTAGE STAMPS, TEXT, MUSIC, ETC.)
- BEADS AND CHARMS
- GLUE STICK
- MASKING TAPE
- CLEAR ACRYLIC SEALER SPRAY
- WIRE OR RIBBON FOR HANGER
- JAPANESE SCREW PUNCH
- METAL EYELETS, EYELET SETTER AND HAMMER

THE SCHOOL MASTER

SEEK

METHOD

-1- BEGIN BY SANDING THE BACKGROUND OF YOUR CARD AROUND THE CENTRAL IMAGE. BE CAREFUL NOT TO SAND HEAVILY OVER ELEMENTS YOU WANT WANT TO KEEP INTACT. USE COARSE SANDPAPER FOR THE BACKGROUND AND FINE FOR FOREGROUND ELEMENTS. SANDING THE SURFACE WILL GIVE THE CARD "TOOTH" FOR THE PAINT TO STICK TO.

-2- PAINT THE BACKGROUND USING TWO OR THREE DIFFERENT COLORS. I LOVE TWINKLING H_2OS BECAUSE THEY CONTAIN MICA AND LEND A BEAUTIFUL GLOW OF COLOR TO MY CABINET CARDS. YOU COULD ALSO USE ANY OTHER WATER-BASED, MICA PAINT. ADD SEVERAL LAYERS OF PAINT, AND USE A HEATING TOOL TO DRY THE CARD BETWEEN LAYERS. (DON'T LET IT GET TOO HOT!) CONTINUE UNTIL YOU ARE SATISFIED.

-3- USE A DYE-BASED INK AND YOUR FAVORITE RUBBER STAMPS TO ADD INTEREST TO THE BACKGROUND. SET THE INK WITH THE HEAT GUN BEFORE ADDING ANOTHER LAYER OF PAINT. I OFTEN MAKE MY OWN STAMPS USING MOLDABLE FOAM. WHEN HEATED, THIS FOAM WILL TAKE AN IMPRESSION FROM ANYTHING AND MAY THEN BE USED AS A STAMP. YOU CAN ALSO USE REGULAR, PRE-MADE FOAM STAMPS.

-4- ADD BITS AND PIECES OF EPHEMERA AT THIS POINT IN THE PROCESS. A GLUE STICK WORKS WELL TO ADD PAPER ELEMENTS. ONCE THE PAPERS ARE GLUED DOWN, USE MASKING TAPE TO DECONSTRUCT THEM A LITTLE BY REMOVING BITS OFF THE SURFACE WITH THE TAPE.

{MORE AND MORE}

NOW ADD MORE PAINT, MORE STAMPING AND MORE PAPER. REMEMBER, THIS IS A LAYERING PROCESS AND YOU'RE BUILDING UP LAYERS OF COLOR AND INTEREST.

{SET AND FINISH}

TO SET THE PIECE, SPRAY IT WITH AN ACRYLIC SEALER. (PLEASE READ PRODUCT LABEL FOR SAFETY PRECAUTIONS.) YOU CAN ADD A HANGER TO YOUR CARD IF YOU'D LIKE, USING RIBBON OR WIRE. USE A SCREW PUNCH TO MAKE HOLES IN YOUR CARD. CABINET CARDS ARE OLD AND CAN BE VERY BRITTLE; I'VE FOUND THAT A SCREW PUNCH USUALLY MAKES THE CLEANEST HOLE. SET EACH HOLE WITH AN EYELET AND STRING YOUR WIRE OR RIBBON. NOW IT'S READY TO HANG!

PROJECT EXTENSION

Cabinet cards lend themselves to all kinds of creative projects. They make great book pages, with or without covers. For my book, *Children of the King*, I used the front and back covers of a vintage book, cabinet cards and various papers and vintage objects from my collection. The covers and pages are tied to a strip of hardware cloth that serves as the binding. With this type of binding, it is possible to add all sorts of materials to the book: vintage crochet pieces, fabric, a leather coin purse, the spine from an antique book and, of course, don't forget the cabinet cards!

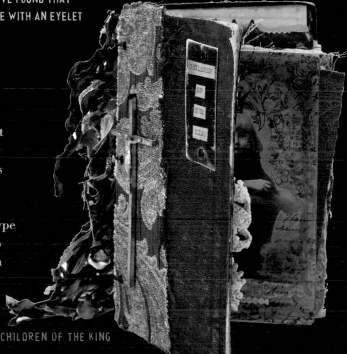

CHILDREN OF THE KING

ART FOR SMALL SPACES

Holly C. Karolkowski

Don't you love where art can take you? It's a journey to a brand-new place. My small assemblage shadowboxes, which I call *Art for Small Spaces*, become worlds in strange lands. They capture a feeling or moment in time and hopefully tell a story about which the viewer wants to know more.

I usually start the process by laying out several square frames on my art table and then the frenzy of flying papers begins. I start to sort through the saved images and patterned papers I've created or collected. I like rummaging through the pile knowing I can always find a good background in there. I begin to experiment to see which papers will work with each frame. This can be a long process for me when there's a wonderful paper I really want to use, but it just doesn't work with what I've got.

Next is a treasure hunt through drawers, boxes and jars of found objects I've gathered. I like to play with these objects, just to see where they take me. One idea can quickly lead me in a new direction. Because I work on multiple pieces at once, ideas are constantly changing and bouncing off one piece of artwork to another. It's great when I stumble upon a long-forgotten finding. I become inspired to create a way to display and show the subject in a new light. I like using items that might be overlooked in everyday life—a decorative pull on Grandma's window blinds becomes transformed into the perfect vase! That rusty hubcap bolt is a natural perch for that red-feathered cardinal I pulled off Aunt Tillie's Christmas card last year. Looking at things differently is a necessary part of creativity.

Building a Shadowbox

Materials

SQUARE FRAME, DEEP ENOUGH TO ACT AS A SHADOWBOX	GLASS (SAME SIZE AS YOUR FRAME)
ARCHIVAL MAT BOARD (SAME SIZE AS FRAME)	GLASS CLEANER
	PAPER TOWELS
SMALL UTILITY KNIFE	DOUBLE-SIDED TAPE (FRAMER'S ATG WORKS WELL)
DECORATIVE PAPERS	
FINDINGS AND NOTIONS	GLAZIER POINTS
TACKY GLUE	SCREW EYES
FOAM CORE 1/8" (3MM) (DOUBLE THE SIZE OF YOUR FRAME)	WIRE
	GLUE STICK
RULER	PAINT, CHARCOAL AND STAMPING SUPPLIES

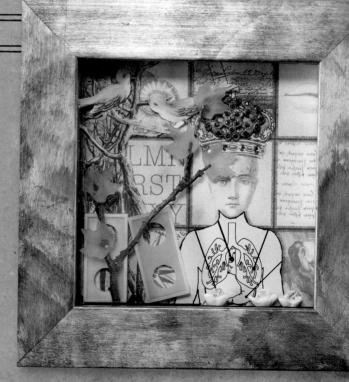

THE LAST PRINCE OF THE FOREST

METHOD

-1- USING A UTILITY KNIFE, CUT A PIECE OF MAT BOARD TO FIT YOUR FRAME; LET THIS BE YOUR PALETTE. PLAY AROUND WITH DIFFERENT PAPERS AND OBJECTS. LOOK AROUND FOR INSPIRATION. I FIND SOME OF MY FAVORITE ITEMS ON THE GROUND, LOST AND WEATHERED. OR MAYBE YOU ALREADY HAVE SOMETHING IN MIND. PERHAPS A PAIR OF OLD EARRINGS CAN BE REJUVENATED INTO SOME WILD WALLFLOWERS. FIND A STORY OR FEELING YOU WANT TO CAPTURE IN YOUR WORK AND THEN GO WITH IT, OR TRY WORKING ON A FEW THEMES AT A TIME. KEEP IN MIND THAT SOME OF YOUR DESIGN ELEMENTS WILL REST ON THE FLOOR OF YOUR SHADOWBOX.

-2- ONCE YOU ARE SATISFIED WITH YOUR DESIGN, START LAYERING ON YOUR BACKGROUND PAPERS AND THEN LAYER OVER THOSE WITH PAINT, CHARCOAL, OR STAMPING TO GIVE MORE DEPTH AND SHADING.

-3- WHEN YOU'RE HAPPY WITH YOUR BACKGROUND, YOU CAN START ADHERING YOUR FOUND OBJECTS AND FINDINGS. (I LIKE SUPER TACKY GLUE FOR HARD-TO-HOLD ITEMS!)

-4- WHILE THE GLUE IS DRYING, IT'S TIME TO MAKE THE SHADOWBOX SIDES. EACH SIDE THAT LINES THE BOX IS REFERRED TO AS A SPACER. THIS CREATES THE DEPTH OF THE PIECE. MEASURE THE DEPTH OF THE DEEPEST OBJECT ON YOUR BACKGROUND. ADD 1/8˝ (3MM) TO THAT MEASUREMENT. THIS WILL BE THE WIDTH OF YOUR SPACERS. MEASURE THE WIDTH OF THE INSIDE OF YOUR FRAME AND SUBRACT 1/16˝ (2MM). THIS BECOMES THE LENGTH OF YOUR FIRST TWO SPACERS. FOR EXAMPLE, IF YOUR FRAME MEASURES 5˝ (13CM) INSIDE AND THE DEPTH OF YOUR DEEPEST OBJECT IS 1˝ (3CM), CUT YOUR FIRST TWO FOAM-CORE STRIPS, 4 15/16˝ X 1 1/8˝ (12.5CM X 2.85CM).

-5- COVER YOUR STRIPS WITH DECORATIVE PAPER: YOU CAN USE THE SAME PAPER YOU USED FOR THE BACKING, OR TRY SOMETHING COMPLETELY DIFFERENT.

-6- AFTER THE FIRST TWO SPACERS ARE COVERED, SET THEM IN THE FRAME ON OPPOSITE SIDES. THEN, MEASURE THE DISTANCE BETWEEN THE TWO STRIPS TO DETERMINE THE LENGTH OF YOUR FINAL TWO STRIPS—THEY WILL STILL BE THE SAME DEPTH AS THE FIRST TWO. CUT AND COVER THE REMAINING STRIPS. CLEAN THE GLASS, USING GLASS CLEANER, AND THEN SET IT INSIDE THE FRAME. ADHERE THE FIRST TWO SPACERS, USING DOUBLE-SIDED TAPE ON THE BACK AND THEN THE OTHER TWO SPACERS.

-7- NOW THAT THE FOUR "WALLS" ARE ALL STUCK INSIDE THE FRAME, IT'S TIME TO ADHERE ANY DESIGN ELEMENTS TO THE BOTTOM "WALL" OF YOUR LINING WITH TACKY GLUE. ONCE THOSE ELEMENTS HAVE DRIED IN PLACE, REST YOUR DECORATED MAT BOARD, FACEDOWN, ON TOP OF THE SPACERS (BEFORE ASSEMBLING, YOU MAY WANT TO GIVE THE GLASS ON THE INSIDE OF THE FRAME ANOTHER CLEAN). ADD A PIECE OF FOAM CORE TO THE BACK OF THE MAT BOARD, AND SECURE WITH GLAZIER POINTS.

-8- ATTACH SCREW EYES AND WIRE TO THE BACK OF THE FRAME FOR HANGING.

Once you create one of these assemblages, you'll want to do more! It's amazing what you can do with so much depth.

STILL LIFE WITH TOMATO

WHEN PIGS FLY

REVIVED RELICS:
FOUND-OBJECT JEWELRY

Jessica Moreau-Berry

When I was a small child, I was a dreamer, an artist and a happy soul. I was lucky enough to have a family who seemed to recognize that this was the way I was destined to live my life, and they encouraged me to do so. My grandfather paid for art lessons, my father bought my creations for a quarter a piece. Both my mother and grandmother bought and sold antiques, and I was never far from either one of them. These special ladies were also extremely crafty and taught me how to sew, do macramé, paint and refinish furniture.

As a teen, I began painting designs onto wooden furniture, selling them at shows alongside my mom. By the time I was in my twenties, I had a full-blown hand-painted-furniture business and an antiques shop. I loved the shabby vintage style, and painted my furniture to this effect, selling cottage-style furniture here in Maine. I discovered blogging as a way to show my pieces and meet up with other creative people.

Designing and Creating a Chain

Materials

BEADS	"O" RINGS
BEAD BOARD	ANVIL
RULER	HAMMER
18-GAUGE STERLING, COPPER OR STAINLESS-STEEL WIRE	DOWEL
	CLASP
WIRE CUTTERS FOR JEWELRY	
NEEDLE-NOSE PLIERS	

Eventually I became burned out from painting flowers onto white backgrounds, and my back grew tired from hauling furniture and boxes of antiques. I took a summer off, enjoying kayaking, gardening and hiking the long summer days away, all the while searching for a new outlet for my creativity. No matter how hard I tried, I just couldn't seem to stay away from the tag sales, flea markets and antiques shops.

Through visiting beautiful blogs, I discovered the art of collage. I fell in love with the layers and layers of paint, stamps and vintage ephemera these talented women were turning into beautiful works of art. This was something I could do! I dug out my stashes of old paper and made a few quick ATCs and cards. Though I loved this process, something was missing in it for me. I went upstairs to the second story of our barn and grabbed boxes and jars filled with old jewelry, hardware and buttons. In the winter of 2005, I made my first piece of "found-object" jewelry. I've worked hard since then to stay true to my own style, usually going on instinct alone to create one-of-a-kind, wearable art for customers, family and friends.

Over the years, through the power of blogging and thanks to the unselfishness of these wonderful bloggers, I have learned many techniques on jewelry-making that have added to the beauty and durability of my art. Through these people, I have discovered creative outlets, swaps and online art groups, where we share our lives and our projects.

I have discovered I wasn't the only child who doodled in her school books and dreamed of selling her wares on the streets of Paris. I wasn't the only little girl scavenging at lawn sales and flea markets, hoarding her treasures. Because of the friends I have made through blogging, I have learned it's OK to be a dreamer and to always follow your heart.

METHOD

YOU CAN DESIGN A CHAIN USING AS MANY BEADS AS YOU'D LIKE: THE BEADS
CAN BE ANY SHAPE, SIZE OR COLOR. YOU CAN ALSO MAKE YOUR CHAIN AS
LONG OR SHORT AS YOU DESIRE. I RECOMMEND USING A BEAD BOARD (AN
INEXPENSIVE AND VALUABLE TOOL) FOR LAYING YOUR CHAIN DESIGN OUT.
IN *CRYSTAL DREAMS*, I USED MORE WIRE LINKS THAN BEADS TO KEEP
THE CHAIN LIGHT AND AIRY.

-1- DECIDE ON THE BEADS YOU'D LIKE TO USE IN YOUR DESIGN AND PLACE
THEM IN A PLEASING PATTERN ON YOUR BEAD BOARD. REMEMBER, YOU CAN
USE ALL BEADS IN YOUR DESIGN, OR YOU CAN ADD SOME SIMPLE WIRE LINKS IN
BETWEEN BEADS.

-2- ONCE YOU HAVE CHOSEN YOUR BEADS, YOU WILL NEED TO TURN THEM INTO
WIRED LINKS. WORKING WITH ONE BEAD AT A TIME, PLACE A BEAD ONTO A RULER AND
MEASURE ABOUT 1/2" (13MM) ON BOTH SIDES OF THE BEAD: MAKE NOTE OF THE TOTAL
MEASUREMENT. CUT A PIECE OF WIRE THAT IS THE SAME LENGTH AS THIS TOTAL MEASUREMENT. TAKE YOUR CUT PIECE OF WIRE AND
GRASP ONE OF ITS TIPS WITH THE TIP OF YOUR NEEDLE-NOSE PLIERS. GENTLY ROLL THIS TIP OF THE WIRE INTO AN "O." RUN YOUR
BEAD THROUGH THE STRAIGHT END OF THE WIRE, AND THEN CREATE ANOTHER "O" WITH THE STRAIGHT END OF WIRE. PLACE ONE "O"
OF YOUR WIRED BEAD ONTO YOUR ANVIL AND GENTLY TAP THE WIRE, TO LIGHTLY FLATTEN IT. THIS "WORK HARDENS" YOUR END,
MAKING IT STRONGER AND MORE DURABLE (TO "WORK HARDEN" MEANS TO STIFFEN OR HARDEN METAL BY BENDING, HAMMERING OR
STRETCHING IT). DO THE SAME TO THE "O" ON THE OPPOSITE END. YOU HAVE CREATED YOUR FIRST WIRED BEAD!

-3- WIRE ALL THE BEADS YOU HAVE CHOSEN FOR YOUR DESIGN (USING STEP 2), PLACING THEM ONTO YOUR BEAD BOARD AS YOU GO,
KEEPING YOUR DESIGN IN PLACE.

-4- NOW YOU ARE READY TO MAKE THE LINKS THAT WILL CONNECT YOUR BEADS TOGETHER: THESE LINKS CAN BE ANY SIZE OR STYLE
YOU WISH. TO MAKE LINKS LIKE THE ONES IN *CRYSTAL DREAMS* (PAGE 82), CUT WIRE PIECES TO YOUR DESIRED LENGTH. GRASP A WIRE
IN ITS CENTER WITH THE FAT END OF YOUR NEEDLE-NOSE PLIERS. GENTLY BRING BOTH SIDES OF THE WIRE DOWN TOWARD THE FLOOR
UNTIL THEY MEET. YOU WILL HAVE A LONG, SKINNY "U." GRASP ONE OF THE WIRE ENDS WITH THE TIP OF YOUR NEEDLE-NOSE PLIERS
AND ROLL UP TOWARD THE CENTER OF THE WIRE. REPEAT THIS STEP ON THE OTHER END. MAKE AS MANY OF THESE LINKS AS YOU
NEED, KEEPING THEM ALL THE SAME SIZE AND LENGTH. LIGHTLY HAMMER YOUR LINKS ON YOUR ANVIL TO "WORK HARDEN" THEM.

-5- PLACE YOUR HANDMADE LINKS ONTO THE BEAD BOARD WITH YOUR WIRED BEADS, BUILDING AND PLAYING WITH YOUR DESIGN.

-6- IF YOU'D LIKE TO ADD "O" RINGS, YOU CAN EITHER MAKE THEM YOURSELF OR BUY THEM COMMERCIALLY. I MAKE MY OWN BY
WRAPPING THE WIRE AROUND A DOWEL. I ALSO TAP THESE OUT ON MY ANVIL TO "WORK HARDEN" THEM. WHEN OPENING YOUR "O"
RINGS, DO NOT PULL THEM APART, BUT OPEN THEM FROM SIDE TO SIDE IN A TWISTING FASHION: PULLING THEM APART WEAKENS
THE WIRE. PLACE ANY "O" RINGS ONTO YOUR BEAD BOARD, INCORPORATING THEM INTO YOUR DESIGN.

-7- START LINKING YOUR PIECES TOGETHER, REMEMBERING TO OPEN AND CLOSE YOUR LINKS FROM SIDE TO SIDE.

-8- CONNECT YOUR PENDANT TO YOUR CHAIN BY USING "O" RINGS OR A HANDMADE PENDANT HOLDER. TO FINISH, ATTACH YOUR
CLASP, PUT YOUR NECKLACE ON, AND ADMIRE YOURSELF IN THE MIRROR!

POETIC SPIRITS

POETIC SPIRITS

I have a box in my studio filled to the brim with old watch faces and parts. I love using them in my designs because they make an instant "frame" to show off a mini collage or piece of art. The watch used to create this swanky choker necklace didn't have a crystal, but that didn't stop me from seeing its instant beauty. Because I was working in a small space, small images had to be used.

Over the years, I have collected vintage bindings, ribbons and lace. I love to incorporate these into my designs, sometimes using a variety of colors and textures. In this particular piece I used vintage seam binding and ribbon.

CRYSTAL DREAMS

I've always loved chandeliers and think they are so dreamy. Unfortunately, my old farmhouse, with its small rooms and low ceilings, doesn't provide enough room for a chandelier, but that doesn't mean I can't use the crystal gems in my art!

When designing your own crystal pieces, try finding an old piece of hardware that has two holes, one on the top and one on the bottom. If you can't find one with holes, you can always drill a hole with a handheld rotary tool.

A SPIRIT TOO DELICATE

When I had my antiques shop, Whimsies, my favorite items to sell were gleaming, vintage silver plates and sterling silverware. If I found a box at a flea market or tag sale, my heart would race and I'd get a light-headed, dizzy feeling. I'd stay up late at night watching old movies and happily polishing my new treasures!

Using an old spoon in jewelry design is not a new concept, but you can make it unique by using creative collage and a one-of-a-kind design. Flatware can be sliced and drilled, using a rotary tool, and collaged with your favorite element, adhering them with Diamond Glaze.

Here I have created a simple U-shaped pendant holder, but after playing around with your wire, you might find you'd like to try your hand at more intricate shapes!

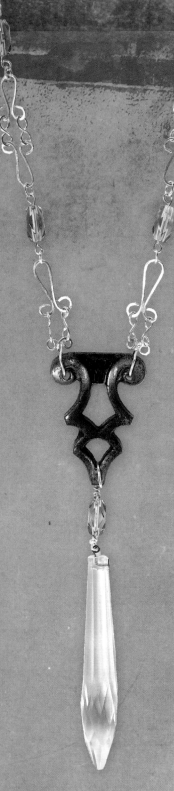

CRYSTAL DREAMS

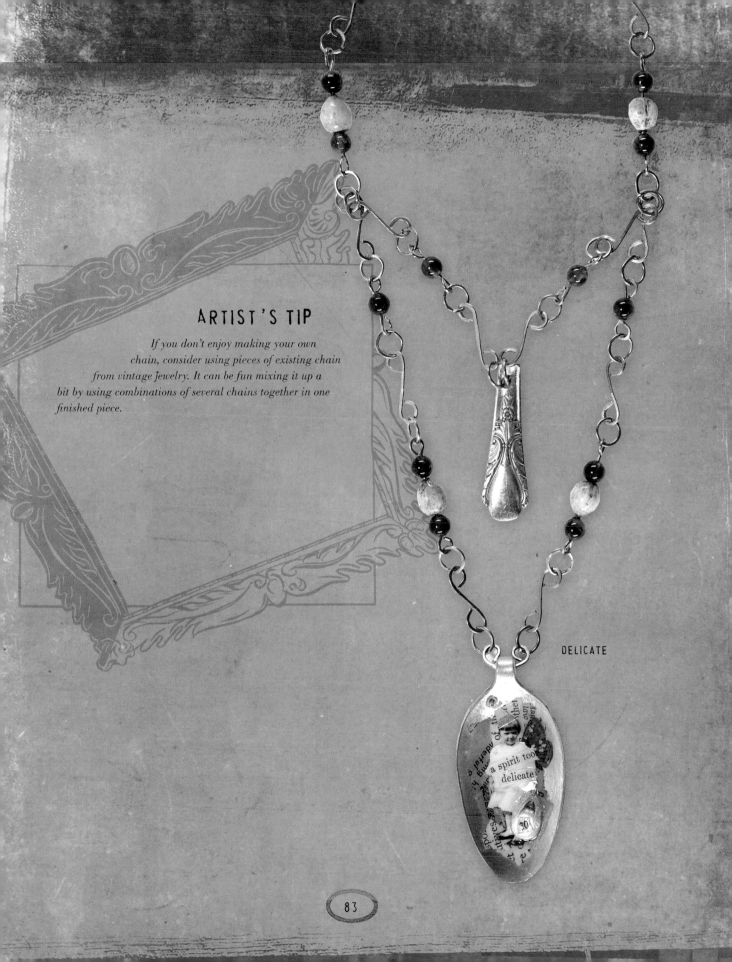

ARTIST'S TIP

If you don't enjoy making your own chain, consider using pieces of existing chain from vintage jewelry. It can be fun mixing it up a bit by using combinations of several chains together in one finished piece.

DELICATE

MY MUSICAL MOSAIC

Joselyn Walsh

I am entranced by glittery things and color. To me, beads are like candy, and I can't get enough! When I was twenty-five I became inspired by jewelry-making and started my own little jewelry business. I lived near New Orleans and started collecting Mardi Gras beads to incorporate into my jewelry pieces. My passion for collecting anything "jewel-like" led to what I call the "Fantastic Mosaic" technique.

The adventure starts with collecting—all kinds of things—beads, shells, old jewelry; just use your imagination. Objects that have one flat side are preferable. Save bottle caps, charms and shells; you might try filling their hollows with glitter glue and putting beads into the glue.

Apply a Mosaic Look to an Instrument

Materials

OLD UKULELE OR SMALL GUITAR

YOUR COLLECTION (BEADS, SHELLS, CHARMS—WHATEVER!)

GLUES OR ADHESIVES (I PREFER ALEENE'S ORIGINAL WHITE TACKY GLUE AND ALEENE'S CLEAR GEL TACKY GLUE)

SMALL PHOTOS OR GRAPHICS

PAINTS

ASSORTED COLORED GLITTERS

JEWELRY PLIERS

THICK SPRAY VARNISH FOR SEALING (DECOART TRIPLE THICK GLOSS GLAZE VARNISH SPRAY) OR A TWO-PART RESIN LIKE ENVIROTEX LITE (PLEASE READ SAFETY PRECAUTIONS ON PRODUCT LABELS)

WIDE RIBBON

METHOD

-1- START WITH A CLEAN AND DRY SUBSTRATE (I USED A UKELELE). MAP OUT WHERE YOU WOULD LIKE TO PLACE SOME OF YOUR MORE SIGNIFICANT PIECES, KEEPING IN MIND THAT BALANCE IS IMPORTANT. SPREAD YOUR BIGGER PIECES OUT: YOU WILL BE CONNECTING THEM WITH THE SMALLER PIECES.

-2- APPLY A GENEROUS COAT OF WHITE TACKY OR CLEAR GLUE TO THE BOTTOMS OF YOUR MOSAIC PIECES. TRY TO BE AS NEAT AS YOU CAN, BUT DON'T BE TOO CONCERNED WITH PERFECTION—THIS KIND OF GLUE USUALLY SHRINKS AS IT DRIES. ALWAYS TRY TO GLUE OBJECTS FLAT-SIDES DOWN. ROUND BEADS CAN BE SET INTO A PUDDLE OF GLUE OR GLITTER GLUE. (THIS WORKS BEST IF THE SUBSTRATE IS FLAT.)

-3- WORK IN SECTIONS, AND AFTER YOU HAVE A FEW MAIN PIECES APPLIED, START FILLING IN THE REST OF THE AREA WITH SMALLER PIECES. TRY TO FOLLOW THE SHAPE OF YOUR PIECE, UTILIZING REPEATING PATTERNS, SUCH AS EIGHT OR TEN BUTTONS PLACED ALL IN A ROW ALONG THE EDGE OF YOUR INSTRUMENT. YOU MIGHT WANT TO PLACE A PRETTY LITTLE STRAND OF BEADS AROUND THE HOLE OF THE UKELELE, OR CREATE A CLUSTER OF SMALL SHELLS AND COAT THEM WITH SOME FINE GLITTER, NESTLING A FEW TINY PEARLS IN AMONG THEM. YOUR PIECE WILL BE COMPLETE WHEN ALMOST EVERY LITTLE NOOK AND CRANNY OF THE SUBSTRATE IS FILLED. I HAVE GIVEN YOU A FEW IDEAS, BUT IT IS YOU WHO UNLOCKS THE DOOR TO YOUR OWN CREATIVITY. AT RIGHT, SEE "IDEAS FOR CREATIVE ELEMENTS."

ARTIST'S TIP

Due to the meticulous nature of this altered art, periodic stretch breaks are recommended—maybe a nice cup of tea with a cookie, and then back to it with a fresh perspective.

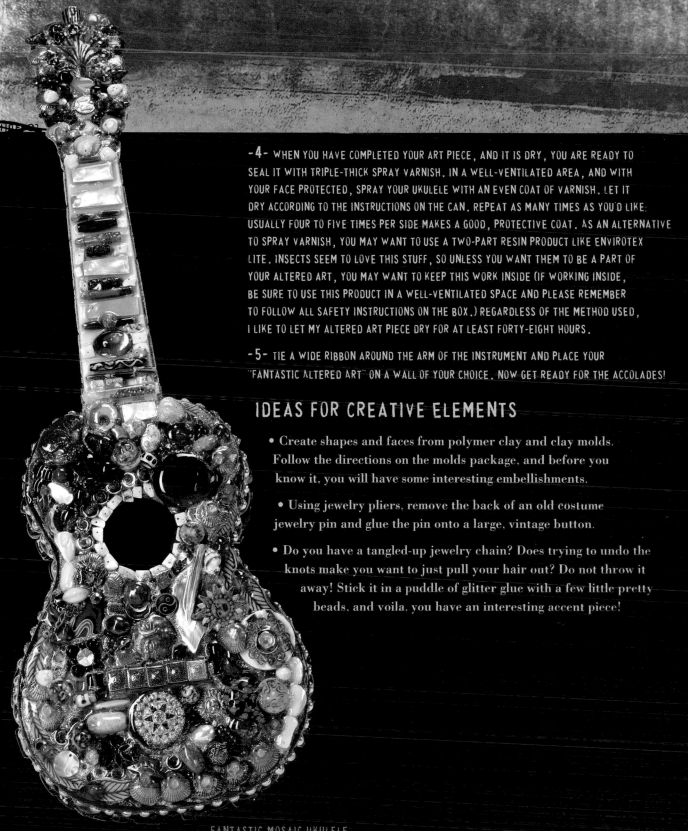

-4- WHEN YOU HAVE COMPLETED YOUR ART PIECE, AND IT IS DRY, YOU ARE READY TO SEAL IT WITH TRIPLE-THICK SPRAY VARNISH. IN A WELL-VENTILATED AREA, AND WITH YOUR FACE PROTECTED, SPRAY YOUR UKULELE WITH AN EVEN COAT OF VARNISH. LET IT DRY ACCORDING TO THE INSTRUCTIONS ON THE CAN. REPEAT AS MANY TIMES AS YOU'D LIKE: USUALLY FOUR TO FIVE TIMES PER SIDE MAKES A GOOD, PROTECTIVE COAT. AS AN ALTERNATIVE TO SPRAY VARNISH, YOU MAY WANT TO USE A TWO-PART RESIN PRODUCT LIKE ENVIROTEX LITE. INSECTS SEEM TO LOVE THIS STUFF, SO UNLESS YOU WANT THEM TO BE A PART OF YOUR ALTERED ART, YOU MAY WANT TO KEEP THIS WORK INSIDE (IF WORKING INSIDE, BE SURE TO USE THIS PRODUCT IN A WELL-VENTILATED SPACE AND PLEASE REMEMBER TO FOLLOW ALL SAFETY INSTRUCTIONS ON THE BOX.) REGARDLESS OF THE METHOD USED, I LIKE TO LET MY ALTERED ART PIECE DRY FOR AT LEAST FORTY-EIGHT HOURS.

-5- TIE A WIDE RIBBON AROUND THE ARM OF THE INSTRUMENT AND PLACE YOUR "FANTASTIC ALTERED ART" ON A WALL OF YOUR CHOICE. NOW GET READY FOR THE ACCOLADES!

IDEAS FOR CREATIVE ELEMENTS

- Create shapes and faces from polymer clay and clay molds. Follow the directions on the molds package, and before you know it, you will have some interesting embellishments.

- Using jewelry pliers, remove the back of an old costume jewelry pin and glue the pin onto a large, vintage button.

- Do you have a tangled-up jewelry chain? Does trying to undo the knots make you want to just pull your hair out? Do not throw it away! Stick it in a puddle of glitter glue with a few little pretty beads, and voila, you have an interesting accent piece!

FANTASTIC MOSAIC UKULELE

ASSEMBLAGE ARTIFACTS

Lou McCulloch

IN CONTROL

My husband and I often dream up art projects together; he provides the mechanical ideas, while I provide the artistic vision. I get to do the fun part—rummaging for supplies! One day I came across a box of old clock parts and an articulated doll made of wood. We found a suitable old drawer and began our assemblage layout.

HOW WE DID IT

The clock parts were loosely arranged, and the moveable arms of the doll were made to look like they were controlling the springs and gears. Once I was satisfied with my arrangement, I glued down most of the gears and clock parts with an adhesive like Liquid Nails. I put together some of the parts with brass screws and tiny nails, so they could actually move. Once the adhesive was dry, I painted and distressed my structure. For the brass pieces, I used touches of Patina Green antiquing solution by Sophisticated Finishes. I painted all the other surfaces with Golden's heavy body acrylics, using shades such as Green Gold, Quinacridone/Nickle, Azo Gold, and Anthraquinone Blue. These colors work well together to achieve a rusty, aged look. Once these mediums were dry, I sealed my piece with water-based, brown antiquing polish (FolkArt). I then glued a paper face to the doll and stenciled on the number *1*. The inside back of the box was painted to look like the sky, enabling the figure to stand out from the background. Twine was strung between some of the metal parts to form pulleys. To complete the piece, I took a miniature metal steam engine, once used by my husband in a train layout, painted it and adjusted it to fit on top of the box. Using white paint, I stenciled *in control* to the base. I feel many women could relate to this piece because they often try to regulate their lives!

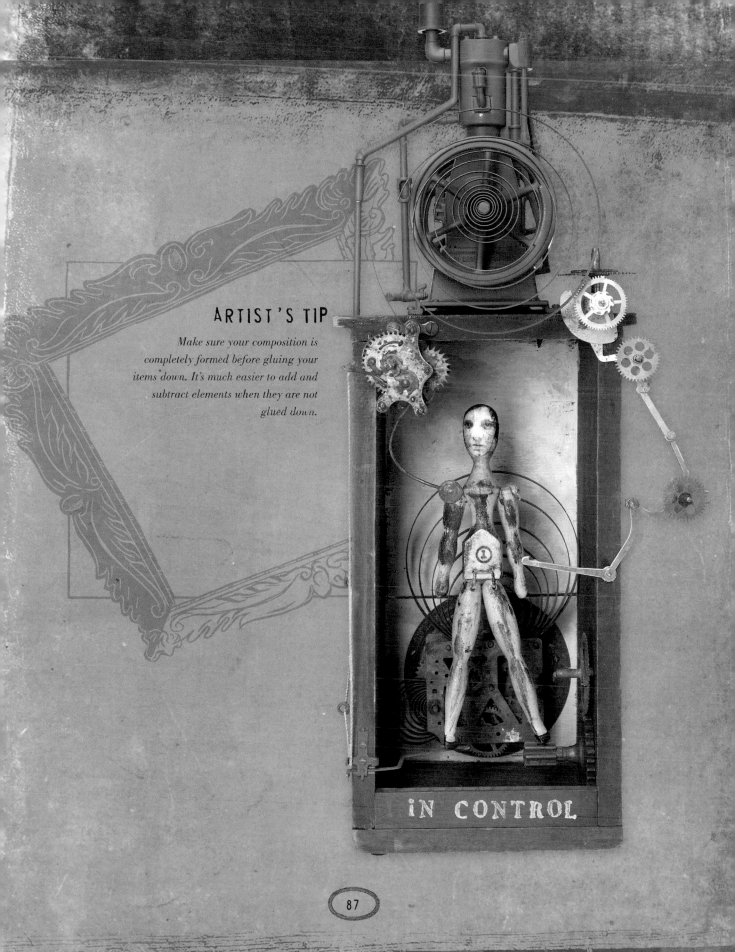

ARTIST'S TIP

Make sure your composition is completely formed before gluing your items down. It's much easier to add and subtract elements when they are not glued down.

IN CONTROL

FOUND OBJECTIVITY

Marie Otero

I can clearly recall my eighth-grade art teacher looking at a piece of abstract drawing I had been commanded to produce and scornfully telling me I didn't possess an artistic bone in my body. It was a pronouncement I unfortunately took to heart, and one that kept me from attempting anything remotely creative for a long time. I was thirteen. At thiry-nine I bought my first rubber stamp and began my adventures in the world of mixed-media art.

My initial experiments with paper arts rapidly lead me to the broader horizons of collage, and it was through my vast network of online pals and groups that I ended up attending ArtFest for the first time. It was an experience akin to giving a cup of water to a desert traveler—I was thirsty for the opportunity—so much to see, do, learn and digest. That year I took a class with found-object master, Keith Lo Bue. I had such fun creating mini masterpieces out of the flotsam and jetsam we found on the grounds of Fort Worden, I couldn't wait to experiment further.

My opportunity to do just that arrived via the invitation of a friend I had made at ArtFest: a like-minded metal junkie who was looking for a companion to join her at a workshop that summer. The invitation was quite serendipitous, as the retreat was only miles away from the location in the Pocono Mountains where my two sons were booked to go to summer camp! So we checked them in at camp and then headed to the retreat, anticipating a glorious week of creativity and community over saws, drills and found-object delights.

The workshop was held at Peters Valley Craft Center, a retreat for artists and crafters in New Jersey with an extremely impressive catalog of classes. In many ways the venue was just like a "summer camp" for grown-ups. The accommodations were rather sparse—quaint, creaky beds, bathrooms that were just a little dubious, and standard mess-hall food. But what the retreat lacked in four-star luxuries was more than made up for with impressive working studios, outfitted with every possible tool, machine and accessory a serious metalsmith could ever dream of.

The class was a week-long intensive taught by Thomas Mann; we found out after the fact that the course was primarily targeted toward college students who needed extra credits and some highly experienced craftsmen. My friend felt confident in her metalworking abilities, but my relatively new skills with a jeweler's saw and drill definitely made me feel a little intimidated. But, as they say, jump in deep and start swimming, which is exactly what I did.

THE TASK LIST

The days were full and fast-paced, and after what seemed like a fairly relaxed introduction, it became clear the teacher was determined to push us further and further each day. We started out by making a piece of jewelry he called a found-object sandwich—layers of metal, imagery and acrylic cut to shape, joined with cold connections and adorned as we each desired (see the piece *Heritage Crown*). Then came the tricky bit. We were given a task list instructing us to independently create a minimum of four pieces. The tasks were as follows:

1) Create a piece using image repetition. Take the same image and repeat it several times, and then incorporate it into a wearable piece of art (Sense of Seeing).

HERITAGE CROWN

2) Create a brooch using a piece of found metal (we could either use our own or something from the class pile) and incorporate a window for some chosen imagery (1923).

3) Create a wearable, hanging piece that includes a handmade bail (Clockwork Vision).

4) Construct an earring (Starstruck).

After completing those tasks we were free to work and create anything else we liked.

EXECUTING THE TASK LIST

I wish it would have all been as simple as it looks on paper. Mr. Mann was a meticulous teacher with a painstaking attention to detail. Each time we created something, we had to sketch out our proposed design and figure out what materials we needed, keeping in mind that what we could use was limited to base metals, found objects and materials needed for cold connections. If he was not satisfied with our design, he would make us go back and rework it. During production he would frequently check our work to force us to examine our design principles and the functionality of the finished piece. He would not tolerate sloppy or poorly thought-out work.

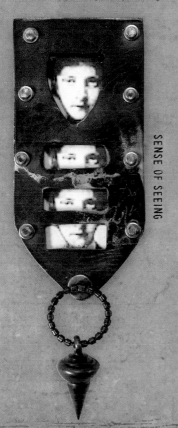

SENSE OF SEEING

1923

As someone who likes to work quickly and execute things in a short space of time, I often found this to be a challenge, but ultimately it was one of the best lessons I have learned.

During the week of class, some students labored over a piece or two and nothing more. My friend finished about five pieces. Dear old me, the impatient jeweler, ended up winning the "award" for being the most prolific, with nine pieces to my name. I still haven't figured out if Mr. Mann really intended that award to be a compliment or not. Regardless, the instruction I received was a revelation. Having the opportunity to immerse myself in a creative pursuit, with very little distraction, and with access to a state-of-the-art workshop was just fabulous! The concentration of time in which to work showed me just how much the distractions of daily life can hamper one's creativity; perhaps a real "studio" away from home is not a bad thing. Taking the time to think through a design and truly give forethought to how it will work when it is finished really can pay off. This careful planning and attention to detail can affect how the wearer of a piece will enjoy it, long after you, the creator, is gone.

The "found-object" part of the process also taught me a lot about how to "see" things. So often we imagine we need a shopping list of supplies in order to create something, but in the class, we seldom had much more than a pile of rusty, old junk on which to base our finished pieces. Taking three or four items from the pile and just sitting there layering and moving them around until pleasing possibilities occurred was good visual training.

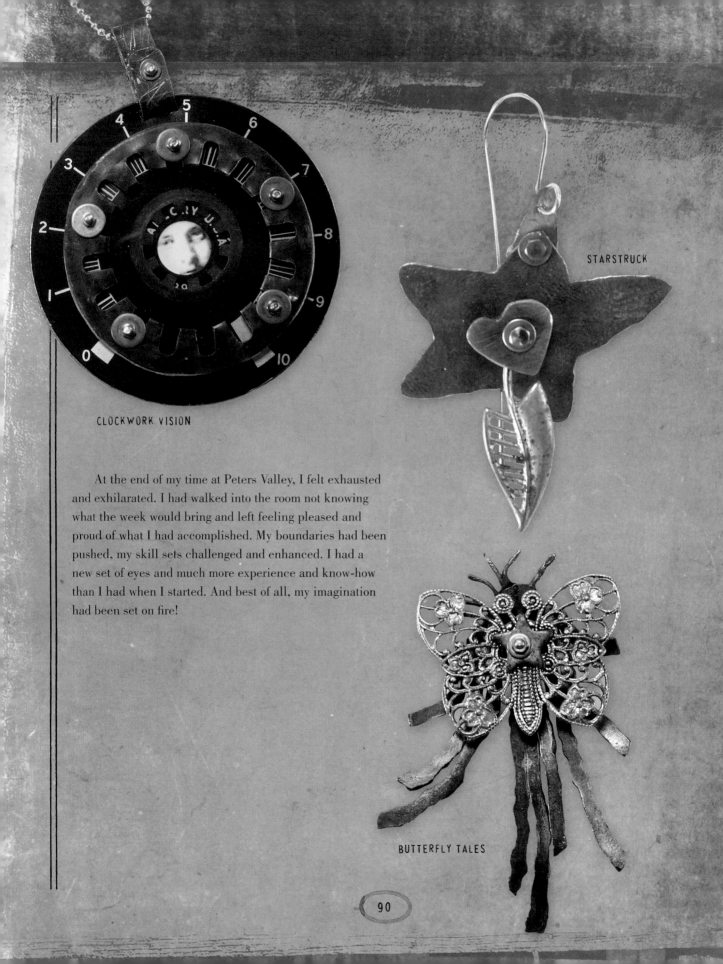

CLOCKWORK VISION

STARSTRUCK

At the end of my time at Peters Valley, I felt exhausted and exhilarated. I had walked into the room not knowing what the week would bring and left feeling pleased and proud of what I had accomplished. My boundaries had been pushed, my skill sets challenged and enhanced. I had a new set of eyes and much more experience and know-how than I had when I started. And best of all, my imagination had been set on fire!

BUTTERFLY TALES

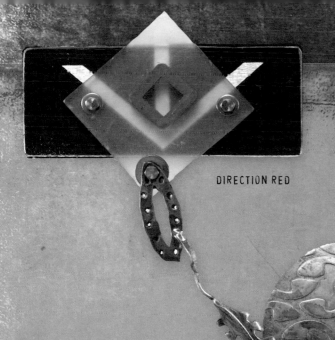

DIRECTION RED

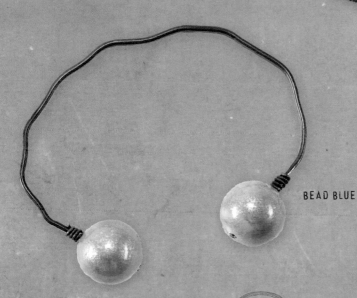

 EYE SPY

BEAD BLUE

91

CREATING ART IN THE DIGITAL AGE

Peggi Meyer Graminski

ROOTS

I was blessed to have parents who instilled a great love of the arts in me and my four siblings. Our home was always filled with music and singing, and weekends meant trips to the St. Louis Art Museum or finger painting on the porch on rainy afternoons. Our family spent hours at a time out with nature—we visited many of the city's glorious parks or simply watched the birds from our kitchen window. In springtime and in summer, our backyard was filled with a myriad of flowers, plants and trees—brilliant yellow for-sythia, purple and pink lilacs, golden daffodils, and roses of varying shades of red. There was always something growing, something new to see and draw or even press into the pages of heavy old books. In the fall, our yard was a paradise of red and golden leaves my brothers and I would play in for hours. The winter brought a delicate, snowy wonderland to life, right outside our window, where we built snow forts, had friendly snowball fights and made snow angels. And, of course, there was my dad, always on the sidelines with his camera, taking pictures of us. Every year we grew a bit bigger and became slightly less innocent in our ways; yet to this day we have those photographs to hold and look at—those reminders that let us call back the memories of an awakening of our senses, and our love and respect for the beauty of nature. I suppose that what I am getting at here is that what has inspired me the most in my artistic endeavors is my family, the people I have known and loved in my life, the simple beauty of nature, glimpses into my past and attempts to keep a bit of my past alive.

I began working in collage in 1995. At the time, I was living in southeastern Arizona (where we had moved when I was ten) with my husband and two small children. My parents lived in the same small town, nearby, and my mom was taking art courses at the local college. After spending many hours with her discussing art, the Great Masters and browsing through her art books, I became greatly drawn to collage. I admired the collage and assemblage work of Joseph Cornell and the mixed-media work of Nita Leland, Claudine Hellmuth and Katherine Chang Liu, to mention only a few. Their works inspired me to give collage and mixed media a try.

My dad was instrumental in broadening my interest, as he kindly purchased a VHS tape of Gerald Brommer's collage techniques for me. In the video, Mr. Brommer created amazing abstract collages with 300-lb. (640gsm) watercolor paper and watercolors. He

KEEPSAKE

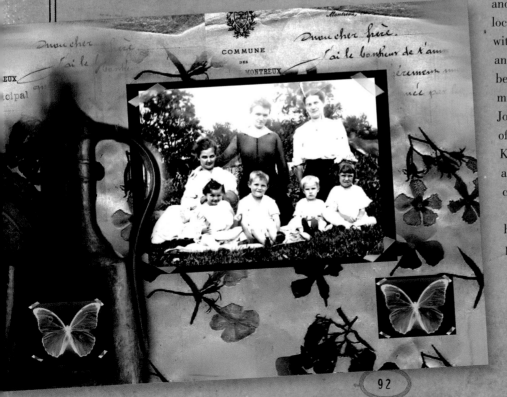

brought textures to life and blended his watercolors to create rich and fantastic hues. I was mesmerized by his work and honestly became "hooked" on collage; I felt a whole new world had opened its doors to me.

A BUDDING DIGITAL ARTIST

A few years later, my husband, John, and I were having an evening discussion about my art, and where I felt I was going as an artist: frankly, I felt I was at a bit of a standstill. My mom had recently passed away, losing a long and painful battle with lung cancer, and I was going through a major period of depression—my family and my artwork really "kept me going" during that time. My dad and I spent many hours together at monoprint classes (great fun!) and doing a lot of photography—of the Arizona desert, historic towns such as Bisbee and Tombstone, old ghost towns and ruins and the mountain canyons. My dad was a fantastic photographer; his nature photos were especially beautiful—close-ups of flowers and insects, deserts and streams, even photos he took in our own backyard; he truly inspired me to "pick up my camera" and get moving.

As a photographer I began seeking out different textures and color combinations—compositions created by Mother Nature's hand grabbed my soul, and I tried to capture those sights with my photography. I was simply there as an observer, capturing each brief moment as it occurred.

It was about this time that my husband told me about Corel Paint Shop Pro Version 10™. He thought I might be able to utilize it in my photography and my scanned collages to add more interest and detail. This sounded quite fun, and I decided to give it a try. Truly this was my biggest turning point as an artist and photographer. I began taking my digital camera out with me everywhere and took photos of just about anything—an old piece of wood with a nail in it, a leaf simply lying at my feet on the ground, people visiting a car show or carnival. The photos themselves really didn't matter—they didn't have to be anything special or great. When I returned home I loaded them onto my computer into Paint Shop Pro—I extracted various textures from photos,

cropped different areas of each image, etc., and combined these elements until I came up with an interesting, artistic result. I kept in mind composition and color contrast, and I overlapped and layered images with digital ephemera like vintage images and old letters. (Please note: Paint Shop Pro is the only program like this I have ever used; there are similar products on the market, and one of these may work best for you. Shop around and see which you like best.)

This is where I am at today, and it has been a journey— a therapy, a recreation—and a way to connect the past to the present. My dad passed away in the spring of 2006; when I am out with my camera, taking pictures of nature or of my family, I have recollections of those early days in St. Louis, where each spring, summer, fall and winter my dad was always there with that old camera, taking the pictures my children study and ask questions about to this day.

Art is always around us and touches us in many different ways. I believe the role of the artist is to interpret "how" we can be touched by nature, or our past, or those we love—both for our viewers and for those who will come after us. It's a way for our hearts to be known to others and a way to reveal our innermost secret hopes and desires to ourselves.

WINTERLAND

To create the piece *Winterland*, I began with a photo of a snowy forest I had taken with my digital camera. After loading the image onto my computer, into Corel Paint Shop Pro, I gave the image more interest by using the "Seamless Tiling" image effect. This gave the photo more depth and added dimension. I then worked with some various texture effects to give

WINTERLAND

the new image a "collaged" look—like it was tissue paper glued onto paper. For my final adjustments, I worked with the color balance and brightness, striving for a cool, blue "winter-type" feeling. I thought the image turned out well, and I especially liked how the texture effects brought a whole new depth to the piece.

STORMCHASER

For this piece, I actually combined two photos: one a rather boring photo of an old road near my home, and the other, the original image used on page 93 in *Winterland* (if you look closely, you can see where the tree branches are quite the same!). Being inspired by the textures I had achieved while working on *Winterland*, I went ahead and again worked with a variety of textures (using the texture effects) until I came up with something pleasing to my eye. Color adjustments, light/dark adjustments and merging of layers also played a role in finalizing this piece.

FACES FROM THE PAST

This digital collage combined several different images: an old family photo, a couple of "picture tubes" (the butterfly and the log) available on Paint Shop Pro and an altered image I had created from a photograph of a window. I added a bit of pattern (asphalt), available from the program's "Material Properties." The final image turned out nicely, but I thought the "Picture Frame Image" tool (corners taped) gave the final product more of a scrapbook-type appeal. Finally, I merged all the different layers and ended up with a visually appealing, vintage-style, digital collage.

KEEPSAKE

Keepsake (page 92) is actually a variety of different images combined: negative images of butterflies, an old family photo, a scanned image of handwriting (a vintage family piece), a photo I took at my dad's house of a large, old plate and decanter, and pressed flowers from an old family album. I arranged the images to create my design, made color adjustments, cropped the images where needed and used the "Push Brush" tool to add more softness to some of the edges. I merged all layers and gave the image a simple border.

STORMCHASER

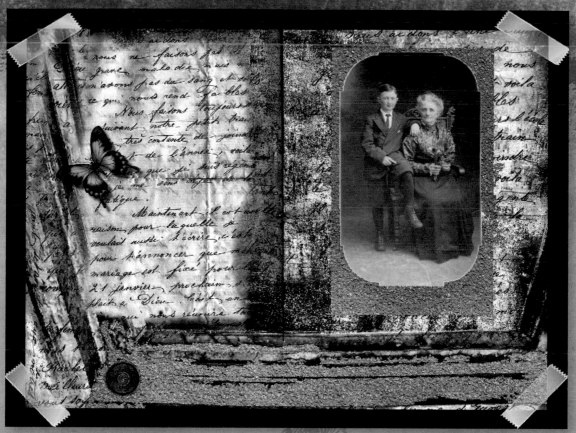

FACES FROM THE PAST

ARTIST'S TIP

Corel has wonderful tutorial books that accompany their versions of Paint Shop Pro. From my own experience, I've found these books to be very helpful.

VOICE: A GUEST SPEAKER FORUM

Welcome to our exhibit's "Guest Speaker Forum," where we have the privilege of "sitting down" with some of the mixed-media art world's best-known personalities. This forum is about voice—artistic voice. Mixed-media artist extraordinaire Claudine Hellmuth reveals how she developed her own artistic voice and answers real, raw questions about her creative life. Collage artist Jonathan Talbot encourages us to follow our mistakes, allowing them to lead us in new directions. This article can change your entire approach to art-making—it changed my life!

If you are struggling with finding your own artistic voice, you've come to the right place. Artist and author Suzanne Simanaitis provides tried-and-true ways for uncovering the unique artist within—and she doesn't mess around (is she related to Dr. Phil?). And once you do find your voice, there is always the inevitable visitation from that unsightly, unwelcome guest we like to call the "creative block." We've all had the experience—so, what to do when that happens? Sheri Gaynor, mixed-media artist, writer and life coach brings an interesting, fresh approach to the table—one sure to crack even the toughest of blocks.

Ted Orland, well-known author of *The View from the Studio Door: How Artists Find Their Way in an Uncertain World*, enlightens us with countless insights on how to "create your own path and go it alone" as you put your artistic voice out there. And I leave you with a quote of his that will stay with me for life: "If you lead an interesting life, you're on track to make interesting art."

Claudine Hellmuth:
THE ORDINARY, EXTRAORDINARY WOMAN BEHIND THE ART

Tell us a bit about how you developed your own unique artistic style. Further, do you feel your style has changed/grown over time? If so, do you expect it will shift in the future?

My work made a drastic change from 2002 to 2003; before 2002 I was creating collages in a romantic, nostalgic style that I had been working in for close to six years.

What signaled the change in my work was a desire to try something new. I had become very familiar with my artistic patterns and working in the way that I had been for some time. Instead of being exciting, it was more like I was simply going through the motions with my artwork, repeating ideas and compositions I had done in the past. I had just finished writing my first book, *Collage Discovery Workshop*, about my techniques, and I felt burned out. I felt like my work needed a change; it took me almost a full year to arrive at my new look—lots of experimentation.

I made a lot of lists full of notes about the types of artwork I enjoyed looking at. I tried to get very specific and narrowed it down to just the elements, like line quality or whimsical color or symbolism, etc.

My list of things that I liked consisted of texture, line, whimsical themes, bright colors and drawing. Most of all I wanted to bring more drawing back into my work and create with collage by using more of my own images. At first I felt I needed to draw realistically, almost as if to prove that I could. Yet when I looked at artists who drew in a stylized and whimsical manner, I enjoyed their artworks more than if they had drawn "realistically." Why then did I feel the need to prove something with my drawing ability when I liked whimsical drawing by other artists? I decided it was my ego getting in the way and I would explore whimsical drawing and bring that into my collage along with the other items from my listing and research.

BAKING CUPCAKES

It was a period of much growth and change. Along with drawing, color and texture, I also wanted to bring more fun and happiness into my work. Life is too short not to have some fun!

I see myself working in this vein for as long as I need to. I'll keep at it until I feel I have explored all the aspects of it. Then I'll know it's time for a change. As an artist, I feel I have to keep moving forward and try new things, discovering and expressing what's most important to me at the time.

From where do you draw your inspiration when making art, and what do you do to motivate yourself in the studio if you get frustrated and/or hit a creative block?

Usually, if I am feeling blocked, that means it is time to step away from the studio and get out of my head by going to a movie, reading a book, etc. I take a day off. If that doesn't work, I try doing menial tasks in the studio, like organizing supplies, cutting papers, etc.—things I can do to feel productive until the work starts flowing again.

How often do you make art? Typically, how long does it take you to complete a piece?

I make art just about every day—Monday through Saturday. I am usually in the studio for about seven hours, with the last hours of my day usually devoted to paperwork, e-mail, blogging, etc. Every art piece takes its own amount of time; some of them go really fast, and I complete them in one day (about seven hours),

while others take longer because it might be more difficult to get them to cooperate!

What artistic goals have you set for yourself?

I have all kinds of goals and make new ones every day! I love coming up with new things to shoot for. I hope to expand further into illustration and also license more of my artwork in the gift industry. I would love to animate my artwork, something with a whole story! Also, I have always wanted to illustrate children's books, so that is a goal I hope is in my future.

GARDEN GIRL

Besides art, what are your other interests? What do you do to relax? What do you like to do for fun?

Relax? What's that!? I have to admit I am a bit of a workaholic, so if it's not work related, I have a hard time doing it. I do love to read and go to movies, but I don't have any hobbies or anything that takes much time outside of my artwork.

Tell us something most people do not know about you.

Most people don't know I like to read the Uline shipping-supplies catalog at night in bed before I go to sleep. I love looking at all the boxes and packages of bubble wrap!

Describe what a typical day looks like for you.

6:00 am: Get up walk our dog, Toby, eat breakfast
6:30 am: Go back to bed
10:30 am: Get up and get going!
11:00 am: Do yoga
12:00: Eat lunch, check e-mail, go to the studio and start working
3:30 pm: Walk Toby again
4:00pm: More work in studio
7:00 pm: Eat dinner, check e-mail, update blog
8:30–10:00 pm: Work in studio some more
10:00 pm–midnight: Check e-mail, try to catch up on business stuff
Midnight: Walk Toby again
1:00–2:00 am: Watch TV, get to sleep!

That is sort of a typical day. But my "typical day" can vary greatly with more time being spent on business stuff like e-mail, packing, shipping and paperwork and less time in the studio. I really end up doing whatever needs to be done at the time, so each day is wildly different from the next, and that's what I love!

KNITTING PRETTY

Do you have a favorite color?
A favorite artistic technique?
A favorite art supply?

Favorite art supply: Gel medium
Favorite color: Teal
Favorite techqniue: Hmmm . . .
can't think of one.

Have you ever had negative responses to
your art (although I can't imagine that),
and, if so, how did you handle that?

Yes, I have. There are a few people who don't
get it, or it's just not for them. I know not
everyone can like it, and that's OK. The
people who do like my work find me through
my Web site and blog, and so it seems to work
out good that way! My mom actually really
didn't like my new work when I first started
creating it. She liked the older work I was
creating, and it was hard for her to adjust to
my new work. Now she likes it a lot, but at
first she didn't know what to think about it!

What kind of music would we hear playing
in your studio while you are working?

I listen to NPR, so a mix of classical and news
and talk.
I love *This American Life*. I cannot get enough
of that show.

What are you afraid of?

Oh, all sorts of things! I am afraid I won't be able
to sustain myself as a full-time artist and will have
to go back to a day job (shudder!). But my biggest
fear is that I wouldn't be able to make art anymore.
That is my worst nightmare.

Suzanne Simanaitis:
NOTES ON BORROWING FROM THE MASTERS AND DEFINING YOUR OWN STYLE

"ORIGINALITY IS THE ART OF CONCEALING YOUR SOURCES."
—BEN FRANKLIN

As an art-zine publisher, it's my joy and my job to encourage readers to share their artwork for publication. It warms my heart to hear so many say, "This is the first time I've ever submitted a piece for consideration." What a wonderful thing! How brave! It's a thrill to know that my little magazine has inspired numerous someones to make the leap and put their artwork out there for the world to see.

The only small disappointment that occasionally pricks at my conscience is that so many first-time contributions exhibit what I call crown-itis. I certainly help perpetuate this trend by including numerous wonderful crown-anointed, wing-festooned collages in *ARTitude Zine*. But I'm here today to suggest, to cajole, to insist that if you have been working in the Pointy Hat collage tradition for a while already, *put down the glue stick and back away from the table slowly.* New possibilities lay within you. I propose that your personal creative vision really has very little to do with crowns and wings and party hats. Really! These icons may transmit a convenient beginners' shorthand, but they should represent a phase of your journey, not a culmination.

Back when painting pretty much summed up "art," the education of an artist followed a particular pattern: learn to render dimensional forms, to mix colors and to place each brushstroke in a manner that achieves the desired effect. Even today, people obtain permission to set up easels in museums around the world, from the Louvre on down, where they painstakingly copy fine art stroke by stroke, hoping not only to reproduce the appearance, but to glean the secrets behind the masterpiece. Another traditional aspect of artist training was the dissection of cadavers to reveal and record the anatomical structures that give shape to our outer forms. OK, I'm not exactly sad that *this* isn't standard practice anymore.

In our anything-goes mixed-media world, things aren't as structured, but many of us still tend to follow a beaten path, and it's very easy to stall in a comfortable shady spot along the way. If you are like me, your art journey began when you picked up a rubber stamp and realized you didn't have to learn to draw! You could count on these perfectly rendered images again and again, and your role was to juxtapose them, color them and build stories or patterns with them. One day you gave some thought to color values, proportions and composition, layered pretty papers among your insta-stamped imagery and *voila,* another budding collage artist was born. Eventually you subscribed to a magazine or three, felt a thrilling sense of community and took shelter in a design aesthetic that "fits" one publication or another. It was almost like pledging to a sorority, aligning yourself with the house of nostalgia, the girls who party all the time or the sisterhood of the striped stockings. What you must eventually face is that part of being an artist, and really deserving that title, is having your own style, a spark of something special.

When you see artwork that makes your heart skip a beat, you may wish to emulate it, to live in that creative space for a while. Go ahead! That's how you gather the components of your style. Bathe everything in walnut ink. Draw crosshairs on your focal points until that red grease pencil is just a stub. Liberate arrows from a trousseau's worth of sewing-pattern tissue. Try anything and everything that looks interesting. Just keep in mind that the time-honored practice of copying the Masters was meant to be one step in an apprentice's development, not the final result. You must find motifs and techniques that make your heart leap out and then *exercise that joyful muscle.* As Robert Henri put it, "Know what the old masters did.

Know how they composed their pictures, but do not fall into the conventions they established. These conventions were right for them, and they are wonderful. They made their language. You make yours."

As your style develops, try to balance borrowed and imitated elements with fresh and direct observations of your own. Immerse yourself in the swirling currents of visual input our modern world provides. And for heaven's sake, *please* don't saddle yourself with the pressure of "finding your style." Just crank out as many experimental riffs as possible. Your style will emerge as you become a student of your own processes.

French artist Eugène Delacroix confided in his 1824 diary, "What moves men of genius, or rather, what inspires their work, is not new ideas, but their obsession with the idea that what has already been said is still not enough." Push a favorite idea to extremes. Exaggerate shapes or repeat a familiar element to the point of absurdity. Try a borrowed technique in a dramatically different color scheme or on a different scale than your inspiration artist used. Probe the edges of everything you pilfer to find your own slant on it.

Your childhood piano teacher told you practice makes perfect, but, for visual artists, sustained practice over time is actually a messy breeding ground for a certain magical *lack* of perfection. *Practice* is a psychological space where you do things over and over again, inviting variations to come into play—allowing for the performance of clunkers as well as pleasant melodies.

Fall in love with your failures along with your successes. Some pieces will be atrocious, it's guaranteed. Be curious about each "failure" and how you might change it up. Lately I've been observing two kittens learning about their place in the world. One weekend they mastered the flying leap from the sofa to the bookcase; then their little bodies experienced growth spurts, and suddenly their calculations were off, and gangly feline limbs went tumbling in all sorts of comical directions. But kittens never get up from one of these spills with an attitude of, "Wow, what a *disaster*—that's the last time I attempt *that* leap!" No, they shake it off, scope out the situation and make the same jump over and over again with different trajectories until they either master it or I convince them it's in their best interests to cease and desist. (Guess who's winning that one?)

Take a tip from the kittens and keep leaping. As you accumulate a body of work, you'll note characteristics that define *your style*. Some aspects may make you intensely nervous—these, if you explore them further, often turn out to be your *next* style! As one artist put it, "My new style fascinated me, then interested me, then bored me." You'll become intimately acquainted with the intricacies and possibilities of your ever-changing style as you construct three, thirty, three hundred collages or paintings or pop songs.

Three hundred collages?! That's a good start. Thomas Edison observed, "Genius is one percent inspiration and ninety-nine percent perspiration." Whether you're developing brilliant inventions that will revolutionize life as we know it, or just a personal visual vocabulary for one, it's going to involve considerable elbow grease. That's not to say that making art is a struggle. Developing your artistic style is an evolution, a process that takes time and many iterations. Patience, Grasshopper.

Your style may be as unique as your signature and as individual as your thumbprint. Or perhaps your style honestly, legitimately just happens to closely resemble a popular style of the day. You know what? Go for it, as long as you are being authentic. If crowns and wings are what you consider meaningful and beautiful, there's nothing wrong with using them. The important thing is to imbue your artwork with a sense of who *you* are and where you stand in your creative journey, and don't worry about what anybody else says is the cool product, technique or motif to use this month. Remember: Fashion is dictated by outside influences—true style comes from within. Believe in yourself and the design elements that ring truest for you. Enthusiastically pursue your strangeness. Even if it does wear a party hat.

Jonathan Talbot:
PLAYING THROUGH ONE'S MISTAKES

ARTISTS CREATING NEW COMPOSITIONS ARE LIKE MUSICIANS PLAYING JAZZ OR BLUEGRASS. WE IMPROVISE . . .

– JONATHAN TALBOT

If Larry Rivers hadn't given up playing the saxophone to become one of the leading painters of the New York School, I might never have become an artist. It was his example and my impatience with the internal politics of the music business which inspired me to abandon my musical career for the more solitary visual arts studio.

It wasn't an easy decision . . . I had performed at Carnegie Hall and Fillmore East and recorded albums for ESP-DISK and Columbia Records. I hungered for the applause as much as many other performers. But I was approaching thirty (which seemed "old" to me then), and my hard-won successes had been accompanied by even more failures. Failures to get paid when the gigs were over, failures to collect the royalties owed to me from the all-powerful record companies I allowed to rule my life, and, from time to time, some failed performances as well. I was ready for a change. I liked the idea that there were far more galleries than record companies, and I believed I would find more independence in the world of visual arts. I also noted with interest that the art world was filled with artists who were relatively poor self-marketers. I thought the promotional skills I had learned in the music industry would give me an edge.

My experiences as a visual artist have exceeded my expectations. Many of the lessons I learned as a musician have turned out to be more useful to me than I ever imagined. Among the most valuable are those lessons that concern mistakes.

Beginning musicians quickly learn that when one is practicing a new piece, one will inevitably make mistakes, and if one makes a habit of stopping to correct those mistakes, one will never learn to play the whole piece. Instead, musicians learn to ignore their errors and forge ahead. When the music is difficult, many mistakes will be made, but each time the piece is played there will be fewer errors, and eventually one will get all the notes right and be able to consider phrasing, emotional content and the other more creative possibilities music has to offer.

Every performer instinctively knows that if a mistake is made during a live performance there will be no way to correct it. What is done in front of an audience is done. All one can hope is that the next time one will do it better.

Performers also learn that the show must go on. One cannot stop just because one makes a mistake. Of course, technically, especially now in the computer age, this is not true in the recording studio. One can play songs over and over again, or in segments, making numerous mistakes, and then splice together the good parts from different "takes" in order to achieve a successful recording. But onstage, a mistake is still a mistake. It's out there in the universe for all to see.

How do musicians cope with onstage mistakes? If they are classical musicians playing written music, they recover as fast as they can and hope the audience will prove forgiving. If they are musicians playing improvised or less formal music like jazz or bluegrass, they may, with skill, allow the mistakes to lead them in new directions.

As a performing musician I applied these lessons instinctively. But because I was not, during my musical years, consciously aware of these lessons, it took me time to learn their relevance to painting. Often, at the beginning of my art career, an area of an etching or a painting would become problematic, and in my efforts to "fix" it I would ruin the whole piece. Time and again my works ended up in the trash bin.

My experience in the music business had left me with a more-than-ample supply of cynicism, a quality which I now guardedly believe to be of little use. It was that cynicism that informed me and pointed me in the right direction. As I began my life as an artist, I noticed that the public buys just as much bad art as good art. With this in mind, I accepted my errors, doing the best I could with each piece and moving on to the next. I hoped each work would be better than the one that preceded it, but, of course, that didn't always happen. Each of us, just like Georgia O'Keeffe, Pablo Picasso, Hannah Höch, Kurt Schwitters and all our other artistic ancestors, has good days and bad days. The works we produce vary accordingly. While practice generally made my works get better, I found that some of the works satisfied me more than others. But often, at exhibition time, the works I liked the least received the most praise from both the critics and the public. As a result, I learned not to allow my personal likes and dislikes to determine the relative merit of my works.

Practicality also helped me avoid getting trapped by my mistakes. I was committed to earning a living as an artist. My job was to complete works and sell them. I could not afford to get hung up on errors.

But it was watching my friends create that was the most informative. Over and over again I saw my fellow artists get stuck because of some perceived mistake, and, as a result of their efforts to get unstuck, I saw them end up with overworked or ruined pieces.

It's not that my colleagues' experiences were all that different from my own. I had plenty of frustrating experiences as well. But watching the struggles of others prompted me to reflect on the nature of my own creative processes. It was then that I recalled the musical lesson about playing through one's mistakes and ignoring one's errors in order to learn how to eliminate them.

Imagine you are working on a collage and you glue down an element. Feeling unsure about your decision, you pause to consider what you have done. You decide that you have put the element in the wrong place or that it doesn't belong in your piece at all. What can you do?

Often one's instinct is to paint over the element, paste something else over it or try to remove it. I would suggest that exercising any of these options will result in a missed opportunity.

Consider the following questions:

1. Are we the best ones to judge whether an element is in the right place or the wrong place? Is it useful for us to judge our works before they are finished?

2. Is there really a right place or a wrong place? Some years ago Gerald Brommer, an accomplished artist, teacher and author, wisely reminded me that in the math classroom each problem has one right answer and an infinite number of wrong ones, but in the art classroom each problem has an infinite number of right answers and no wrong ones.

3. Is it our task to control where the artwork is going and what it is going to look like? To what extent must we direct the process, and to what extent might we allow ourselves to be guided by the artwork?

4. Can we honestly say that any creative modality is the best? Some artists paint highly accurate pictures of whatever is in front of them. Some artists depict what goes on in their imaginations. Some artists say they do not control their creative process at all and that they simply put the energies that flow through them onto the surface of the paper or canvas. Still other artists allow the materials they are using to inspire them.

Instead of painting over the supposedly misplaced element, pasting something else over it or trying to remove it, consider looking at the piece and accepting that while the composition (a word used by both artists and musicians) may not be what you originally intended it to be, its new form may be just as valid as your original intent. Then remind yourself that this is a new composition and that you are not following a written set of instructions. Ask what the new form tells you that you did not know before.

When you go out for a drive, which kind of journey do you find most exciting: the one where you end up exactly where you intended to go or the one where you take a wrong turn and accidentally discover something new?

If you are one of those who enjoy discovering new things when you think you have made a mistake, consider letting go of your urge to control the process. Instead, try allowing the artwork itself to tell you what it has become, where it wants to go, and how you can help it get there. Consider allowing your artistic mistakes to become the beginnings of new adventures . . . new roads that will either return to the main theme or lead to new resolutions.

In the language of jazz this would be described as allowing an unintended note to become the beginning of a new "riff." In country music and bluegrass the word used for such an unplanned melodic excursion is a "lick." But the language we choose doesn't matter. What is important is that we allow ourselves the freedom to make mistakes, that we play through our mistakes and that, whenever possible, we follow their lead. If we do this, our works will unfold in gloriously unexpected directions, and we will continually find new opportunities for creative celebration.

-JONATHAN TALBOT, WARWICK, NY, MAY 23, 2008©

THESE PICTURES SHOW THE EVOLUTION OF ONE OF THE WORKS IN JONATHAN TALBOT'S *Patrin* SERIES.

-1- TALBOT STARTS OUT WITH THE INTENTION OF CREATING A NEW COLLAGE SIMILAR TO AN EARLIER WORK, *PATRIN 020333* (SHOWN ABOVE), WHICH HE DESCRIBES AS "AN HOMAGE TO THE RUSSIAN CONSTRUCTIVISTS WITH A TOUCH OF GLASNOST."

-2- TALBOT STARTS THE NEW WORK. CONFIDENT THAT MINOR CHANGES WILL LEAD HIM IN NEW DIRECTIONS, TALBOT REPLACES THE RUSSIAN TEXT WITH LARGER-SCALE TEXT FROM A 1776 ENGLISH EDITION OF SIR ISAAC NEWTON'S *PHILOSOPHIAE NATURALIS PRINCIPIA MATHEMATICA* AND APPLIES MORE BLACK PAINT THAN WAS HIS ORIGINAL INTENTION.

-3- FOCUSING ON HIS ORIGINAL PLAN, TALBOT ADDS THREE BLACK SQUARE ELEMENTS, ONE WITH ORANGE HIGHLIGHTS.

-4- OBSERVING THAT THE WORDS *COMET* AND PART OF THE WORD *ELLIPTIC* ARE PROMINENT IN THE TEXT AND THAT THE RIGHT-HAND SIDE OF THE WORK IS DARK AND UNINTERESTING, TALBOT ADDS A STYLIZED COMET, ITS SLIGHTLY ELLIPTICAL TAIL MADE BY SMEARING PAINT WITH THE SIDE OF HIS THUMB. HE ALSO EDITS THE BACKGROUND TO EMPHASIZE THE SQUARES AND ADDS SOME SPLATTERED PAINT AND THE WORD LIGHT. THE RESULT IS *COMETARY PATRIN*, PICTURED HERE.

Sheri Gaynor:
CONQUERING CREATIVE PARALYSIS

Signing a book contract can be just the thing to invoke creative paralysis—I know, for that is exactly what happened to me! One month after signing on the dotted line and manifesting my heart's deepest desire, I was locked up harder than a . . . who-knows-what. I have to tell you, it was terrifying! Thank Goddess this isn't the first time I've been down this road, so I decided not to panic. Instead, I pulled out my surfboard and surfer shorts and rode the tsunami until the seas were calm again.

What is it about starting a new canvas, page or fabric piece that can be so unnerving for me? Staring into the blank abyss has been known to elicit feelings of inadequacy, incompetence and panic. The "white void," as I call it, has the power to wake the dancing gremlins, tickle their toes and send them into a wild frenzy!

When looking into that void, we are standing at a creative crossroads and wondering which direction to go. For some people, this is the place where the creative edge lives; for others, it can become a time when we decide to clean house—literally. I am just guessing that some of you might know what I mean here. The truth is, no matter how comfortable we are with the great white void, there will probably be a time when we too will choose to scrub the toilet or polish the silver set our grandmother gave us (that has been sitting in a drawer unused for ten years) instead of facing that blank canvas. With that said, let's look at some fun, interactive ways to move past the dreaded color white, so you can set your compass and find your true creative north.

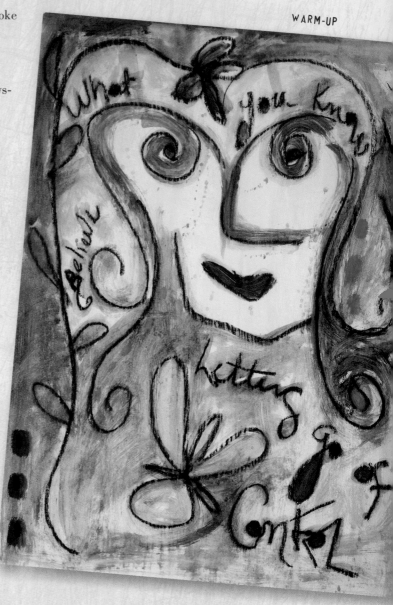

WARM-UP

108

WARMING UP

I confess I am a simmerer. "What the heck is that?" you might ask. A simmerer is someone whose creativity bubbles up inside them until the creative pot boils over. This simmering process can run anywhere from a couple days to a couple weeks, and the time frame is often dependent on a looming deadline. This is my creative style, and I used to get down on myself for it until I realized that simmering and a little warm-up exercise go a long way in loosening my creative juices.

Athletes warm up and stretch their bodies before any event so they can be flexible and mentally prepared for the challenge ahead. Well, guess what? Warming up our creative muscles is just as important! Getting the juices flowing and allowing for unreserved expression, by making a big unbridled mess, can help us tackle our fear of the great white void and support us in diving into the unknown. Accidents are a huge part of this process. Most artistic types are all too ready to pull out the magic wand (a.k.a., the eraser) and say, "Oh, it's not perfect. That line isn't straight." So, out comes the eraser, faster than you can say "disappearing ink," and the perceived imperfection is gone. Have you ever noticed the chatter that is just underneath that one task? What might happen if we left the crooked line alone and saw the mistake as an opportunity or a new door that might have opened to something really unique? Do you think Benjamin Franklin or Albert Einstein figured things out perfectly the first time, or do you think they made a heck of a lot of happy accidents that led them to their breakthroughs and discoveries? Why should it be any different for us?

Back to the book; I invited eleven other talented artists to participate in my project. WOW! It has been quite humbling, to say the least. I've known several of these phenomenal artists since my rubber-stamp business days—way back when—but others were gracious enough to say yes to a perfect stranger. So here we see the root of the block and it goes deep into the soil like a bad weed we can't get rid of but won't use chemicals to eradicate; it is the weed of COMPARISON—comparing our art to others' art! All sorts of voices could be heard in my head, shouting their ill

advisement at "Critics Corporate Headquarters." Working with others in this way set me back a few years to some old familiar ways. As a coach and therapist, I work all day helping people with just this issue, so it was time for me to "walk my talk" and do battle with the lies my internal critics were telling me. And so I chose to cross the great divide as a warrioress sets out on the heroine's journey. I knew how to do battle with these demons, and so, like the goddess Kali, I pulled out my trusty creative sword and gathered my tools: a large roll of newsprint paper, paints and oil pastels.

I began using this little trick the day I decided I didn't have to be a photographer to express my vision—that in spite of what I had been told, I could in fact learn to paint. The first few paintings were kind of frightening, to be sure, but I had a few rules I created around this: 1) Just keep painting even if it looks like mud. 2) Date it, title it. 3) Put it in the closet, and don't show anyone! I kept at this process for almost nine months, a gestation period of sorts, and when I came out the other side, I was actually amazed by the results. The images were very mythical and archetypal. I did not take a class—which I knew would have locked me up even more by impressing the importance of color theory and design—I just painted my heart out! I now teach this approach to people who want to begin to find their own artistic voice without using other people's images. Don't get me wrong, I have nothing against using other people's images, stamps or angel clip art; in fact I do this all the time in my journal work, but I also believe inside of us we have a story that is uniquely our own and waiting to be told.

I am happy to report that once I "let it rip" on the newsprint, the creative pot finally boiled over and has not stopped! This, combined with a loving coaching session with my book editor and duct-taping the critics' mouths! To be sure, I know they are in there trying desperately to get the duct tape off, but I know I have the key to unlock my heart, and so I keep my creative sword at the ready. I am never without a few nasty cheap brushes, acrylic paints and a roll of newsprint. There is nothing like a warm-up to find your way back to center and your creative heart and soul.

Warming Up, Creatively

Materials

TARP OR PIECE OF DRYWALL TO
TAPE YOUR PAPER TO

ROLL OF NEWSPRINT OR
A NEWSPRINT PAD NO SMALLER
THAN 16″ X 20″ (41CM X 51CM)

INSPIRING MUSIC AND A CANDLE

INEXPENSIVE BRUSHES

ACRYLIC CRAFT PAINTS
(INEXPENSIVE)

WATER

WATER-SOLUBLE OIL PASTELS
(PORTFOLIO SERIES IS A
GREAT CHOICE)

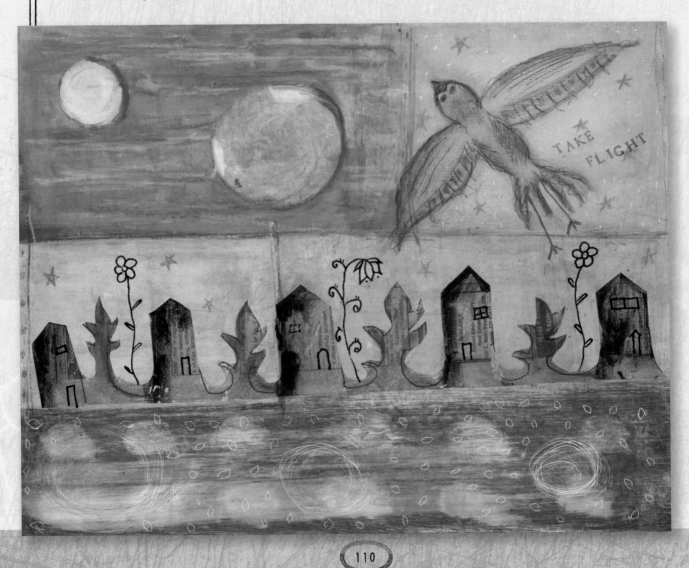

METHOD

-1- LAY OUT OR HANG YOUR TARP. I WORKED ON MY KNEES FOR A LONG TIME IN OUR SPARE BEDROOM BEFORE I HAD MY OWN STUDIO. SOMETHING ABOUT IT WAS ACTUALLY VERY GROUNDING.

-2- TAPE THE FOUR CORNERS OF YOUR PAPER TO THE TARP OR YOUR DRYWALL.

-3- HAVE ALL BRUSHES, A LARGE CONTAINER OF WATER AND SEVERAL DIFFERENT TUBES OF ACRYLIC AND OIL PASTELS PLACED ON THE TARP.

-4- TURN ON YOUR MOST ENERGIZING AND INSPIRING MUSIC AND LIGHT A CANDLE. CLOSE YOUR EYES, TAKE A FEW DEEP BREATHS AND REPEAT THIS AFFIRMATION: "EVERYTHING I NEED IS ALREADY INSIDE ME. I AM AN ENDLESS CREATIVE WELL."

-5- OPEN YOUR EYES AND CHOOSE THE FIRST COLOR THAT CALLS TO YOU. DIVE IN, MAKE SOME MUD, START PAINTING. ADD SOME OIL PASTELS. SCRIBBLE, MAKE LINES, MARKS. DO YOU SEE SHAPES? IF SO, BRING THEM FORWARD, EVEN IF THEY MAKE NO SENSE.

-6- IF THE PAPER TEARS . . . SO BE IT. IF THE COLORS TURN TO MUD . . . IT'S PART OF THE PROCESS. WHEN THE CRITICS AND GREMLINS ARE DOING THEIR DANCE, GET OUT THE DUCT TAPE AND REPEAT YOUR AFFIRMATION, "I AM AN ENDLESS CREATIVE WELL."

-7- THIS IS NOT ABOUT CREATING A WORK OF ART: THIS WORK IS ONLY FOR YOU. DON'T SHOW IT TO ANYONE—THEY LIKELY WON'T "GET IT," AND YOU'RE OPENING YOURSELF UP TO A SABOTAGING MOMENT. THIS IS ABOUT WARMING UP THOSE CREATIVE MUSCLES SO YOU CAN FIND YOUR TRUE NORTH AND OPEN THE GATE TO CREATIVE FREEDOM.

TAKE FLIGHT

After completing my own warm-up, I decided to dive right in and just go for it. I made five sections on the Clayboard, using a ruler and light pastel pencil line. For the background, I coated the substrate with different washes of acrylics (Cerulean Blue, Yellow Ochre and Titan Buff).

To make the two moons, I created circular stencils out of paper. I then spread a wash of Cerulean Blue over the tops of the moons.

In a paperdoll-like design, I created a line of houses and vines from newsprint. Then I stained the paper with Sumi ink and a light wash of rust glaze. I outlined the elements with oil pastels and allowed it to dry.

I continued adding layers of washes and paints until I was happy with the effect, allowing all layers to dry thoroughly between color applications. I love to sand with fine sandpaper between layers to add texture and design.

Using gel medium, I adhered the houses-and-vines row to the board and then painted Titan Buff and Yellow Ochre circles on the bottom section of the substrate.

Once everything was dry, I used sandpaper to scratch over the two moons and the circles on the bottom section. I used a black gel glaze pen to draw in the flowers.

Finally, using graphite and pastel pencils, I drew a bird. Yes . . . I did say drew. Are you quivering? Here is the exciting news: It can wash off or erase easily, so I wasn't afraid to take the risk. You could do it too. Imagine you are five again, when you knew exactly what a bird looked like. Stretch your wings and fly. You can do it! I then colored in the different aspects of the bird using paint. When everything was dry, I added my phrase using alphabet rubber stamps and distressing ink.

Ted Orland:
THE VIEW FROM MY STUDIO DOOR

This is not an easy time to be an artist. The moment artists venture beyond their studio door, they quickly discover—usually the hard way—that pursuing a life in the arts is not like studying to be a chemist or a truck driver or a computer programmer. Among other things, those people have a place waiting for them in the workforce. Becoming an artist, however, means creating your own path and in all likelihood going it alone. It means relying almost entirely on yourself in a world that's more or less indifferent to all that you do. One reason artists have their own studios is simply that no one else is likely to build one for them. So while art may get recognized as a noble profession, it rarely gets mistaken for a useful occupation. "HELP WANTED— FINE ARTIST" is not a large column in the classifieds.

What all this suggests is that to make your own place in the world you'll probably need to create a life in which working on your art becomes a natural part of your everyday life. And that is, in fact, the way most artists work. Most artists are regular people who work all the time and lead real lives all the time as well. Annie Dillard nailed it when she wrote, "How we spend our days is, of course, how we spend our lives." Artists are not exempt from that truism. Fix breakfast, cut the grass, do the laundry, write a poem: *That* is the real life of an artist.

Personally, I'm content to let someone else pencil in "Change Basic Structure of Society" at the top of their own to-do list. I'm more concerned with the practical, day-to-day issues that arise every time I walk into my studio and try to get at the work I need to do. In my experience, the essential first step to building a life in the arts is simply getting past the obstacles that keep that initial brushstroke from ever reaching the canvas in the first place. After that it's just a slow but cumulative process, changing the world one artwork at a time.

My own efforts in that realm have carried me on a long, slow, forty-year traverse across the fields of commercial and fine arts. For the first dozen years after graduating from college I worked straight nine-to-five jobs. Then I jumped off the treadmill—and have led a life of economic levitation ever since. I've learned to trust in the law of averages—namely, that some check or another *will* arrive in my mailbox "soon" (even though a scan of my calendar reveals no clue as to how I'll avoid joining the ranks of the homeless in short order). It may be that the real test for sustaining a life in the arts is not whether you can survive on a cycle of feast and famine, but whether you can live with the uncertainty.

At least in my case, however, being a Free-Range Artist hasn't really made all that much difference, at least not financially. I never had enough money when I was working full time, and I don't have enough money now. What has changed, however, is that I have a *lot* more free time. When life beckons I can drop everything and walk out the door on a moment's notice—and freedom like that beats job security hands-down.

Finding time and space to make art is one thing; finding the art you are meant to be making is another thing altogether. Of course we'd all like to reach that state of artistic maturity quickly, or instantly, or preferably yesterday. After all, most artists don't fantasize about making great art—they fantasize about *having made* great art. I'm reminded of the wonderful parable about the young artist who approached a Zen Master and with the forgivable brashness of youth asked straightaway, "Tell me, Master, how can I paint a perfect picture?"

The Master smiled. "It is very simple," he replied. "First, lead a perfect life. Then, by its very nature, every picture you paint will also be perfect."

Ah, so. Well, if you have achieved that state of grace, you are probably not reading this book. But if leading a perfect life is unlikely, it's still entirely possible to lead an *interesting* life—and I would maintain (as my modest

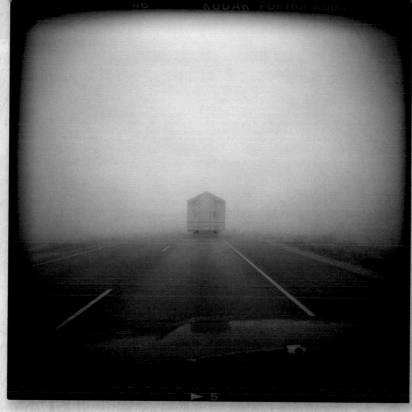

LITTLE HOUSE ON THE FREEWAY

contribution to art theory) that if you lead an interesting life, you're on track to make interesting art. (How could it be otherwise?) Your job is to put yourself on an intercepting path with interesting experiences.

I can, in fact, reconstruct quite clearly in my own mind just how I finally came to embrace that concept. As a beginning photographer I attended a Yosemite photography workshop taught by Ansel Adams. The workshop was a perfect vehicle for learning the craft of photography and a perfect introduction to the then-tiny community of photographic artists. It also made Ansel my first and only photography teacher, with the not-surprising result that I swallowed his artistic vision hook, line and sinker. Large-format black-and-white landscapes quickly became my *definition* of art photography. It took me years to realize that I don't lead a sharply focused, fine-grained life—that far more often, in fact, life had been whooshing right past me while I was trying to set up my tripod.

That realization finally hit home when I decided to print an album of family pictures to give my son for his eighteenth birthday—a hundred images, with Jon as a designated audience of one. And, yes, the final album was indeed quite poignant, but in the process of gathering the pictures I made a disconcerting discovery. In searching through literally thousands of negatives I'd made over those eighteen years, I found that for every photograph I had of Jon, I'd made about a hundred pictures of sand dunes, weathered barns, geometric abstractions, majestic landscapes and other certifiable "Fine Art" subjects. Yet compared to my snapshots of Jon—images I wouldn't trade away for *anything*—my so-called "serious" pictures seemed singularly artificial and, well, insignificant.

That one revelation entirely changed the way I approached my art-making. Ever since then, I've worked hard to keep the line between my life and my art as short and straight and clear as possible. Now when I go out to photograph, I don't carry forty pounds of camera gear or agonize about creating "significant images" that equate realism with reality. Instead I hang a little plastic camera around my neck, carry it pretty much everywhere I go and photograph—*en passant*—whatever crosses my path.

But while mastering your craft and finding your own voice may be essential prerequisites to making art, neither will mean a thing if you end up quitting along the way. It's hard to over-emphasize the fact that the most difficult part of art-making isn't the learning-the-craft part or the making-a-living part—it's the staying-alive-as-an-artist part. Artists today stand at the edge of an uncertain world, where the promise of art runs headlong into the difficulty of practicing that art.

Your first job is to get past that obstacle—but, surprisingly, it's not as difficult as it may at first appear. Even if you can't change the whole world in one fell swoop, you can change your own immediate surroundings. If you can identify the conditions that allow art to flourish, you can work toward creating equivalent conditions in your own world. For myself, converting that idea into a practical reality has meant establishing or joining or otherwise surrounding myself with an artistic community that supports and values the work I'm trying to do.

There are, of course, a number of ready-made examples of large-scale artistic communities—Greenwich Village, the Left Bank of Paris, Soho and the like—but my own sensibilities (and economics) favor communities much closer to home and often begun from scratch. These have usually taken the form of small artists' groups ranging in size from a handful to upward of thirty participants. I've been part of a dozen or more artists' groups over the past thirty-odd years. Some of these have been virtual communities where the interaction has been mostly on paper—through correspondence (or, more recently,

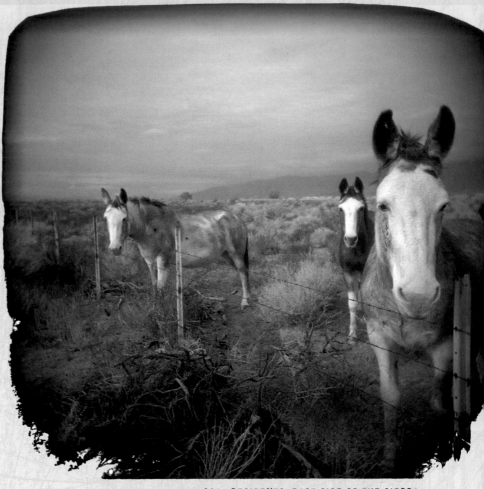

LOCAL RESIDENTS, EAST SIDE OF THE SIERRA

e-mail). In other groups we've held recurring face-to-face gatherings, sometimes to work together in the field, sometimes to share food and wine and fresh art. Some of these communities have been fleeting, others more or less permanent. Some have been carefully planned, others just grew like topsy. Some have even been unintended. And on rare occasions when all the stars were perfectly aligned, sharing something as simple as a weekend workshop brought changes that carried over into the work of a lifetime.

In recent years my efforts in this direction have taken the form of a classic artists' gathering, loosely modeled after the Paris Salons of the 1920s. It's an easy-to-replicate form: Once a month six or eight of us gather and share a potluck dinner and wine. Then we clear away the dishes

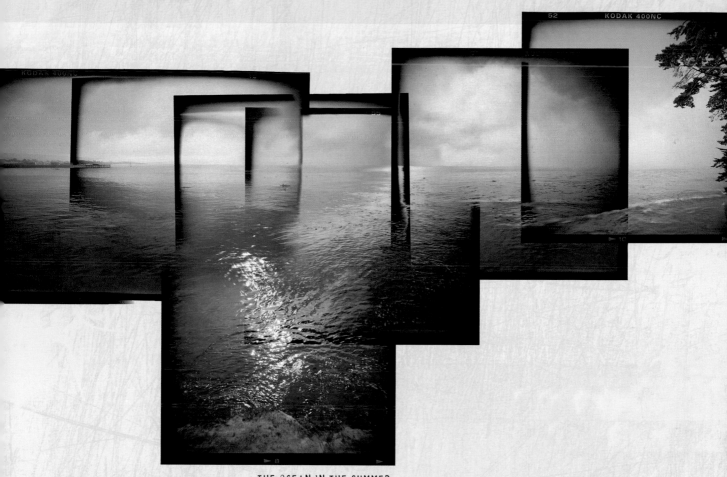

THE OCEAN IN THE SUMMER

and share work—finished work, in-progress work, experimental work, doomed work, uncomfortable work that's been sitting around bothering us, whatever.

Our gatherings are free-for-alls in the best sense of the term. I've known most of these people for many years now, yet whenever we get together to debate ideas about art-making, we still find ourselves changing our position on one question or another, switching sides in the middle of an argument, abruptly seeing an issue in some entirely new light—or all of the above. To say the format works is simply to say that it provides benefits that can only come from outside ourselves—among them, support, trust and a certain strength that comes from knowing you're in the company of like minds and kindred spirits.

Starting your own artists' group is absurdly easy. And, really, what have you got to lose? After all, it's not like this is the Middle Ages, when the word *DEADLINE* had literal overtones. And it's not like you're designing elevators or airplanes, where one wrong decision can bring real disaster. Personally, I'll go with the advice of computer guru Alan Kay—namely, that the very best way to predict the future is to invent it yourself.

NO-GET-LOST RECIPE FOR AN ARTISTS' GROUP:
- *Call up a few friends you enjoy spending time with.*
- *Invite them over for pizza.*
- *Ask them to bring along a piece or two of their artwork to show everyone what they're up to.*

There! Done! You don't even need to tell them you're starting a group. If they find their time together enjoyable (informative, stimulating, profound or just plain fun), the future will take care of itself. If the idea needs fine-tuning, you can always alter the number of participants or the meeting time or the food or whatever else until you find the right mix.

There was a time when all communities were to some degree "artistic communities." There was once far less separation between art and craft, and since most work *was* craft, there was similarly less distance between art and work. People routinely integrated their ideals into their daily work—a trait that today remains widely practiced *only* in the arts. In that sense, artistic communities exist today as exemplars of an attitude toward life we have allowed to slip away from us. But among the many benefits today's artistic communities provide, the most important is also the most basic: They keep you in the game. They give you the encouragement you need to continue. It may sound old-fashioned, but at least by my accounting you're only allowed to call yourself an artist if you *actually make art*. Make it so.

—TED ORLAND, SANTA CRUZ, CA, NOVEMBER 21, 2007©

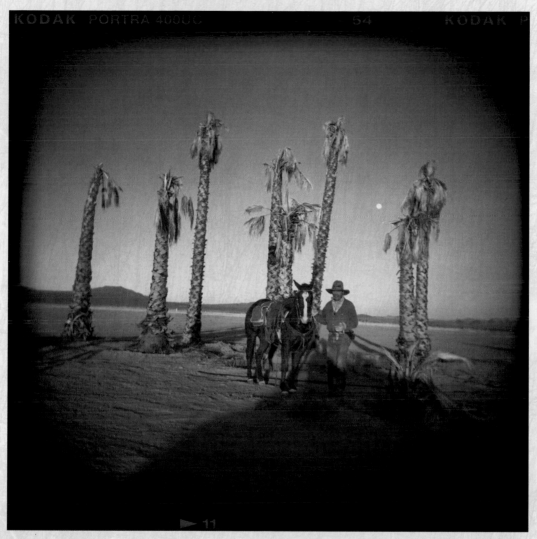

THE LAST COWBOY

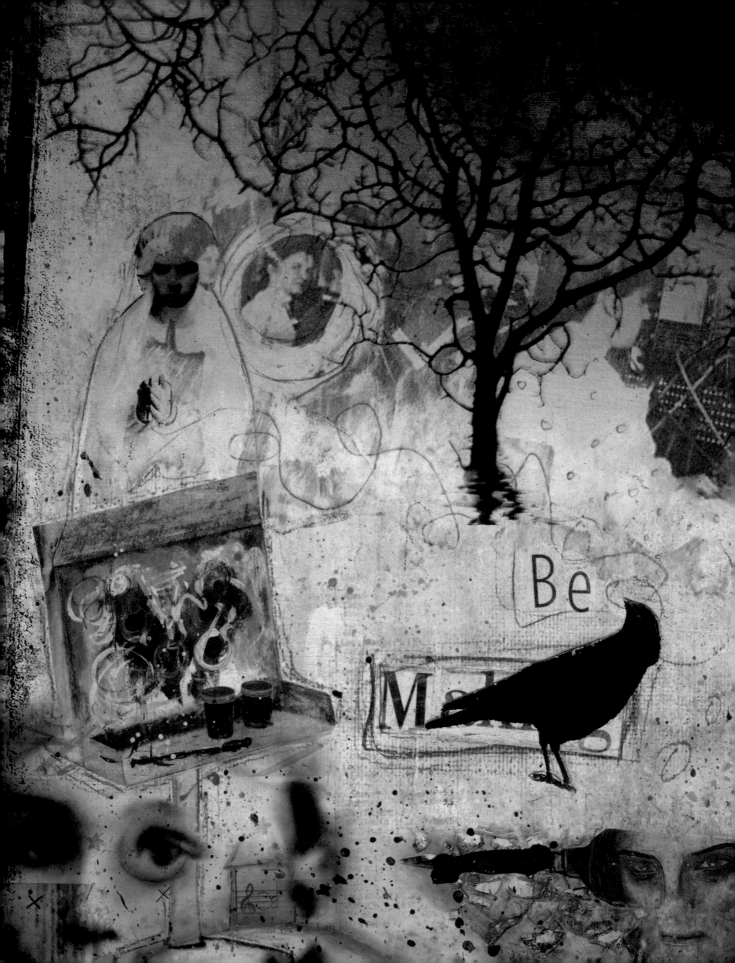

Be

M

NOW GO MAKE ART

Sometimes all we need is a little prompt to spark our creativity to point us in a new direction, show us possibility, and engage our imagination in ways we hadn't previously entertained. As an artist, you can appreciate the experience of going to a museum or gallery exhibition—viewing works that inspire— feeling imbibed with creative ideas spurred on by all the artistry around you.

It is my hope that you are feeling inspired by the art within the pages of this book . . . that you are experiencing a compelling need to enter your studio or creative space, to pour out all the unique ideas that have bubbled up inside you. It's time to unleash the muse—splash some paint, tear some paper, sift through your found objects, grab your camera, go with whatever form your art-making takes.

This chapter contains ten art challenges, or prompts, to further kick-start your creativity. The challenges are accompanied by interpretations from individual artists: the artwork generated from the prompts, techniques used for their projects and personal anecdotes and pearls of wisdom gleaned from the exercises. Now go make art!

CHALLENGE NO. 1:
PAINT A DREAM IZABELLA PIERCE

Create a piece of art that appears as it would if you
were in a dream.

For me, trying to describe one of my dreams is as difficult a task as trying to describe art, or trying to explain what it feels like to fall in love. Sometimes words can be so banal and often fall short describing these types of experiences. When I gaze at art that speaks to me, I often feel a mesmerizing sensation, feelings of absolute awe and the urge to just crawl into that indescribable piece of art.

A year ago, a beloved friend said to me, "I sometimes find myself wishing I could live within the worlds that I create. Imagine walking through the swirling colors in the deep velvet sky." These beautiful words had such a profound impact on me and changed forever the ways I would perceive other artists' work, as well as my own work. I now allow myself to get lost in the mystery of what I am creating or viewing. I take in the array of colors and meanings in a state that is very much like a waking dream. I have come to recognize a connection between art and spirituality, especially within my own art; in fact, it has played a huge part in my newfound love of art. When I create, I don't set out with any preconceived plans; my creation just magically appears, with my hands being the vessel through which a message flows—almost surreal-like. When I complete a piece, I sometimes wonder, "Where did that come from?!" Art-making has been a spiritual awakening for me; I try to share this "ethereal deepness," vividness, sorrow, hopes and dreams in every piece I create. I'd like to think of my creative process as "painting my own lucid dreams"—that's why this challenge was perfect for me.

Incorporating Digital Techniques into Mixed-Media Art

Materials

IMAGERY (ACTUAL PHOTOS, COLLAGE SHEETS, ETC.)

SCANNER

MATTE PHOTO PAPER

COLORED PENCILS (PRISMACOLOR)

PASTEL CRAYONS

BLACK PEN WITH A FINE TIP

ACRYLIC PAINTS

FLAT-BRISTLE PAINTBRUSH

PHOTO-EDITING SOFTWARE

METHOD

-1- FIND JUST THE PERFECT IMAGE. (I SIFTED THROUGH MY COLLECTION OF VINTAGE PHOTOS AND DECIDED ON A PHOTO OF MAUDE FEALY.)

-2- SCAN THE IMAGE AND PRINT IT ONTO MATTE PHOTO PAPER.

-3- APPLY COLORED PENCIL TO BOTH THE BACKGROUND AND THE IMAGE ITSELF, USING PENCILS IN PURPLE, PINK, YELLOW, BLUE, GREEN AND BLACK. ADD A FEW STROKES OF YELLOW AND PURPLE PASTEL CRAYON TO THE BACKGROUND, AND USE A BLACK INK PEN WITH A FINE TIP TO CREATE ELEMENTS LIKE EXTRA JEWELRY, SUCH AS THE CHOKER NECK PIECE I ADDED HERE. ADD A FEW MORE DETAILS WITH THE BLACK PEN: OUTLINE THE EYES AND EYELASHES AND GIVE MORE DEPTH TO THE HAIR. WITH A FLAT-BRISTLE PAINT BRUSH, GENTLY APPLY ACRYLIC PAINTS TO THE IMAGERY, USING THE SAME COLORS ALREADY PRESENT IN THE PIECE.

-4- SCAN THE PAINTED PIECE AND SAVE THE IMAGE TO YOUR COMPUTER. DIGITALLY ALTER THE PIECE WITH THE FOLLOWING SPECIAL EFFECTS. NOTE: I USED MICROSOFT DIGITAL IMAGE SUITE™, BUT YOU CAN ACHIEVE SIMILAR RESULTS WITH ANY PHOTO-EDITING PROGRAM.

-5- START BY SELECTING "REMOVE DUST."

-6- INTENSIFY THE COLORS BY INCREASING THE SATURATION LEVELS.

-7- COLORIZE THE IMAGERY WITH "SOFT EDGED" AND "ART STROKE" BRUSHES OF VARIOUS SIZES, USING THE COLORS BLACK, PURPLE, PINK AND BLUE.

-8- SELECT A "DISTORTION BRUSH" WITH A "SMEAR" FEATURE TO DISTORT THE HAIR. (I ENJOY USING THIS TOOL IN VARIOUS SIZES.)

-9- FINALLY, INCREASE THE CONTRAST LEVEL AND INCREASE THE SATURATION LEVELS ONCE AGAIN. SAVE THE CHANGES TO YOUR IMAGE, AND VOILA, YOU'RE FINISHED!

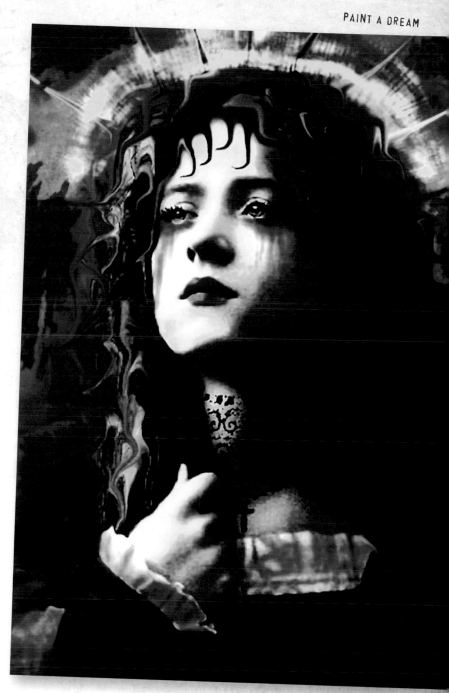

CHALLENGE NO. 2:
COLLAGE WITH NEWSPAPER SUSAN TUTTLE

Create a collage using imagery and text from a standard newspaper for your elements.

There's just something about the look, feel and smell of the Sunday morning paper (coupled with a cup of bold, steaming coffee) that I find very appealing—although I must admit that with two young children, my days of leisurely thumbing through and poring over the pages are pretty much put on hold. I do find the newspaper useful, however, in my art studio. I have a stack of old ones I use to catch my creative messes as I work. I've often marveled at the chance pieces of art I have created on these newsprint "drop cloths." The random layers of paint and markings often have a spontaneity and boldness to them I find hard to create with conscious intention. The hints of text and imagery on the newsprint show through the paint, giving a unique texture and depth to the substrate. I have saved these scraps for later use in future pieces.

My experiences with newsprint have inspired me to engage in this challenge of making a collage piece from newspaper clippings. When searching through the paper for imagery I wanted to use, I was lucky enough to find one that looked like an easel, a tube of paint and one of female telephone operators on the job. I imagined myself as one of the women staring at the camera, wishing she was somewhere else: in her studio making art, following her passion, instead of at her mundane and stressful job.

Using Newspaper in a Collage

Materials

CANVAS BOARD (I USED 9˝ X 12˝ [23CM X 30CM])

NEWSPAPER

GEL MEDIUM, MATTE (GOLDEN)
(READ PRODUCT SAFETY PRECAUTIONS)

GESSO

ACRYLIC PAINTS (A VARIETY,
INCLUDING BLUE, RED, YELLOW AND ORANGE)

WATER

MASKING TAPE

BRISTLE BRUSH

GRAPHITE PENCIL

BROWN DISTRESSING INK

FOAM MAKEUP WEDGE

NONTOXIC VARNISH

METHOD

-1- CUT A PIECE OF NEWSPAPER TO FIT YOUR CANVAS BOARD. COAT THE BOARD WITH GEL MEDIUM (READ SAFETY PRECAUTIONS ON LABEL) AND ADHERE THE PIECE OF NEWSPAPER TO THE CANVAS. BEGINNING AT THE TOP, SMOOTH IT DOWN WITH YOUR HANDS TO WORK OUT BUBBLES.

-2- COAT THE NEWSPAPER WITH A LIGHT COAT OF GESSO, ALLOWING MUCH OF THE TEXT TO SHOW THROUGH. THIN OUT SOME ACRYLIC PAINT OF YOUR CHOICE WITH WATER, AND COAT THE MIXTURE OVER THE ENTIRE CANVAS.

-3- ALLOW TO DRY UNTIL ONLY SLIGHTLY DAMP. WITH A PIECE OF MASKING TAPE, PULL UP PARTS OF THE NEWSPAPER IN A RANDOM FASHION TO ACHIEVE A DISTRESSED EFFECT.

-4- TEAR IMAGES YOU LIKE FROM A NEWSPAPER AND ADHERE THEM TO THE CANVAS WITH GEL MEDIUM.

-5- PAINT A LIGHT COAT OF GESSO AROUND THE OUTER EDGES OF THE IMAGES TO INTEGRATE THEM WITH THE BACKGROUND YOU'VE CREATED. ADD TEXT FROM LETTERS YOU CUT OUT OF THE NEWSPAPER.

-6- TO ADD A LITTLE COLOR AND INTEREST TO THE CANVAS, DIP A SMALL BRISTLE BRUSH IN WATERED-DOWN ACRYLIC PAINTS, AND SPLATTER PAINT AROUND THE CANVAS BY TAPPING THE EDGE OF THE BRUSH ON YOUR NON-WORKING HAND.

-7- ADD SCRIBBLES AND HIGHLIGHTS WITH A GRAPHITE PENCIL.

-8- GIVE THE PIECE AN ANTIQUED LOOK BY BLENDING BROWN DISTRESSING INK INTO THE EDGES OF THE CANVAS, USING A MAKEUP WEDGE. SEAL WITH VARNISH TO FINISH.

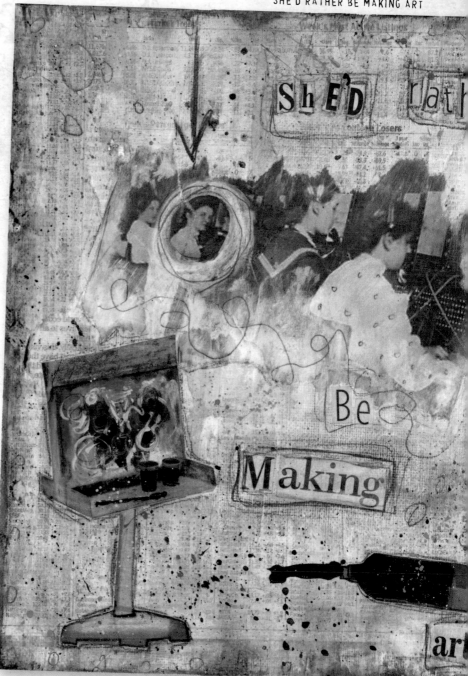

CHALLENGE NO. 3:
MAKE FRIENDS WITH NEW COLORS CARLA KURT

Limit yourself to five colors you usually avoid and utilize all of them on a substrate of your choice.

As an artist, my truest joy comes from giving visual shape to the images in my mind and the emotions in my heart. I paint on both canvas and wood, building a story for my vision with each layer, using a variety of distressing techniques as I go—sanding, scratching, scrubbing and so on—to create textural interest and provide glimpses of the work's history.

I find myself repeatedly drawn to certain colors that resonate with me on some instinctive level, while at the same time avoiding other colors that just don't feel right. In fact, working in my color-comfort zone is so much a part of my creative juju I completely panicked when I was presented with the challenge to use five colors I usually avoid.

I admit it, I'm just not one who likes to play by the rules and have always managed to devise a way to gracefully circumvent boundaries and restrictions that cramp my style. I needed to fulfill my assignment without stifling my creativity . . . and, of course, I wanted to paint something very beautiful!

My first impulse was to re-create an existing painting in an entirely new palette. I was certain it would be an exciting process with equally exciting results.

After sketching the image on a prepared wood panel, I laid out a warm palette (my typical palette is serene and cool) and went to work methodically substituting warm for cool, red for green. But somewhere in the process, I found myself reaching for colors outside my stipulated five, and soon the painting looked a lot like the first one.

Clearly, I had not been able to see my original painting with new eyes, so I decided I would instead create something entirely new, relying on the mysterious muse of inspiration to arrive and help me choose the image and the five colors.

As it happened, I didn't need to wait very long. One day, while listening to Richard Thompson's hauntingly beautiful song "Beeswing," the muse arrived, laden with gifts. As Thompson sang about his headstrong and wild love, ". . . a rare thing, fine as a bee's wing" I visualized the painting I wanted to create—a delicate but strong woman in deep reds and browns, surrounded by nature, rendered in tones of blue and gold. The image was so vivid and compelling I could hardly wait to start!

I decided to turn to the palette of contemporary impressionist painter Anda Styler, an early mentor whose work and instruction has had a significant influence on my art. My colors consisted of Van Dyke Brown, Quinacridone Crimson, Yellow Oxide, Diarylide Yellow and Cobalt Turquoise along with the "freebies" of Titanium White and Carbon Black. These colors seemed to reflect the earthy/ethereal dichotomy of the image I visualized, and I knew I could mix them to create a delicious spectrum of other colors. I could have chromatic freedom and still play by the rules.

TELLING A STORY: CREATING A HISTORY

When I create a work of art, I channel the mood and the story of my subject, building layers of history with paint and other media so the viewer can play the role of archeologist, reading the narrative my painted artifacts reveal.

I started with a cradled birch wood panel, prepared with a single coat of gesso. After lightly sanding the surface to make it nice and smooth, I went to work, transferring a printed illustration of the figure (the transfer process adds additional texture as opposed to drawing directly on the support), blocking in the composition with thin washes of color and then moving back to the figure to concentrate on detail work. Although I usually prefer to get the background

mostly settled before working on the foreground images, in this case, because the girl was my painting's raison d'être, I was anxious to bring her to life.

As I started painting her face, I was especially pleased with my color choices. By combining Titanium White with small amounts of the other colors, I was able to create beautiful skin tones. The hair was painted with combinations of brown, crimson and Yellow Oxide, both by mixing various shades on my palette and by laying colors next to each other directly on the surface. It was a process that left me delighted but creatively depleted. She was emerging exactly as I had imagined her, mesmerizing with her bold yet vulnerable gaze, but I was stalled. I just couldn't decide how to approach finishing the background, and, honestly, I didn't want to ruin my beautiful girl. So I propped her up on my dresser against the mirror (that's where I put unfinished work I want to think about) and looked at her for a couple of days until the solution revealed itself.

Moving to the background, I added more color, layer upon layer, sanding between layers. I wanted to include Richard Thompson's song in the painting, so I made a transparency sheet of the lyrics using a very delicate script font. I planned to use the lyrics as a transfer to achieve both texture and meaning, placing them in the central section of the background, but once I got them down, the whole painting looked heavy and busy. It also looked

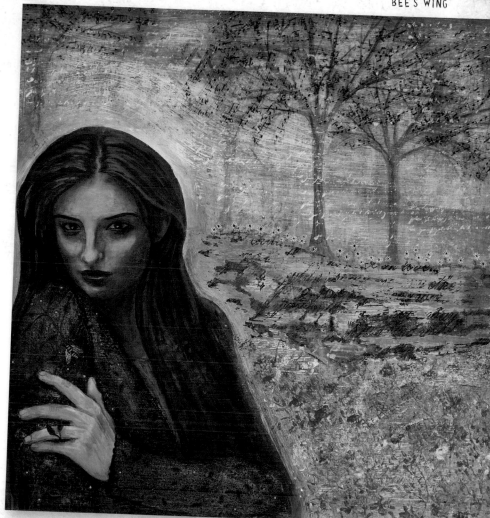

BEE'S WING

too obvious. I prefer secrets and mystery—deeper meanings that may or may not be discovered. On top of that, the various sections of the background all seemed to be of the same value as the foreground. My painting had gone from a masterpiece to a mess! I felt devastated and very nervous. The deadline was fast approaching, and I wondered if I would be able to come through with something I would be proud to share. Once again my girl was given a time-out on the dresser so I could ponder a solution to my dilemma.

THE FINAL STRETCH

After my spirits had plummeted, my confidence had dissolved and I had started to plunge into the abyss of self-doubt and fear, I finally mustered up the courage to revisit the painting. As often happens, my inner voice saved me, commanding me to go back and regroup—try something different. So out came the gesso, and in a matter of minutes, the background was gone. Once again, I started painting and sanding and scratching with my trusty razor blade. And that's when the magic happened. Bits of overpainted gesso started flaking off, revealing portions of the transferred text and the original base colors! I continued painting and sanding, watching as shapes emerged. The painting seemed to almost create itself, giving me hints of trees and clouds and hills, so I followed its lead. After a frightening detour, I was back in the zone and working with intuitive synergy.

I completed the background by stamping in additional texture along the bottom, transferring sheet music as leaves for the trees, drawing flowers with gel pens and stamping bits of white script to lighten the atmosphere. I then returned to the figure, painting a pattern of vines on her clothes with the added surprise of a stalk growing through her fingers, marrying her to the surrounding landscape. The finishing touch was a small bee clinging to the vine on her arm. My girl with her "brown hair zigzag around her face and a look of half surprise, like a fox caught in the headlights" (Thompson) was done, and she was everything I had initially envisioned—and more.

Many people liken the creation of art to giving birth, but I think the process of painting a challenging piece is more than that; it's like raising a child through an easy birth, a hyperactive childhood, a troubled adolescence, and then experiencing the magical transformation that often occurs in early adulthood. After all I went through with this painting, I wanted to keep her around for a while to enjoy her beauty, her wit, her multifaceted personality, but she had places to go and people to meet. As I packed the painting to send it off to the publisher, I imagined her whispering, "As long as there's no price on love, I'll stay, and you wouldn't want me any other way" (Thompson).

Incorporating an Altered Image into a Painting

Although my process is often intuitive, I generally create a painting such as *Beeswing* using the techniques and steps that follow. I suggest these only as guidelines; after all, there really is no substitute for the magic that comes when the muse pays a visit!

Materials

CRADLED BIRCH WOOD PANEL (APOLLON)

FOAM BRUSHES

GESSO

SANDPAPER

INK JET MATTE PHOTO PAPER FOR PAPER TRANSFERS

SOFT GEL MEDIUM, GLOSS (GOLDEN)
(READ PRODUCT SAFETY PRECAUTIONS)

BRAYER, BONE FOLDER, OLD CREDIT CARD
FOR BURNISHING TRANSFERS

ASSORTED SPONGES

CONTÉ PENCILS—LIGHT PEACH OR LIGHT GRAY

HEAVY BODY ACRYLICS (GOLDEN)
(READ PRODUCT SAFETY PRECAUTIONS)

ASSORTED ACRYLIC BRUSHES

RAZOR BLADES

3M SANDING SPONGES—MEDIUM- AND FINE-GRIT

FLORAL PATTERN AND SCRIPT STAMPS

PAPER TOWELS

GEL PENS

ACRYLIC SPRAY CLEAR COAT
(READ PRODUCT SAFETY PRECAUTIONS)

METHOD

-1- START WITH A WOOD PANEL IN A COMFORTABLE SIZE. USING A FOAM BRUSH, APPLY A THIN COAT OF GESSO. WHEN THE GESSO IS DRY, LIGHTLY SAND ONCE AGAIN SO THE PANEL IS SMOOTH.

-2- CHOOSE A CENTRAL IMAGE. PRINT IT OUT ON PLAIN PAPER FROM YOUR INK JET PRINTER, AND MAKE IT A MIRROR IMAGE (IT WILL REVERSE WHEN YOU TRANSFER IT). THE IMAGE CAN BE A SCAN OF YOUR OWN DRAWING, A PERSONAL PHOTOGRAPH OR ANY OTHER COPYRIGHT-FREE IMAGE. APPLY SOFT GEL MEDIUM TO BOTH THE RECEIVING SURFACE AND THE PRINTED IMAGE, AND PLACE THE IMAGE FACEDOWN ON THE PANEL. BURNISH IT WELL USING A BRAYER, A BONE FOLDER OR A CREDIT CARD, BUT BE CAREFUL NOT TO TEAR THE PAPER.

-3- ONCE THE CENTRAL IMAGE IS IN PLACE, LET IT DRY. REMOVE THE PAPER FROM THE TRANSFER BY CAREFULLY SOAKING AND RUBBING IT WITH A DAMP SPONGE. A COMBINATION OF LIGHT PRESSURE AND PATIENCE WILL REMOVE ALL THE PAPER, LEAVING THE IMAGE EMBEDDED IN THE DRY MEDIUM.

-4- SKETCH THE BACKGROUND AREAS WITH A LIGHT-COLORED CONTÉ PENCIL. (I PREFER A CONTÉ PENCIL TO OTHER DRAWING MEDIA BECAUSE IT CAN EASILY RUB OFF WITHOUT LEAVING A MARK.)

-5- PAINT IN THE BACKGROUND WITH THIN WASHES OF ACRYLICS, SANDING BETWEEN LAYERS. I FIND IT HELPFUL TO LIGHTLY FILL IN THE ENTIRE BACKGROUND SO I CAN GET AN IDEA OF THE COMPOSITION. CONTINUE PAINTING AND SANDING TO CREATE TEXTURE AND TONAL VARIATIONS.

-6- AT THIS POINT, YOU MAY WANT TO PAINT OVER YOUR TRANSFERED IMAGE (I USE MY TRANSFERS SIMPLY AS A GUIDE AND FOR THEIR TEXTURAL VALUE, PAINTING OVER THEM COMPLETELY WITH VERY FINE BRUSHES) OR CONTINUE WITH THE BACKGROUND.

-7- ONCE YOU HAVE THE BASIC BACKGROUND SHAPES PAINTED, START ADDING OTHER IMAGE TRANSFERS TO CREATE TEXTURE AND HIDDEN MEANING. ONE OF MY FAVORITE PRACTICES IS TO ADD SONG LYRICS OR LINES OF POETRY RELATED TO THE NARRATIVE OF THE PIECE. ALTHOUGH THEY WON'T ALWAYS SHOW COMPLETELY, I FEEL THEY ADD TO THE "VIBE" OF THE WORK, AND THE PATTERN AND TEXTURE ADD TO THE VISUAL APPEAL.

-8- TRY COVERING SOME OF THE TRANSFERS WITH GESSO AND PAINT. WHEN DRY, SAND OR SCRAPE WITH A RAZOR, REVEALING SECTIONS OF THE TRANSFER AND THE BASE COLORS.

-9- USE A MEDIUM-GRIT SANDING SPONGE TO SUBTRACT SHAPES, SUGGESTING BACKGROUND IMAGES SUCH AS TREES AND CLOUDS. STAMP OVER AREAS OF YOUR BACKGROUND WITH PATTERN OR SCRIPT STAMPS. I USUALLY USE ACRYLIC PAINT AND TAKE A PAPER TOWEL TO BLOT THE EXCESS PAINT FROM THE SURFACE. I THEN CREATE A MONOPRINT ON ANOTHER PART OF THE PAINTING WITH THE PAINT-COVERED TOWEL.

-10- FINISH UP DETAILS USING GEL PENS TO ADD FINE ELEMENTS.

-11- WHEN THE PAINTING IS DRY, TAKE IT TO A WELL-VENTILATED AREA AND APPLY AN EVEN COAT OF CLEAR ACRYLIC SPRAY TO FIX THE INK. ONCE THE CLEAR COAT IS DRY, YOU CAN VARNISH YOUR PAINTING WITHOUT WORRYING ABOUT IT SMEARING.

WORK CITED

Thompson, Richard. "Beeswing." *Mirror Blue*. CD. Capitol Records. 1994.

CHALLENGE NO. 4:
FIND THE VISUAL IN A SONG SUSAN TUTTLE

Listen to a song that moves you in some way, and create a piece that reflects what you have heard.

Buena Vista Social Club, John Mayer, Suzanne Vega, Phil Collins, Coldplay, Dawn Upshaw, Yo-Yo Ma—these are just a few of the musicians you will hear reverberating off the walls of my art studio. Music and art, art and music—they go hand in hand for me, as they do for many a creative folk. My background is music, with formal training in Flute Performance and Music Education. Music is such a huge part of my being, and that being said, you can see why it's only natural for me to integrate it into my art-making.

MIX MUSIC WITH ART-MAKING

• *Turn on some jazz if you're aiming for bold colors and textures. Try a little Coltrane, Carmen McRae, Dexter Gordon or Oscar Peterson.*

• *If I'm looking to tell a story through collage that features vintage imagery, I often listen to Suzanne Vega or James Taylor. The stories that unfold in their lyrics inevitably find their way into my art; I find myself imposing the musical storylines on my subjects, which affects the context, colors, text and overall flavors of the artwork.*

• *When working on abstract paintings, I usually listen to classical music. If you listen to J. S. Bach's music, you'll notice he starts with a germination of a musical idea that he works and reworks in his pieces, as if he is trying out his idea in all of its possible forms. Anytime I play Bach while I am working, I tend to subconsciously mirror his technique on the canvas. Other classical favorites I have loved since my youth include Polish composer Henryk Gorecki, Igor Stravinsky, Beethoven and Rimsky-Korsakov.*

• *If you're trying to achieve a look with lots of quick accents, as opposed to long lines, try listening to West African drumming genius, Babatunde Olatunji. I actually drum on the canvas, imitating the drumming patterns I hear, with my bare hands covered in paint. Make sure to put down a large drop cloth when attempting this one!*

• *You may want to set the mood for a piece by choosing a particular musical selection. If you're aiming for happy and excited, try anything by Buena Vista Social Club; for introspective, try something by October Project; and when exploring darker emotions, try songs by Irish musician Mary Coughlan.*

• *If you need to relax, loosen up or quiet your brain, you may enjoy listening to more meditative music like Enya, Loreena McKennitt or George Winston.*

• *Sometimes it's just as simple as letting a random piece of music inspire a theme or dictate the direction of a piece, as I did for this challenge.*

Create a Collage Inspired by a Piece of Music

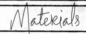

MAGAZINE IMAGERY AND FOUND TEXT

ACRYLIC PAINTS (RED, WHITE, BLUE, BLUISH/GREEN)

BONE FOLDER

SCISSORS

STRETCHED CANVAS (4" x 6" [10 CM x 15 CM])

BRISTLE BRUSH

RUBBER STAMP

GEL MEDIUM, MATTE (GOLDEN)
(PLEASE FOLLOW PRODUCT SAFETY PRECAUTIONS)

GRAPHITE PENCIL

BROWN DISTRESSING INK

NONTOXIC VARNISH

METHOD

FOR MY TUNE I CHOSE "WALK THROUGH THE WORLD" BY MARC COHN. I LEAFED THROUGH A MAGAZINE LOOKING FOR AN IMAGE THAT SPOKE TO ME: WOULDN'T YOU KNOW IT, I FOUND A PAIR OF BOOTS THAT MESHED SO WELL WITH THE LYRICS I WAS HEARING.

-1- BEFORE CUTTING YOUR IMAGERY FROM A MAGAZINE PAGE, ALTER IT WITH ACRYLICS. I PAINTED THE BOOTS IMAGE RED AND THEN HIGHLIGHTED THE SOLES, SEAMS AND BUCKLES WITH WHITE ACRYLIC PAINT.

-2- USING SOMETHING POINTED, BUT NOT TOO SHARP (LIKE A BONE FOLDER OR YOUR FINGERNAIL), SCRATCH SOME OF THE PAINT OFF TO GIVE THE IMAGERY A DISTRESSED LOOK.

-3- ONCE THE PAINT IS COMPLETELY DRY, CUT THE IMAGERY OUT.

-4- TO CREATE THE BACKGROUND, COAT THE CANVAS WITH ACRYLIC PAINT (IN THE COLOR OF YOUR CHOICE). WHILE STILL WET, DIP YOUR BRUSH INTO A SECOND HUE OF THE SAME COLOR (I USED A BLUE WITH A GREEN TINT FOR THE SECOND COAT) AND LIGHTLY BLEND THAT INTO THE BASECOAT.

-5- ONCE DRY, ADD A STAMPED IMAGE AND ADHERE THE MAGAZINE IMAGE WITH GEL MEDIUM.

-6- ADD TEXT, DOODLES AND SHADOWS WITH GRAPHITE PENCIL, AND RUB BROWN DISTRESSING INK INTO THE EDGES. SEAL IT WITH VARNISH.

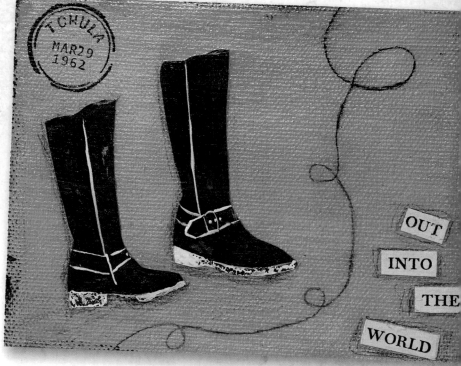

OUT INTO THE WORLD

CHALLENGE NO. 5:
VEER FROM NORMAL TONIA DAVENPORT

Create a piece of artwork with unexpected colors or surprising relationships between components—elements that would be considered a veer from what we perceive as "normal" or expected.

Are the seas of the earth not filled with salt?
Are the words that I hear misspelled?
Does the stuffing inside of my threadbare heart
not give in when it's squeezed and it's felt?

Will a mitten not keep my numb fingers warm?
Did I misunderstand rain is wet?
Does the dust that settles on feelings not found
not get spit on and smudged with regret?

I guess I was thinking a new seed will sprout,
if it's planted away from the weeds.
I assumed that blue paint left to dry undisturbed
would coat and protect my raw needs.

But you ask me to question or trust not my eyes,
nor my ears, nor my heart nor my mind.
I refuse to believe that the sky will soon fall
Though perhaps that's because love is blind.

Things are often not what they seem, and even more often we don't see what is actually there. Our human brains actually filter out a good majority of what our eyes see, our ears hear and our noses smell, to allow us to be undistracted enough to get through a typical day without going crazy from overstimulation.

For this challenge, I wanted to create a piece of art that would appear "normal" at a glance but upon closer inspection would reveal atypical or unusual elements. I also wanted to challenge myself to create in a style I wasn't accustomed to. Enter The Landscape. I'm much more comfortable creating abstract art, so I knew this would be good for me. One reason I prefer working abstractly is that I get hung up on making places or things appear realistic (I refuse to even attempt people—that can be the next challenge). But I let go of my insecurities and just did it, and it was actually rather fun!

I decided to work in encaustic for this exercise and started with a piece of Plexiglas as a substrate. Elements I used that could be considered unexpected include a layered piece of vintage ledger paper as "earth," a house made of sheet music, pink glitter in the sky, a transparent tree and leaves on the tree made of crushed glass.

This turned out to be more fun than I had expected. I loved having permission for things to be unrealistic. When I was finished, I decided to take it even one step further and make an unexpected frame, so I made one from Plexiglas! If you'd like to make your own plexi frame, begin with Plexiglas as your substrate. Scrape away any medium from the edges of the substrate before building the frame.

Making a Frame From Plexiglas

Materials

SHEET OF PLEXIGLAS, APPROX. 16" X 20" (41CM X 51CM)

PLASTIC CUTTER

METAL STRAIGHTEDGE

CUTTING MAT WITH A GRID

PLASTRUCT PLASTIC CEMENT (READ PRODUCT SAFETY PRECAUTIONS)

EPOXY (READ PRODUCT SAFETY PRECAUTIONS)

MITRE SAW OR JEWELER'S SAW AND CARPENTER'S TRIANGLE

SANDPAPER OR ROTARY TOOL WITH SANDING ATTACHMENT

SAWTOOTH HANGER

METHOD

-1- MEASURE THE WIDTH OF YOUR SUBSTRATE AND CUT TWO STRIPS OF PLEXIGLAS TO THAT LENGTH X 1/2" (13MM). TO CUT, USE THE PLASTIC CUTTER AND THE STRAIGHTEDGE TO MAKE SEVERAL SCORES IN THE PLASTIC (SEVEN OR EIGHT) AND THEN SNAP IT OVER THE EDGE OF A TABLE TO BREAK IT.

-2- USING PLASTIC CEMENT, GLUE THESE PERPENDICULAR TO THE MEASURED SIDES OF THE SUBSTRATE BY HOLDING THE STRIPS TO THE SUBSTRATE AND RUNNING THE EPOXY BRUSH ALONG THE SEAM. HOLD FOR TWENTY SECONDS OR SO TO CURE.

-3- WHEN THE FIRST TWO SIDES FEEL STABLE, MEASURE THE REMAINING SIDES, INCLUDING THE ADHERED STRIPS. CUT TWO MORE 1/2" (13MM) PIECES TO THIS MEASUREMENT AND ADHERE IN THE SAME WAY, ALSO GLUING THE SEAM WHERE THE STRIPS MEET.

LEAVES OF GLASS

-4- CUT FOUR 1" (3CM) STRIPS THAT ARE AT LEAST 3" (8CM) LONGER THAN THE DIMENSIONS OF YOUR SUBSTRATE.

-5- USING A MITRE SAW OR A CARPENTER'S TRIANGLE AND JEWELER'S SAW, MAKE A 45-DEGREE CUT AT ONE END OF ONE PIECE.

-6- USING THE LENGTH OF YOUR SUBSTRATE MINUS 1/4" (6MM), MAKE A MARK FROM THE SHORTER END OF THE ANGLE ON THE STRIP. THEN MAKE A CUT IN THE OPPOSITE DIRECTION, AT THAT MARK. REPEAT FOR AN IDENTICAL PIECE.

-7- REPEAT THIS PROCESS TO CUT TWO PIECES FOR THE WIDTH OF YOUR SUBSTRATE. USING THE GRID ON YOUR CUTTING MAT TO KEEP THINGS SQUARE, GLUE THE FOUR SIDES OF THE FRAME TOGETHER, FLAT, USING PLASTIC CEMENT.

-8- WHEN THE FRAME HAS CURED, ROUND AND SOFTEN THE CORNERS OF THE FRAME USING SANDPAPER OR A ROTARY TOOL. ALSO SAND ONE SIDE OF THE FRAME TO GIVE THE PLEXIGLAS A FROSTED APPEARANCE.

-9- GLUE THE FRAME TO THE "BOX" SIDES THAT ARE GLUED TO THE SUBSTRATE AND SET A BOOK ON IT WHILE IT CURES.

-10- TO ATTACH HANGING HARDWARE TO THE BACK, USE AN EPOXY TO ADHERE A SAWTOOTH HANGER.

CHALLENGE NO. 6:
PAY ATTENTION SUSAN TUTTLE

Using all your senses, jot down things you notice, or things that speak to you as you go about your day. Incorporate at least three of these things into an art piece in any way you wish.

Winter is coming. The trees are mostly barren, save for the few leaves that are left—brown, brittle and curled, shaking like rattles in the wind. The smell of wood smoke fills the air. I breathe in deeply, inhaling its cold, acrid, sweet-smelling scent I can taste on the back of my tongue. I watch the crows as they fly overhead and listen to their cackling deep in the woods; for some reason, their presence is felt more strongly this time of year. The winterberries are plump, blood red and vibrant against the toasty, cinnamon hues and bleached-out greens of the decaying forest. Soon they will be covered in snow.

I take a rest on our granite stoop and am a bit shocked at the initial sensation of my body against the stone: almost like sitting on a block of ice. I look out at the late-afternoon sky filtering through the crooked tree branches and brambles. It's getting dark so soon; I watch the last sparks of color along the western horizon—soft pinks, mixed with peach and lavender tones, reminding me of watercolors bleeding into each other.

I can feel it in my bones—the change of season beckons me to slow down, become more introspective and rest both physically and emotionally. In some regard I am relieved and eager to do this, but on the other hand, it is hard to let go of the warmer months, embrace the change and welcome the passing of time. The feelings are bittersweet.

Creating a Cold-Feeling Collage

Materials

4˝ X 4˝ (10CM X 10CM) PIECE OF FOAMCORE

GESSO

HEATING TOOL

PHOTO-EDITING SOFTWARE

IMAGERY

SCISSORS

TRANSPARENCY PAPER

CLEAR GLUE

BLACK CHARCOAL PENCIL

FINE SANDPAPER OR SANDING BLOCK

BRISTLE PAINTBRUSHES

BLACK ELECTRICAL TAPE

METHOD

-1- COAT A 4" X 4" (10CM X 10CM) PIECE OF FOAMCORE BOARD WITH GESSO. DRY WITH A HEATING TOOL. REPEAT THIS STEP THREE MORE TIMES. FOR ADDED TEXTURE AND INTEREST, BRUSH GESSO ON WITH STROKES GOING IN A VARIETY OF DIFFERENT DIRECTIONS.

-2- USING A PHOTO-EDITING PROGRAM LIKE ADOBE PHOTOSHOP ELEMENTS™, SUPERIMPOSE IMAGERY OF A HEAD WITH A SAD EXPRESSION OVER THE HEAD OF A GIRL IN A VINTAGE PHOTO. SOME BACKGROUND KNOWLEDGE OF THE PROGRAM IS REQUIRED IN ORDER TO EXECUTE THIS STEP.

-3- PRINT OUT THE IMAGERY OF THE GIRL AND CROW ONTO PHOTO PAPER, AND CUT THEM OUT.

-4- PRINT THE PHOTO OF THE TREE AND SKY ONTO TRANSPARENCY PAPER (AVAILABLE AT OFFICE SUPPLY STORES). MAKE SURE THE IMAGERY MEASURES 4" X 4" (10CM X 10CM) SO IT WILL FIT PERFECTLY OVER THE ENTIRE PIECE OF FOAMCORE.

-5- ADHERE ALL IMAGERY (SANS THE TRANSPARENCY) TO THE FOAMCORE WITH CLEAR GLUE. ONCE DRY, ADD SHADOWS AND HIGHLIGHTS WITH BLACK CHARCOAL PENCIL.

-6- LIGHTLY SAND THE IMAGERY OF THE GIRL AND THE EDGES OF THE CROW TO GIVE AN AGED, DISTRESSED EFFECT. BRUSH OFF THE EXCESS RESIDUE.

-7- APPLY A DOT OF CLEAR GLUE ON EACH CORNER OF THE SUBSTRATE. ADHERE YOUR TRANSPARENCY TO THE TOP OF THE SUBSTRATE AND LET DRY.

-8- TO COVER UP THE GLUE DOTS AND FRAME YOUR COMPOSITION, ADHERE STRIPS OF BLACK ELECTRICAL TAPE TO EACH OF THE FOUR EDGES OF YOUR SUBSTRATE.

CREDITS

The imagery of the crow featured in the piece: ©iStockphoto.com/tiburonstudios

ONE FOR SORROW

CHALLENGE NO. 7:
FIND INSPIRATION IN YOUR FEAR LISA FALZON

Explore your fear(s) on a substrate of your choice, keeping in mind that beautiful art is not always pretty, but, rather, an expression of your truth.

When I was approached to embark on this project, I was asked to create a piece of artwork to go with the title, "What Are You Afraid of?" I am by no means a brave person; in fact, I still wake up at nights quaking about ghosts and ghouls . . . although I am in my twenties, and married, and in my own home.

So I had a plethora of quirks and situations I could have depicted—seeing as how I am afraid of many things. I wanted to choose something peculiar, perhaps particular to me that could also be symbolic. So I chose one of my most irrational fears—that of having my hair cut off by a stranger, should I fall asleep on a bus or train.

I don't like art to be straightforward—I love mystery and double meanings. What I like most about this fear, however weird and annoying it may be, is there are underlying issues in it: mistrust of public places, guarded vanity, suspicion of strangers and mistrust of friends— such lovely things indeed! These are all matters that could ultimately be unpeeled by the viewer of the art piece.

All my life I created artwork traditionally—with canvas, paper, oils, aquarelles—the whole shebang. But as of six months ago, I made a personally natural leap into the digital realm by switching to completely computer-created graphics. An immense love for computers, a dislike for cleaning brushes and my extremely tiny Paris apartment all contributed to this leap. So for this project, I sketched on paper, scanned it and then worked entirely in Adobe Photoshop Creative Suite 2™.

1ST STEP—THE SKETCH

Sketching is a very important stage because it helps me work on what I believe to be a crucial aspect of art—the composition. Basically, rules of composition that exist, if employed, will make an artwork/photograph/architectural piece look complete and harmonious. They will also dictate where the area of focus will lie; this is important because you want to direct the viewer to look where you want them to.

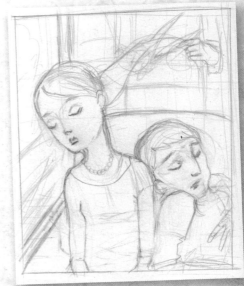

EXHIBIT A

In the sketch, I used diagonals to "point" toward the area of action, that is, the hands cutting the hair. Note the diagonal of the train window, the rough diagonals created by the swing of her hair and the bodily diagonal of the sleeping boy. It's really good to look at old-master paintings for compositional instruction; other than having an innate eye for it (and some people do), looking at master art is the only way to learn the ways of composition.

2ND STEP—SCANNING AND LAYERS

There are many ways to create a digital painting—mine is the one that works best for me. Feel free to experiment— some tutorials will tell you "This is the way." Well, I say whichever way works for you is fine, even if it's roundabout and long-winded. Art is about the final image, not the making of it.

After scanning in the sketch (sometimes I sketch digitally too, if the picture isn't complicated), I block in the main areas of color on a layer set to "multiply" (see Exhibit B). This will preserve the lines but also allow me to choose a color sheme. This is much like draughtsmanship composition, where colors must "work" together. Fortunately my program allows for color tweaking, so I can get the colors just right. As you can see in Exhibit C, I went for warm colors for the inside and cold colors for the outside. This not only acts to define spaces in a really closed area, but it also has the psychological effect of making the inside cozy and "safe"—which in this case raises irony and mystery.

LAYERS

I use layers a lot. I work the highlights over a certain area by first creating a new digital layer over the image. Once the new layer is there, I can add the highlights within that new layer or safely paint over areas to test a color change. I used this method for this digital piece when creating highlights over the nose and eye areas.

Essentially, the layer tool could be considered one of the most useful aspects of painting digitally; in traditional painting, there is no way to easily retrieve the details that lie beneath a new layer of oil paint, but in digital painting, this can

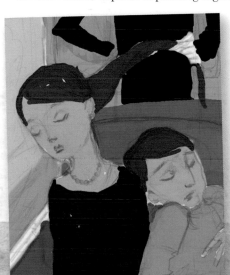

EXHIBIT C

EXHIBIT B

be quickly achieved if the project employs the use of several layers.

I like to use a new layer for every new subject in the picture, and then several within each subject. For instance, I used separate layers for the boy and the girl, and then several more layers for each. Naming the layers helps keep everything in order.

3RD STEP— REFINING FACES

I like to start with faces because I tend to let go of many projects if they take too long—but if I like a face, it sort of propels me to finish the rest. I add highlights in different layers and work as I would work traditionally—doing big areas first and then gradually refining. I draw with both the mouse and a "graphics tablet," which is a little digital pad and pen tool you attach to your computer. The graphics tablet performs the same functions as the mouse, only it feels more like traditional drawing and painting. You don't really need a graphics tablet, it's just a handy tool to have.

Once the basic face color is blocked in, I use brushes to refine the details of the face. For each refining step, I create a new layer and use progressively smaller brushes and bigger zooms to pick out the details, such as the dark line of

EXHIBIT D

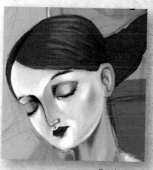

EXHIBIT E

the eyelid or a subtle outline. You can see the process of refining the female face in Exhibits D and E (previous page).

The same technique goes for the clothing. For added interest and texture, I used a crosshatch shading technique over the girl's clothes, adding more in the shadow areas. It is virtually the same as crosshatching with a pencil, only it is done on a new layer and with the graphics tablet. It's important to use different shading techniques within one image, in order to give a sense of different materials and textures. I opted for a rougher form of crosshatch shading over the boy's shirt because I wanted it to look more fluffy.

BRUSHES

I like to use custom brushes. Changing brush texture, like changing shading technique, will prevent everything from looking like it's made of the same material. Too often one looks at digital art and it feels very "airbrushed" and soft all over; that is because the same soft brush was employed each time. If you look at an actual face, you'll notice some places look shiny and smooth, while others look porous. It's brilliant when you can capture these details in your digital artwork. Ultimately, texture is described by the way light reflects; in smooth areas, like the little darts in the inner corner of the eye area, light will be reflected, while the cheeks, that tend to have pores, will look less smooth and less shiny.

Creating a custom brush is pretty easy. Think of a pattern you'd like repeated—a crosshatch pattern, for instance. Create a new file, where you draw the brush pattern in black. Then go to the menu and select "Define as brush." This option will issue a prompt allowing you to save your own brush and use it. There are also many online resources from which you can download Photoshop brushes; trawl the Internet for many freely provided finds and try them out for interesting effects.

4TH STEP—OVERALL COLOR BALANCE

As the piece begins to flesh out, I look at color and see if it's working. For this piece, I decided it needed to be warmer. Adobe Photoshop provides several tools that can be used to alter a particular hue or an overall color scheme. I chose the "Hue/Saturation" option (found under Image>Adjustments) and tweaked the balance using the controls, moving toward the redder color scheme. This is a quick and easy way to "unbrighten" your image, for instance, by turning the slider toward the desaturated end of the tool, or, conversely, to make the colors pop by increasing color saturation. I then decided the girl's brown hair was not working, so I redid her hair entirely to put in that splash of yellow I felt the picture needed (see Exhibit F).

5TH STEP—FINISHING TOUCHES

I try to flatten layers and make new ones once I find myself happy with the process; this prevents an endless list of forty-plus layers that slow down my computer. Toward the end of the process. I try to make the picture "pop" out more by emphasizing highlights and shadows and "texturizing" the far background, so as to "push it back." I push shadows back by first creating a new layer, choosing a darkish but neutral brown and then setting the layer to "multiply."

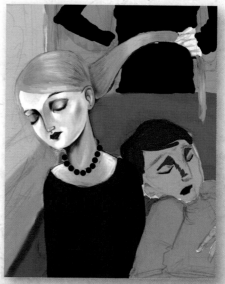

EXHIBIT F

Then I set the pencil opacity to around 30 percent and proceed to block out areas of shadow. I keep at this until I turn to the eraser tool, which I use to take out any excess shadow bits. This eraser/painting technique is my own special way of refining shadows.

I gave a hint of a reflection in the windowpane by copying an area around the girl's face, pasting it in its designated area and then flipping it horizontally. The pasted image is automatically in a new layer; I move it around until it's in a plausible location over the windowpane, and then I lower the layer opacity to make it translucent. I used the eraser tool again to haze the edges around the pasted mirror-image. I also put snowflakes on the outside to bring about that "cold on the outside, warm on the inside" effect.

I also felt the painting would benefit from some loss of color saturation, to make the colors pop less and to heighten the mystery. Using the color sliders available, I desaturated the image in order to achieve an old-schoolbook effect. This is the beauty of working digitally!

And voila, it's done! Ultimately, it must be said that when using a digital program, just as with any other artistic medium, experimentation is key. It is the way I learned. Notes and tutorials will only take you so far, so test it out for yourselves; experiment with different tools—you might just stumble upon some extraordinary things.

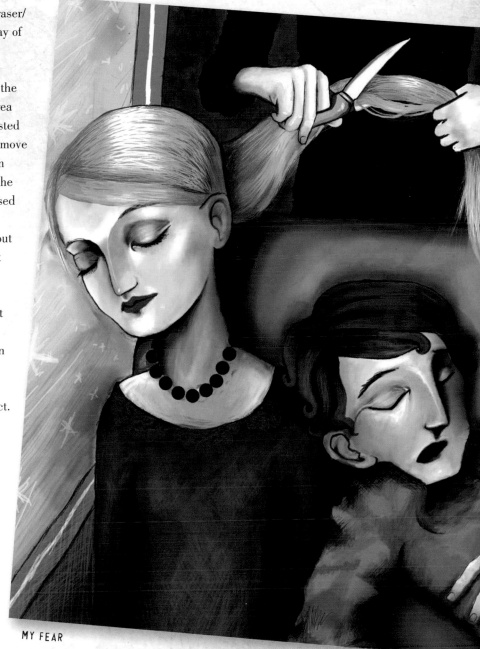

MY FEAR

CHALLENGE NO. 8:
USE YOUR HANDS SUZANNE SIMANAITIS

Create a mixed-media painting with your bare hands—
no brushes or tools allowed.

Anyone who makes art with me knows I love to get messy. I've been known to declare that *I paint with my hands—paintbrushes be damned!* So I welcomed this challenge: to create a mixed-media painting using only my hands, no tools. *This'll be a cinch*, I secretly gloated.

Boy, was I wrong

I had overlooked the fact that while I usually don't use a paintbrush to apply paint to surfaces, I *do* use a multitude of improvised tools to move the paint around, such as an old credit card to drag through the paint, bubble wrap to pick paint up and the plump round imprint made by the bottom of the paint bottles themselves. Even the humble crumpled paper towel is a valuable element in my process. Every time I squirted out some paint I reached instinctively for one of these old friends, only to recoil upon remembering the challenge: *No tools whatsoever.*

Hmmm.

I could drizzle and fling paint straight from the container a la Jackson Pollock. Nah, I wanted the finished piece to retain a clear sense of my hands. I also figured my fluid acrylics would self-level into a puddle rather than provide any approximation of Pollock's luscious textures. Anyway, I think old Jack the Dripper perfected that sort of thing, and he used tools too, even if they were just dried-up old brushes and cans with holes.

I could layer numerous colors and patterns onto paper using fingers, palm, knuckles and nails. I envisioned a result somewhere between prehistoric cave paintings, classic paste papers and Anne Bagby's luscious "complicated papers." But my attempts at manipulating the paint fell (literally) flat, and I decided that thickening it with wallpaper paste would be too much of a crutch and therefore off limits. No, this exercise was strictly about me and the paint.

Finally, I arrived at the most helpful realization of all: *Stop thinking about it so much and just start!* So that's what I did.

I chose a roomy, 16" × 24" (41cm × 61cm) stretched canvas that would allow me to use sweeping gestures, laid down a tarp and began squirting paint around. At first I daintily dabbed with fingertips, but soon I was smearing great swaths of paint using the side of my hand, vigorously massaging paint into the canvas and recklessly scratching it back off.

Between colors I sometimes swished my hands in a bowl of water to keep the whole affair from deteriorating into madness. The residual water on my skin helped to lift and spread the fluid acrylics on the canvas, resulting in some nifty transparent areas. I flicked water droplets onto freshly painted areas, hoping to generate drips or another interesting effect. Was using water out of bounds? Maybe, but I decided clean hands were better than the alternative.

Eventually I had one of what I call my "cosmic anvil moments," when I realized it was not entirely true that my only tools for this project were my hands. Without even thinking about it, I also employed my artist's eye to assess what was happening on the painted surface, and I called upon my artist's intuition to direct my choice of colors, strokes and placement. I could not have disengaged those "tools" if I'd tried, short of wearing a blindfold or working in a pitch-black room. So I decided to celebrate this trio of bodily tools in my composition by using a fingernail to scratch *eye*, *heart* and *hands* into the rapidly drying paint. A few more dabs resulted in simple (really simple!) visual representations of the same.

As I applied the finishing touches, it surprised me to notice that I'd become a bit emotional about this canvas. While I worked on it, I thought it might turn out

"interesting" or even "pretty," and I did not expect it to become imbued with deep personal significance. But it did. I guess that in stripping my process down to the bare minimum and turning off my brain for a while, I prepared a welcoming environment for symbol and meaning to bubble up.

I certainly do not think of myself as an accomplished "painter," but this exercise in simplicity helped me recognize the powerful creative gifts I carry with me at all times. You can take away an artist's tools, but that won't deplete her essential artistness.

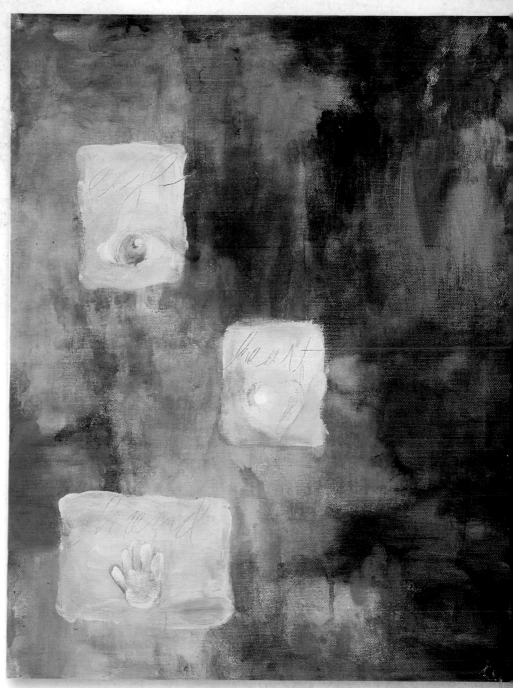

EYE/HEART/HAND

CHALLENGE NO. 9:
FOCUS ON A MEMORY TRICIA SCOTT

Call to mind an experience you would like to explore through your art-making. Allow your perceptions to surface, unfold and guide you.

I grew up a silent child, taught to speak only when spoken to. It wasn't until I became pregnant with my own daughter that I began to realize my personal strength and discover my true voice. When I read this challenge, I knew I wanted to create a piece that reflected the pain I had experienced growing up—not being allowed to express myself with my words. I wanted this art to be a mirror into my soul, telling my story.

Making art is a great way to work through hurts and other issues that may be keeping you from experiencing a full, complete life. We all have issues, don't we? Whether big or small, whether the experience happened many years ago or last week, I believe it's possible to release these feelings and come to a place of greater self-awareness through this process of making art.

Exploring a Memory Through Art

Materials

PHOTO/IMAGERY

COMPUTER, SCANNER AND PRINTER

PHOTO-EDITING SOFTWARE

TRANSPARENCY FILM FOR YOUR PRINTER

SCISSORS

WHITE CARDSTOCK

ASSORTED PAPERS (OLD LEDGER PAGES, LETTERS, SCRAPBOOK PAPERS)

TEXT AND IMAGES FROM OLD BOOKS

GLUE STICK

SEWING MACHINE

THREAD

BLACK CARDSTOCK

SHEET MUSIC

CHARCOAL PENCIL

METHOD

-1- THE FIRST STEP IN CREATING A "SELF-AWARENESS TRANSPARENCY" IS TO ACKNOWLEDGE THE FEELING YOU WOULD LIKE TO WORK THROUGH. I LIKE TO JOURNAL A BIT TO HELP THIS FEELING SURFACE.

-2- CHOOSE THE IMAGE YOU WILL USE. IF YOU DON'T WISH TO USE AN IMAGE OF YOURSELF, YOU CAN WORK WITH A VINTAGE PHOTOGRAPH, BUT IT'S IMPORTANT TO CHOOSE AN IMAGE THAT RESONATES WITH YOU: ONE REMINDING YOU OF YOURSELF. AN IMAGE WITH A LOT OF LIGHT AREAS IS GOOD.

-3- SCAN THE IMAGE AND CROP IT TO INCLUDE THE FACE, PRIMARILY. I LIKE TO ADD A TOUCH OF COLOR TO THE EYES AND LIPS OF MY IMAGE, USING PHOTO-EDITING SOFTWARE.

-4- REMEMBER TO FLIP YOUR PHOTOGRAPH IN YOUR EDITING PROGRAM. PRINT ONTO THE TRANSPARENCY FILM AND TRIM THE IMAGE. CUT A PIECE OF WHITE CARDSTOCK TO THE SAME SIZE AND PLACE THE TRANSPARENCY ON TOP OF THE CARDSTOCK.

-5- PREPARE YOUR MIND FOR CREATION. AT THIS POINT I DO SEVERAL THINGS. I MAKE A POT OF TEA WITH CREAM AND

HONEY, I SAY A PRAYER ASKING FOR GUID-
ANCE IN FINDING THE RIGHT WORDS/IMAGES
TO HELP ME IN MY HEALING AND I TURN ON
SOME MUSIC TO BRING TO MIND A FEELING
OR TO TAKE ME BACK TO THE TIME OF MY
FOCUS. FOR INSTANCE, THE SONGS OF GIL-
LIAN WELCH REMIND ME OF BEING A YOUNG
GIRL IN THE MOUNTAINS OF SOUTHWESTERN
VIRGINIA. FIND WHAT WORKS FOR YOU.

-6- FROM HERE, BEGIN PLAYING BY
LAYERING VARIOUS PAPER ELEMENTS
BETWEEN THE TRANSPARENCY AND THE
CARDSTOCK. SET YOUR FOCUS ON THE
THINGS THAT WERE MOST IMPORTANT TO
YOU IN THE PAST. WHAT INSIDE NEEDS
TO BE HEARD OR NEEDS HEALING?
LOOK TO YOUR PAPER BIN—SCRAP PAPERS,
IMAGES AND TEXTS CUT FROM OLD BOOKS.
THINK OF THE THEME, "FINDING MY
VOICE," AND LOOK FOR WORDS THAT CALL
TO YOU. SPREAD HANDFULS OF PAPERS
ACROSS YOUR WORKSPACE, MOVING YOUR

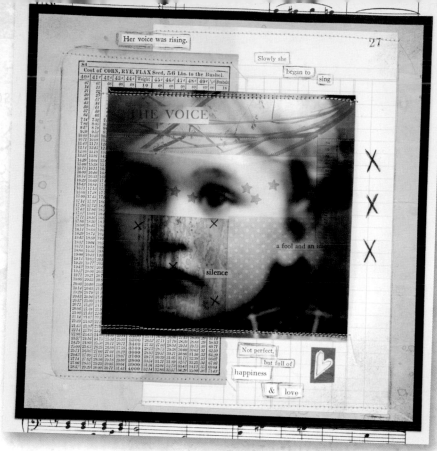

THE VOICE

HAND OVER THEM LIKE A FORTUNE-TELLER WITH HER CRYSTAL BALL. WHEN I WAS DOING
THIS, THE WORD *SILENCE* WAS ON THE FIRST PAPER I TOUCHED. I WAS SO OVERWHELMED AT FINDING THAT
PERFECT WORD. TRY PLACING WORDS THAT SPEAK TO YOU UNDER THE TRANSPARENCY.

 LOOK THROUGH OLD BOOKS FOR IMAGES THAT YOU'RE DRAWN TO AS WELL, LIKE THE CLIPPING OF BRANCHES THAT GOT MY ATTENTION
(A REPRESENTATION OF THE GROWTH THAT WAS GOING ON IN MY MIND). I FOUND A PUNCHED-OUT STAR TO PLACE JUST UNDER THE EYES
TO REPRESENT THE HOPE I FELT AS A CHILD. THE WORDS "THE VOICE" JUMPED OUT AT ME, AND I LET OUT A SMALL SQUEAL, LOVING THE
WAY THINGS COME TOGETHER WHEN YOU TRUST. A FAILED ATTEMPT AT A PHOTO TRANSFER WAS PERFECT FOR THE AREA UNDER THE
MOUTH. THE XS ON IT CAN REPRESENT EACH INFLICTED HURT . . . AND SO IT GOES. THIS PROCESS CAN BE EMOTIONAL. LET THE TEARS
COME IF THEY NEED TO.

-7- ONCE YOU'RE SATISFIED WITH THE ARRANGEMENT, TAKE A PHOTO WITH YOUR DIGITAL CAMERA. USE THE PHOTO AS
A REFERENCE, SO YOU CAN BE SURE TO CORRECTLY REPLACE YOUR ELEMENTS AS YOU ADHERE THEM DOWN.

-8- USING A GLUE STICK, ADHERE THE ELEMENTS INTO PLACE. PERIODICALLY, SET THE TRANSPARENCY BACK ON TOP TO
MAKE SURE YOU'RE PLACING THINGS ACCURATELY.

-9- AFTER THE ELEMENTS ARE ALL IN PLACE, STITCH THE TRANSPARENCY TO THE CARDSTOCK AND IMAGE LAYER, USING
A SEWING MACHINE. DECIDE IF YOUR PIECE NEEDS ANY FINAL TOUCHES. I LAYERED BLACK CARDSTOCK AND VINTAGE SHEET
MUSIC. WITH A CHARCOAL PENCIL, I ADD THE THREE XS DOWN THE RIGHT SIDE AND OUTLINED THE WORDS OF MY POEM.
I ADDED A HEART SCRAP AND THE PIECE FELT COMPLETE.

You now hold a physical representation of a place and time in your life—an expression of your innermost feelings.
You'll know you have accomplished what you set out to do because there will be an ease in your heart that wasn't
there when you first sat down at your art table.

CHALLENGE NO. 10:
NOURISH A SINGLE WORD PAULETTE INSALL

Open a book to a random page and drop your finger down.
Imagine the word or phrase you landed on is a seed from
which your piece will grow.

GLORIOUS SEEDS OF RANDOMNESS

Many of my paintings begin their lives as a spark of
inspiration gleaned from a line of poetry or a quote.
But there can also be great inspiration from just a
single word.

 For this particular challenge, I opened up a book of
modern poetry to a random page and put my finger down.
The line it landed on was about larks singing over the
fields. My mind started to play with that idea—the idea of
song—and I thought about how, when I'm feeling stressed,
I like to walk around my neighborhood listening to the
birds singing while the wind blows through the magestic
fir trees lining our streets. *Glorious Song* is about finding
peace in the things that surround us if we stop to listen to
the sweetness of their song.

Creating a Figurative Painting

Materials

FINE-TEXTURED
STRETCHED CANVAS

FINE SANDPAPER

FOAM BRUSH

GESSO

SOFT CLOTH

HEAVY BODY ACRYLICS
(GOLDEN)

SPRAY BOTTLE FILLED
WITH WATER

CHIP BRUSH FROM
HARDWARE STORE

HAIR DRYER (OPTIONAL)

PALETTE

PAPER TOWELS

WAXED PAPER

RUBBER BRAYER

FLUID ACRYLIC PAINTS
(GOLDEN)

RUBBER SCRIPT STAMP

SMALL AND MEDIUM-SIZED
FILBERT, FLAT, AND
ROUND BRUSHES SUITABLE
FOR USE WITH ACRYLICS

PRESCRIPTION BOTTLE/LID,
PAPER TOWEL ROLL OR
GLASS TO MAKE CIRCULAR
PATTERNS

GRAPHITE PENCIL (STABILO)

WATER-SOLUBLE PENCIL,
BLACK (STABILO)

ROUND DETAIL BRUSH,
SIZE 00

ACRYLIC CRAFT PAINTS
(PLAID FOLKART)

POINTED COTTON SWABS
(BEAUTY SUPPLY STORES)

CARAN D'ACHE NEOCOLOR
WATER-SOLUBLE
PAINTING CRAYONS

1/2" (13MM) AND 3/4"
(2CM) NATURAL-HAIR
MOP BRUSHES

WORKABLE FIXATIVE
SPRAY (PLEASE READ
SAFETY INSTRUCTIONS ON
PRODUCT LABEL)

VINTAGE BOOK

VINTAGE SHEET MUSIC

SOFT GEL MEDIUM IN
GLOSS FINISH (GOLDEN)
(PLEASE READ SAFETY
INSTRUCTIONS ON
PRODUCT LABEL)

VARNISH SPRAY
(PLEASE READ SAFETY
INSTRUCTIONS ON
PRODUCT LABEL)

METHOD
{LAYERED ORGANIC BACKGROUND}

-1- SAND THE SURFACE OF YOUR CANVAS LIGHTLY WITH FINE SANDPAPER. USING A FOAM BRUSH, APPLY A LAYER OF GESSO OVER THE ENTIRE SURFACE. ONCE DRY, SAND IT AGAIN UNTIL YOU ACHIEVE THE SMOOTHNESS YOU DESIRE. WIPE OFF THE GESSO DUST WITH A SOFT CLOTH.

-2- USING HEAVY BODY ACRYLIC PAINT, PUT A DOLLOP OF A LIGHT COLOR (I USED QUINACRIDONE GOLD) AND WHITE ON THE CANVAS AND SPRITZ WITH WATER. SPREAD OVER THE CANVAS WITH A LARGE BRUSH. LET DRY OR, IF YOU'RE IMPATIENT LIKE ME, SPEED UP THE WAIT BY USING A HAIR DRYER.

-3- ONCE THE FIRST LAYER OF PAINT IS DRY, MIX THE LIGHT COLOR WITH A GENEROUS AMOUNT OF WATER ON YOUR PALETTE. USE THIS GLAZE TO PAINT OVER THE FIRST PAINT LAYER. LET DRY FOR A MINUTE OR SO, AND THEN SPRITZ OR FLICK DROPLETS OF WATER RANDOMLY OVER THE SURFACE. LET THIS SIT FOR A FEW SECONDS, AND THEN USE A SOFT CLOTH TO PAT OFF SOME OF THE GLAZE. HOW MUCH OR HOW LITTLE COMES OFF DEPENDS ON HOW LONG YOU LET THE WATER SIT BEFORE YOU START REMOVING IT.

-4- ONCE THE SECOND LAYER IS DRY, PAINT LARGE, INTERCONNECTING SWIRLS WITH A LIGHT COLOR OF CRAFT PAINT (I USED BLUE), OVER MOST OF THE SURFACE. HIGHLIGHT SOME SIDES OF THE SWIRLS WITH AN EVEN LIGHTER COLOR.

-5- LET THE SWIRLS DRY FOR JUST A FEW MINUTES, AND THEN WIPE OVER THEM WITH A DAMP PAPER TOWEL TO SMEAR THEM AND REVEAL SOME OF THE BACKGROUND UNDERNEATH: THIS WILL MAKE THE PAINT LAYER LOOK AGED AND TIE THE LAYERS TOGETHER. DON'T BE AFRAID TO REALLY RUB THE SURFACE IF YOU NEED TO: STOP ONCE YOU'RE HAPPY WITH HOW MUCH PAINT YOU'VE REMOVED. IF YOU'D LIKE TO AGE IT EVEN FURTHER, AND YOU CANNOT GET ANY MORE PAINT TO COME OFF, SAND THE SURFACE LIGHTLY WITH YOUR FINE SANDPAPER.

-6- TEAR OFF A SMALL PIECE OF WAXED PAPER AND SMEAR A SMALL AMOUNT OF PAINT ONTO IT. PICK A RANDOM SPOT ON YOUR CANVAS, PLACE THE WAXED PAPER ON IT (WET-PAINT-SIDE DOWN). ROLL YOUR BRAYER OVER IT OR RUB OVER IT WITH YOUR HAND, THEN LIFT OFF THE WAXED PAPER. REPEAT THE PROCESS SEVERAL TIMES WITH DIFFERENT COLORS TO BUILD UP LAYERS AND DEPTH. I LIKE TO REPEATEDLY USE THE SAME PIECE OF WAXED PAPER BECAUSE SOME OF THE PREVIOUS COLORS WILL MIX WITH THE NEW COLOR, CREATING COHESIVENESS BETWEEN THE LAYERS.

-7- PAINT SOME FLUID ACRYLIC PAINT (I USED QUINACRIDONE GOLD) ONTO A SMALL AREA OF YOUR RUBBER SCRIPT STAMP WITH A MEDIUM-SIZED FLAT BRUSH. PRESS THE STAMP ONTO THE CANVAS SEVERAL TIMES IN A RANDOM FASHION. TAKE YOUR PAPER TOWEL AND LIGHTLY BLOT OFF SOME OF THE EXCESS PAINT.

-8- TAKE A NEW PIECE OF WAXED PAPER AND SQUEEZE A BIT OF PAINT ONTO IT, CRUMPLE IT AND THEN OPEN IT BACK UP. REPEAT SEVERAL TIMES. THIS WILL SPREAD THE PAINT OVER THE SURFACE OF THE WAXED PAPER AND SETTLE IN DIFFERENT AREAS. BEFORE THE PAINT STARTS TO DRY, LAY THE PAINT-COVERED WAXED PAPER PAINT-SIDE DOWN ONTO THE CANVAS AND ROLL OVER IT WITH YOUR BRAYER. PEEL THE PAPER UP AND MOVE IT TO ANOTHER PLACE. REPEAT THE PROCESS UNTIL NO MORE PAINT WILL TRANSFER TO YOUR PAINTING. THEN REPEAT THE PROCESS AGAIN WITH DIFFERENT COLORS.

-9- LOOK AROUND YOUR HOUSE FOR THINGS THAT CAN BE USED TO CREATE CIRCULAR PATTERNS—OLD PRESCRIPTION BOTTLES/LIDS, THE ENDS OF PAPER-TOWEL ROLLS, PEN CAPS, THE LIDS OF YOUR KIDS' DRIED UP PLAY-DOH. POUR A SMALL AMOUNT OF FLUID WHITE ACRYLIC ONTO YOUR PALETTE. PLACE ONE EDGE OF YOUR CIRCULAR OBJECT INTO THE PAINT. PRESS THE PAINT-COATED END ONTO YOUR CANVAS, JUST LIKE YOU WOULD A RUBBER STAMP. CONTINUE THIS PROCESS RANDOMLY OVER THE SURFACE.

{CREATING THE PORTRAIT}

-1- ONCE YOUR BACKGROUND IS COMPLETELY DRY, SAND THE AREA WHERE THE FACE WILL BE, USING FINE SANDPAPER. WIPE AWAY THE PAINT DUST WITH A SOFT CLOTH.

-2- DRAW YOUR PORTRAIT IN GRAPHITE PENCIL. I LOVE STABILO MARKS-ALL PENCILS IN GRAPHITE BECAUSE THEY ARE WATER SOLUBLE AND DON'T REQUIRE AN ERASER TO CHANGE SOMETHING, BUT ANY PENCIL THAT WILL WRITE ON PAINT IS FINE.

-3- USE A SMALL FILBERT BRUSH AND FLUID WHITE TO PAINT OVER THE AREAS WHERE THE SKIN WILL BE. USE TWO OR THREE LAYERS, DRYING BETWEEN LAYERS. REDRAW FACIAL FEATURES WITH PENCIL AS NEEDED.

-4- MIX UP SOME SKIN TONES ON YOUR PALETTE. MY FAVORITE COLORS TO CREATE SKIN TONES INCLUDE TITANIUM WHITE, QUINACRIDONE CRIMSON, HANSA YELLOW MEDIUM AND ULTRAMARINE BLUE MIXED IN FOR THE SHADOWS. IF YOU DON'T HAVE THESE COLORS, MIX TOGETHER AN OPAQUE WHITE WITH A SMALL AMOUNT OF A TRANSPARENT RED AND A TRANSPARENT YELLOW FOR YOUR PRIMARY SKIN TONE. FOR THE SHADOW AREAS, MIX A LARGER AMOUNT OF RED AND YELLOW WITH WHITE AND ADD A TINY AMOUNT OF TRANSPARENT BLUE. THERE IS NO RIGHT OR WRONG RATIO—IT JUST DEPENDS ON YOUR OWN PERSONAL PREFERENCE AND THE SKIN COLOR YOU ARE GOING FOR. EXPERIMENT ON A SCRAP OF PAPER UNTIL YOU FIND A COLOR YOU LIKE. KEEP IN MIND AS YOU'RE PLAYING WITH VARIOUS SKIN TONES THAT WHEN ACRYLICS DRY, THEY TURN DARKER. FOR YOUR SKIN-TONE HIGHLIGHTS, TAKE A LITTLE OF THE MIXTURE YOU USED FOR THE MAIN SKIN TONE AND ADD A LITTLE MORE WHITE TO IT. MIX YOUR COLORS WELL, OR YOU'LL HAVE STREAKY SKIN.

-5- USE A SMALL FILBERT BRUSH TO PAINT THE MAIN SKIN TONE MIX ONTO THE SKIN AREAS: APPLY AT LEAST TWO LAYERS AND LET DRY IN BETWEEN. THE GOAL IS TO HAVE AS LITTLE OF THE BACKGROUND SHOW THROUGH THE SKIN AS POSSIBLE.

-6- ONCE THE BASE SKIN LAYER IS DRY, USE YOUR DARK-SKIN TONE-MIX TO PAINT THE SHADOW AREAS, ONLY ONE SMALL AREA AT A TIME. LOAD UP YOUR SMALL FILBERT BRUSH WITH THE DARK-SKIN-TONE MIX AND PAINT IT ONTO ONE OF THE SHADOW AREAS (ALONG THE HAIRLINE, NOSE, AROUND THE EYES, UNDER THE LIPS AND ON THE NECK). RINSE YOUR BRUSH OR USE ANOTHER SIMILAR BRUSH AND PAINT ON YOUR MAIN SKIN TONE RIGHT NEXT TO YOUR NEWLY PAINTED SHADOW AREA. WIPE YOUR BRUSH AND THEN BLEND THE TWO COLORS TOGETHER WITH YOUR BRUSH WHERE THEY MEET. CONTINUE THIS PROCESS ALL AROUND THE FACE FOR ALL THE SHADOWS.

-7- REPEAT STEP 6 FOR THE LIGHT SKIN TONES, USING THE LIGHT-SKIN-TONE PAINT MIX.

-8- FOR THE WHITE AREA OF THE EYES, TAKE A TINY AMOUNT OF YOUR LIGHT-SKIN-TONE PAINT MIX, COMBINE IT WITH SOME FLUID TITANIUM WHITE, AND ADD A TINY AMOUNT OF FLUID ULTRAMARINE BLUE, TO TONE DOWN THE WHITE JUST A TOUCH. MIX WELL. USE A SMALL BRUSH TO FILL IN THE WHITE AREA OF THE EYES: LET DRY AND PAINT ON A SECOND LAYER. USE BLACK TO FILL IN THE PUPILS. SELECT AN IRIS COLOR (I USED SAGE GREEN) AND MIX WITH A SMALL AMOUNT OF FLUID BLACK: USE THIS TO FILL IN THE IRISES. LET DRY AND CONTINUE TO PAINT ON ADDITIONAL LAYERS UNTIL THE IRIS AREA IS COMPLETELY OPAQUE. LAYER LIGHTER SHADES ON TOP OF THE BASE SHADE OF THE IRIS TO ACHIEVE DIMENSION. APPLY THE LIGHTEST EYE SHADE (THE MIXTURE YOU USED FOR THE WHITE AREA OF THE EYES) TO THE SIDE OF THE IRIS OPPOSITE FROM YOUR PERCEIVED LIGHT SOURCE. OUTLINE THE EDGES OF THE IRISES AND THE EDGE OF THE UPPER EYELID WITH A BLACK WATER-SOLUBLE PENCIL. TAKE A DAMPENED TINY ROUND DETAIL BRUSH AND GENTLY SMUDGE THE AREAS WHERE THE WATER-SOLUBLE BLACK PENCIL WAS APPLIED.

-9- ONCE THIS IS ALL DRY, TAKE A SMALL AMOUNT OF TITANIUM WHITE ON THE END OF YOUR TINY DETAIL BRUSH, AND APPLY A SMALL DOT OF IT ONTO THE PUPIL OF EACH EYE, ON THE SIDE WHERE THE PERCEIVED LIGHT SOURCE IS COMING FROM, TO CREATE A REFLECTION.

-10- PAINT LIPS WITH PINK CRAFT PAINT (I LIKE ROSE). RE-DRAW THE LINE WHERE THE LIPS MEET WITH GRAPHITE PENCIL.

-11- THERE ARE MANY COLORS YOU COULD MIX FOR THE HAIR. HERE, I HAVE CHOSEN HEAVY BODY QUINACRIDONE CRIMSON AND HANSA YELLOW MEDIUM. MIX YOUR CHOSEN COLORS WITH A LITTLE WATER FOR THE BASE HAIR COLOR. FILL IN THE HAIR AREA WITH THIS PAINT MIX, USING ANY MEDIUM-SIZED BRUSH. ONCE THE LAYER IS DRY, YOU CAN ALTERNATE APPLICATION OF LIGHTER AND DARKER TONES OF SIMILAR COLORS, USING LONG STROKES WITH A ROUND BRUSH. CONTINUE UNTIL YOU FEEL THERE IS DEPTH AND DIMENSION TO THE HAIR. OUTLINE HAIR LOOSELY WITH GRAPHITE PENCIL AND ADD RANDOM LINES TO THE SURFACE, FOLLOWING ITS FLOW.

-12- USE THE SAME COLORS AS IN STEP 11 TO PAINT THE EYEBROWS. USE A SMALL BRUSH TO PAINT THEM WITH LONG STROKES: I FIND IT'S BEST TO PAINT ON SEVERAL LAYERS IN DIFFERENT COLORS, JUST AS YOU DID WITH THE HAIR. THIS WILL HELP COORDINATE THE COLOR OF THE BROWS WITH THE HAIR COLOR. LET THE PAINTING DRY OVERNIGHT BEFORE CONTINUING TO STEP 13.

-13- ENHANCE SHADOW AREAS, CHEEKS AND LIPS WITH APPROPRIATE COLORS OF PAINT CRAYONS TO ENHANCE THESE AREAS. DO THIS BY DAMPENING YOUR SMALL FILBERT BRUSH SLIGHTLY WITH WATER AND BRUSH IT ACROSS A CRAYON UNTIL YOUR HAVE A GOOD AMOUNT OF IT LOADED ONTO YOUR BRUSH. PAINT OVER THE SHADOW AREAS OF THE FACE AND LET DRY. USE POINTED COTTON SWABS TO SOFTEN THE EDGES AND BLEND. A MOP BRUSH CAN BE USED FOR THE CHEEKS AND FOREHEAD. USE BROWN TO DARKEN AROUND THE EDGES AND CORNER OF THE MOUTH AND ALSO WHERE THE LIPS MEET. USE WHITE TO ADD A HIGHLIGHT WHERE THE LIGHT WOULD REFLECT OFF THE LIPS.

-14- SPRAY THE PAINTING'S SURFACE WITH A WORKABLE FIXATIVE. DO THIS IN A WELL-VENTILATED AREA.

{FINISHING DETAILS}

-1- CUT A SMALL PIECE OF ANTIQUE SHEET MUSIC AND ADHERE IT TO THE CANVAS USING GEL MEDIUM. COAT THE TOP OF THE PAPER WITH MEDIUM AS WELL. LET DRY.

-2- MIX A LIGHT COLOR CRAFT PAINT WITH SOME WATER: PAINT THIS MIXTURE ONTO THE CLOTHING AREA. LET DRY FOR A MINUTE OR SO AND THEN WIPE WITH A PAPER TOWEL TO REVEAL SOME OF THE BACKGROUND UNDERNEATH. FILL IN A RUFFLED COLLAR AREA WITH SEVERAL LAYERS OF A SECOND COLOR. ONCE THE PAINT IS DRY, OUTLINE THE RUFFLE AND OUTSIDE OF CLOTHING WITH GRAPHITE PENCIL, AND SMUDGE WITH YOUR FINGER OR POINTED COTTON SWAB.

-3- ADD SECONDARY FOCAL ELEMENTS (LIKE MY BIRD AND THE TREES) BY EITHER DRAWING AND PAINTING THEM ON OR BY CUTTING OUT FOUND IM-AGES, AND ADHERING THEM TO THE SURFACE WITH GEL MEDIUM. SEAL WITH ADDITIONAL GEL MEDIUM.

-4- FLIP THROUGH YOUR VINTAGE BOOK AND STOP AT A RANDOM PAGE. LOOK FOR WORDS OR PHRASES THAT JUMP OUT AT YOU. CUT THEM OUT AND GATHER THEM IN FRONT OF YOU. CHOOSE ONE WORD OR PHRASE(S) THAT GOES ALONG WITH YOUR INSPIRATION "SEED." CREATE A POEM WITH YOUR FOUND WORDS AND/OR PHRASES. ADHERE THEM TO YOUR CANVAS AND SEAL WITH GEL MEDIUM.

-5- TIE IN ALL COLLAGE ELEMENTS WITH MORE PAINT, STAMPING AND MONOPRINTING.

-6- LET THE PAINTING DRY FOR SEVERAL DAYS. THIS LETS THE ACRYLIC PAINTS CURE AND BECOME PERMANENT. ONCE COMPLETELY DRY, USE A SPRAY FINISH OR VARNISH TO SEAL AND PROTECT YOUR FINISHED PAINTING: THESE CAN BE FOUND AT MOST CRAFT AND ART SUPPLY STORES. USE THESE IN A WELL-VENTILATED AREA.

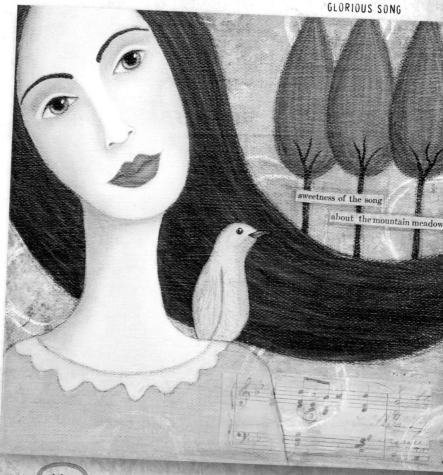

GLORIOUS SONG

sweetness of the song

about the mountain meadow

JUST FOR YOU (clip art)

Did you say he would eat

TANGO

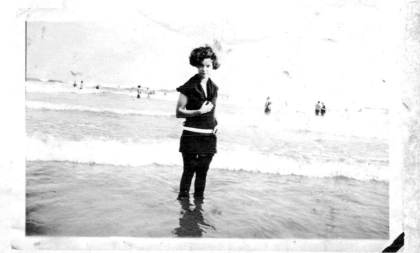

Tyler Smith Co Texas July 21/79

Dear Sir:
Will you be so kind as to give
me your idea of what is meant by the
clause in our new fee bill, "Transcribing
comparing and verifying record books &c
Does it refer to making up new Dockets
at each term of the Court? An answer
from you will be properly appreciated
Yours Truly
P. I. Willcoxon

REGISTERED TRADE MARK

STAR
SAFETY MATCHES
SSUR
MARUTHI MATCHWORKS
HYDERABAD - DN

VISIT OUR
CROCKERY AND HOUSE FURNISHING
DEPARTMENT,
UP STAIRS,
BOLTON & NEELY.
NEW HAVEN, CT.

Ratsdruckerei R. Dulce, Künstlerdruck, Glauchau (Sachs.). Scherenschnitt von Walter Heege, Naumburg

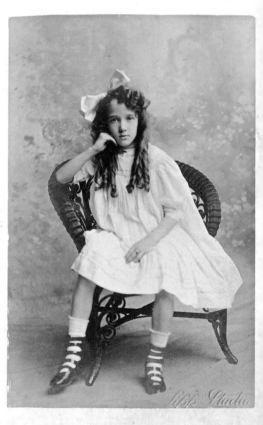

1 MILE

3 MILES

15 MILES

19○10

GET THY TOOLS READY;
GOD WILL FIND THEE WORK.—BROWNING.

TEACH US THE STRENGTH THAT CANNOT SEEK
BY DEED OR THOUGHT TO HURT THE WEAK.
KIPLING.

WE ARE PUT INTO THIS WORLD TO MAKE IT BETTER,
AND WE MUST BE ABOUT OUR BUSINESS.
GEN. ARMSTRONG.

TWO EARS AND BUT A SINGLE TONGUE
BY NATURE'S LAWS TO MAN BELONG.
THE LESSON SHE WOULD TEACH IS CLEAR—
REPEAT BUT HALF OF WHAT YOU HEAR.

CHRIST
SAYS { LOVE YOUR ENEMIES
BLESS THEM THAT CURSE YOU
DO GOOD TO THEM THAT HATE YOU.

1910		APRIL			4th Mo.	
SUN	MON	TUE	WED	THU	FRI	SAT
RIGHT THE WRONG.					1	
3	4	5	6	7	8	
10	11	12	13	14	15	16
17	18	19	20	21	22	23
24	25	26	27	28	29	30

DO THE HARD THINGS FIRST.

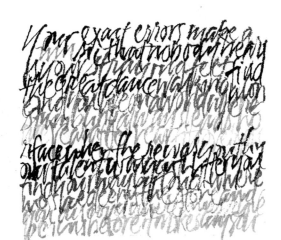

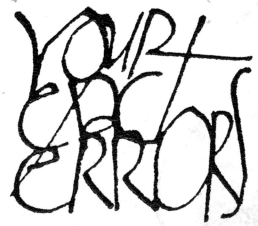

THIRTY-SIX ARTISTS

JOHN CHRISTOPHER BORRERO

Born in Brooklyn to a Latin-American family in 1969, John lived all over the United States and Europe and now resides in New York.

Rooted in anthropology, mythology and theology, John's pieces engage the viewer with stories that speak to the human condition. Each piece addresses the beauty of loving that which is imperfect. John's use of repurposed objects are thought-provoking, captivating and disturbing—sometimes all at once. He's OK with that.

john_borrero@yahoo.com
www.jcborrero.ebsqart.com
www.johnborrero.com

BRANDIE BUTCHER-ISLEY

Brandie Butcher-Isley is a self-taught, mixed-media artist living with her family in West Des Moines, Iowa.

After a lifetime of artistic endeavors, she has discovered her niche in this world through creating mixed-media collage paintings, each with a story to tell.

Brandie's collage paintings have been published in a popular mixed-media publication, she has won an award for "Best 2-D Artist" at West Des Moines's Valley Junction Art Market and received the winning prize for a CD cover-art contest for an up-and-coming local band.

www.littlepiecesofart.com
brandie@littlepiecesofart.com

TONIA DAVENPORT

Tonia Davenport is a mixed-media artist and the Acquisitions Editor for North Light Craft Books, in Cincinnati, Ohio. Her first book, *Frame It!* gave Tonia a lot of experience working with Plexiglas; hence she has published a second book, *PlexiClass: Cutting Edge Projects in Plastic.* She teaches workshops showing others how to incorporate plexi into their work. When she's not making art, Tonia does a lot of thinking about food.

www.toniadavenport.typepad.com

LAURIE DOCTOR

Laurie Doctor lives outside Louisville, Kentucky, where she works as a painter, designer, calligrapher and book artist. Her work has been exhibited and published extensively in the United States and Europe. Laurie teaches painting, book arts and lettering at Naropa University in the United States, Europe, Canada and New Zealand.

Laurie's early studies were in literature, poetry, psychology and religion; she discovered her hands for the first time after graduate school, without having previously imagined that a world of beautiful writing and painting existed. The intoxicating relationship between writing, painting and poetry continues to drive her work.

www.lauriedoctor.com

LISA FALZON

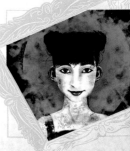

Lisa Falzon was born in Malta, Europe, in 1983. She has never had any formal art training and has an educational background in both science and art history. Lisa has always had a strong interest in art and has been painting since she was very young; she had her first solo exhibition at the age of sixteen. She recently developed an interest in digital art and now works as both a writer and an illustrator.

www.lisafalzon.com

TERRY GARRETT

Terry is a collage artist working primarily with his own photographic images, along with found objects and ephemera. His concern with the human impact on the natural environment is a frequent subject choice, as is his exploration of the concept of home. Currently Terry is an assistant professor in the visual arts department at Bemidji State University in Bemidji, Minnesota.
tgarrett_1@charter.net

SHERI GAYNOR

Sheri Gaynor is a mixed-media artist, writer and life coach living in the Rocky Mountains of Colorado. Her passion is supporting women to creatively reach for their dreams and their true life purpose. Her art has been displayed internationally, and her writings have appeared in national publications, including the *Miami Herald* and *Aspen Times*. Look for her forthcoming book, entitled *Creative Awakenings*, to be released by North Light books in January 2009.
www.sherigaynor.typepad.com/creativeawakenings
www.sherigaynor.com

CLAUDINE HELLMUTH

Claudine Hellmuth is a nationally recognized artist and illustrator. She has become well known for her whimsical photo collages she calls Poppets. Her artworks have been featured on *The Martha Stewart Show*, in *Mary Engelbreit's Home Companion* magazine, on HGTV's *I Want That!* and DIY's *Craft Lab*.

Claudine teaches workshops in the United States and Canada and has written two books: *Collage Discovery Workshop* and *Collage Discovery Workshop: Beyond the Unexpected*. She has also produced three DVD workshops.

Claudine lives in Washington, D.C., with her husband, Paul, and their very spoiled pets: Toby the wonder dog and Mable and Stanley the cats.
www.collageartist.com

PAULETTE INSALL

Like many artists, Paulette has been creative from a young age, but she never thought of herself as an artist until a few years ago. For many years she dreamed of painting but never picked up a paintbrush until October of 2006. That's when her love of creating stories with paint and paper began.

These days, when she's not entertaining her very busy son or making videos about her art, you will find her stealing any moment she can in her home studio, pouring her thoughts and emotions out into the visual stories she creates through her art.
www.pauletteinsall.com
www.pauletteinsall.typepad.com

HOLLY KAROLKOWSKI

Holly Karolkowski resides in Portland, Maine. She has a BA in Fine Arts and Graphic Communications, and holds the title of 2004 Scotch Brand's Most Gifted Wrapper. (She appeared on *The Ellen DeGeneres Show* to demonstrate her wrapping skills!) Holly collects plastic toys, board games, shiny things, lost things and, well, a lot of things!
theholly@artforsmallspaces.net
www.artforsmallspaces.net

KATIE KENDRICK

Katie Kendrick is a self-taught mixed-media artist who finds her intuitive style of creating art to be a potent way of connecting with her true nature and staying in touch with her heart. She thrives on open-ended art-making and is continually delighted and surprised by the unexpected results inherent in the creative process. Katie's work has been featured in several books and magazines, and she teaches workshops nationally. She is passionate about creating and sharing her joy of creating with others.
www.katiekendrick.com
www.joyouslybecoming.typepad.com

CARLA KURT

Carla Kurt's artistic journey began when she was a child, spending countless hours drawing, painting, scavenging trash for treasures and decorating her space with found objects—all to create a world where imagination becomes reality. She took her first painting class when she was ten, beginning a formal study of art that continued through college. Her interest in literature and art history prompted her to major in the humanities, and she graduated from New York University with an undergraduate degree in Classics and later a Master's degree in English Literature. She continues to study painting, working with diverse contemporary painters and mixed-media artists. Kurt currently shows her work in several New England galleries, and her paintings are in private collections in both the United States and Canada.

LINDA KOCH

Linda Koch is a mixed-media artist who resides in Ohio. She enjoys working with fabrics, fibers, paper and beads and finds many clever ways to incorporate all of these into her work.
www.alteredvisions.
typepad.com

SANDY LUPTON

Sandy Lupton is a graphic designer and mixed-media artist. She lives in the woods in Courtland, Virginia, with her husband, Don, their sixteen-year-old son, Gray, and their Jack Russell Terrier, Patch. Her work has been published in numerous publications including *Somerset Studio*, *Belle Armoire* and *Cloth Paper Scissors*. She is represented by Shooting Star Gallery of Suffolk, Virginia.
www.shootingstargallery.net

LOU MCCULLOCH

Lou is a former magazine senior designer who tries to keep up with the latest trends and frequently incorporates vintage ephemera and found objects into her work. She is the author of *Paper Americana* and has contributed to mixed-media art publications including *The Altered Object* by Terry Taylor, *Kaleidoscope* by Suzanne Simanaitis, several Stampington & Company publications, *Cloth, Paper, Scissors, ARTitude Zine* and online publications including *Holograph* and *Art-e-zine*.
www.metamorphosis.typepad.com

DERYN MENTOCK

Deryn Mentock has been creating art all her life. While she is currently exploring many aspects of mixed media, her true passion at the moment is jewelry design. She's typically drawn to vintage and unusual found objects and melds these elements into her work—most of which reflect her devotion to her faith and spiritual matters.

Deryn is a design team member for Paper Artsy, and her work has been featured in numerous articles and publications including *Somerset Studio, Belle Armoire, Belle Armoire Jewelry, Art Doll Quarterly, Stampington's Gallery,* and Somerset's books *Artist Trading Cards* and *Correspondence Art.* Her work is also featured in the book *A Charming Exchange* by Kelly Snelling and Ruth Rae.

mocknet@sbcglobal.net
www.somethingsublime.typepad.com
www.mocknet.etsy.com

PEGGI MEYER GRAMINSKI

Peggi Meyer Graminski recently returned to the Midwest after living in Arizona for most of her life. She and her husband and their two children presently reside in Glen Carbon, Illinois. In her spare time, Peggi loves to cook, visit museums, take long walks, watch films starring Johnny Depp and of course take photographs and create digital collages.

www.desertphotography.blogspot.com

KAREN MICHEL

Karen Michel is a mixed-media artist who loves to mix all things artful in a pot and see what comes out. She lives in New York, where she and her artist husband, Carlo Thertus, run a nonprofit art center for kids called the Creative Art Space for Kids Foundation. Her altered books, paintings and collages have been exhibited internationally and have been published in various books and magazines, including her book *The Complete Guide to Altered Imagery.*

www.karenmichel.com

JESSICA MOREAU-BERRY

Jessica Moreau-Berry is a self-taught mixed-media artist who has been creating with vintage throwbacks since her teens. She started making found-object jewelry in 2004 and to this day still delights in the numerous ways jewelry can be constructed from flea-market treasures. She lives in Maine with hubby, Jon, and their three beloved pets. She finds her muse quite often at home and in the natural surroundings Maine has to offer. When it comes to art and being creative, she follows her own natural rhythms, needs and desires and simply creates what makes her happy at that moment. Jessica's work can also be seen in *A Charming Exchange* by Kelly Snelling and Ruth Rae.

TED ORLAND

Ted Orland lives in Santa Cruz, California, where he pursues parallel careers in teaching, writing and photography. Ted is coauthor (with David Bayles) of the classic artists' survival guide, *Art & Fear,* and is author of its recent companion piece, *The View From the Studio Door.* Ted teaches master-class workshops for seasoned artists, and his own photography is represented by the Ansel Adams Gallery.

www.tedorland.com

MARIE OTERO

Marie Otero is a self-taught mixed-media artist and graphic designer. As a transplanted Australian living in New York, she spends part of the year creating in her studio on Long Island and the rest of the year down under enjoying the sunshine and beach life while working on her art. Marie is the owner of a small boutique rubber-stamp company called Lost Aussie Designs. Her work is on permanent display in several international galleries as well as private collections, and she has also been featured in a number of mixed-media art magazines and special publications including *Cloth Paper Scissors* and *Somerset Studio* as well as Bernie Berlin's book, *Artist Trading Card Workshop*.

www.lostaussie.com
www.lostaussie.typepad.com

JEANNINE PEREGRINE

Jeannine Peregrine is a mixed-media artist and crafter originally from southern California, now living in Suffolk, Virginia, with her husband and two kitties. Her artwork has been published in *Somerset Studio*, *Somerset Gallery* and *Somerset Workshop* and exhibited in local galleries. Jeannine is a member of the Suffolk Art League and the Norfolk Craft Mafia.

www.jperegrineart.typepad.com
www.jperegrine.etsy.com

IZABELLA PIERCE

Izabella Pierce lives in Las Vegas with her husband and their two sons and their sweet little Maltese, Snowy Angel, near Red Rock Mountain, west of the Vegas strip. Her journey in discovering collage began less than three years ago at a flea market, where she came across a magazine called *Somerset Studio*, which she had never seen before; it contained an article about artist Keith Lo Blue. Right then, Izabella came to the conclusion, "I have to create!" She caught the mixed-media collage fever, and hasn't looked back since! You can view more of her work in *Artist Trading Cards Workshop* by Bernie Berlin.

www.izabella.typepad.com

JOANNA PIEROTTI

JoAnnA Pierotti is a full-time, self-taught, mixed-media artist who lives tucked away in the middle of a rural forest. She has a passion for anything vintage, be it paper or fabric. JoAnnA loves creating with found objects and assembling funky finds. Her delight in life is mingling with other artists who have the same passion.

www.mosshill.blogs.com

STACIE RIFE

Stacie Rife currently resides in the Pacific Northwest, twenty miles outside of Seattle, Washington, with her husband, Jeff, daughter Audrey, and dog Lucy Lu. You can view more of her work in *Artist Trading Cards Workshop* by Bernie Berlin.

www.baileysbliss.com
www.baileysbliss.blogs.com
www.baileysbliss.etsy.com

RICHARD SALLEY

Richard Salley has been a public school teacher in southern California for thirty-one years. He has taught grades K–12, incorporating art into as many lessons as possible, and most recently he taught photography at the high school level.

Richard began working with metal as an assistant to Carmel metal sculptor Malcom Moran in 1969. His interest in metalwork has recently turned toward jewelry. Keith Lo Blue, Susan Lenart-Kazmer and Robert Dancik have been major influences, and all have helped point him in the direction of found-object jewelry, with a love for cold connections. His work has been featured in magazines including *Step-by-Step Wire Jewelry* and *Jewelry Artist*, and in Susan Lenart-Kazmer's book *Making Connections*.
www.rsalley.com

BELINDA SCHNEIDER

Belinda Schneider is a self-taught mixed-media artist who has been creative since early childhood, when she started with painted wood pictures and baker's-dough ornaments. She currently creates collages using mainly paper, fabric and felt and enjoys making art freestyle. Her artwork has been published in *Somerset Studio*, *ARTitude Zine* and other publications. Belinda is German and resides in Luxembourg.
belinda.schneider@yahoo.com

TRICIA SCOTT

Tricia Scott is a mixed-media artist and home-school mom who lives in Roanoke, Virginia.
www.a-little-birdie.blogspot.com
triciascott@cox.net

SUZANNE SIMANAITIS

A dabbler in all media and master of none, Suz Simanaitis doesn't feel she has developed a unique artistic style yet, but she vows to create three hundred artworks during 2008—as long as "artworks" can include poorly crocheted granny squares (with the kittens' "help"). Follow her progress at her blog. She publishes *ARTitude Zine*, an award-winning independent quarterly publication about art, craft and creativity and is author of the vibrant and engaging book, *Kaleidoscope: Ideas + Projects to Spark Your Creativity*, which beckons to you from your local bookseller's shelf. Suz thrives in sunshiny Hawthorne, California.
www.artitudezine.typepad.com
www.artitudezinc.com

ROBEN-MARIE SMITH

Roben-Marie Smith is a self-taught, mixed-media artist, instructor and designer. In addition to sharing her art in publications and through teaching at stores and artistic gatherings throughout the country, she is the owner of Paperbag Studios, which offers a full line of rubber art stamps. Roben-Marie resides in Port Orange, Florida, with her husband of eighteen years.
www.robenmarie.blogs.com
www.paperbagstudios.com

JONATHAN TALBOT

Works by painter and collage artist Jonathan Talbot have been exhibited at the National Academy and the Museum of Modern Art in New York and have represented the U.S. overseas in exhibitions sponsored by the State Department and the Smithsonian Institution. Talbot's works are included in museum collections in the U.S. and Europe and in other public and private collections worldwide. Talbot is the author of *Collage: A New Approach.* The artist maintains his studio in Warwick, New York, where he lives with his wife, Marsha. They are the parents of two children, Loren and Garret.

jonathan@talbot1.com
www.talbot1.com

SUSAN TUTTLE

You can learn more about Susan on page 159.

LORI VRBA

Lori Vrba is a photographer who specializes in and is committed to traditional photographic techniques, including use of black-and-white film, natural light and wet darkroom printing. She specializes in photography of children and families, with the intention of recording the ordinary moments of childhood in a way that results in extraordinary, timeless photographs.

www.lorivrba.com

DAVID WALLACE

David Wallace is a collage artist, painter, graphic designer, illustrator, musician and amateur gardener living in Pittsburgh. His work has been shown in galleries and museums in Pittsburgh, Nashville, St. Louis, Bethesda, Columbus and Brooklyn.

David has done graphic and Web design for independent filmmakers, psychedelic rock bands, experimental theater companies, puppet festivals and plumbers. His illustration work was recently featured in the *Communication Arts Illustration Annual,* a very prestigious honor that made his mother very proud.

As guitarist and contributing artist with performance troupe Squonk Opera, David tours the U.S. and internationally.

www.salaczar.com

JOSELYN WALSH

Joselyn Walsh was born in Santa Ana, California, in 1959. She moved to the Rocky Mountains of Colorado at age ten and also lived with her husband, Terry, and son Gavin in Florida for many years. Joselyn recently moved to Maine, where she lives with her husband and her dog, Seamus McGee. She owns a local art gallery called the the Blue Moose Emporium.

www.bluemoose.etsy.com

JUDY WILKENFELD

Judy Wilkenfeld resides in Sydney, Australia—the city of her birth. A few years ago, she abandoned her career in the not-for-profit sector to work full time on her Visual Anthologies™, which can be found in homes across Australia.

Judy's artwork has been featured on a number of online sites, and she has written a number of articles for online publications. A cover article in *The Australian Jewish News, Life* magazine featured Judy's artwork, in particular her work related to Holocaust victims and survivors. An "Artist's Profile" on her work appeared in *Cloth Paper Scissors,* and Judy has taught at Art and Soul in Portland, Oregon.

www.redvelvetcreations.blogspot.com
judy@redvelvet.net.au

INDEX

INDEX

ABOUT SUSAN

Susan Tuttle resides in a small rural town in the
Midcoast region of Maine with her two young children
and supportive husband. Her studio, although tiny,
has a marvelous view of the woods, which provides
countless moments of inspiration as she works—she
enjoys creating collage, assemblage and altered art,
using found imagery and recycled objects. Susan
explores abstract intuitive painting on huge canvases,
often with bold colors and patterns, and has a passion
for photography and digital art. You can often find her at
the town dump, collecting vintage discards, metal scraps
and old, dusty books—which she lovingly brings back to
life in her art.

Susan has played the flute since the age of nine and
went on to further pursue her musical studies at Rutgers
University—Mason Gross School of the Arts and the
Boston Conservatory. She taught K–12 public school
music over a span of ten years in both the greater
Boston area and in Maine. After a life-altering car
accident in 1996, which she amazingly survived and
came away from practically unscathed, she began her
journey of creating art in the visual realm. She embraced
this newfound part of herself and recognized it as being
a necessary component of her life—one she needed in
order to feel complete and whole. Susan strongly believes
the arts, in whatever form they take, are for everyone—
not just an elite few—and that it is never too early or
too late to make it a part of your life.

Her work has been published in *Kaleidoscope:
Ideas and Projects to Spark Your Creativity* by Suzanne
Simanaitis (North Light Books, 2007), *Somerset Studio*,
several Stampington & Company special publications
and *ARTitude Zine*. *Exhibition 36: A Gallery of Mixed-
Media Inspiration* is Susan's first book. You can view
more of her work on her site, Ilka's Attic, at
www.ilkasattic.com and visit her blog at www.ilkasattic.
blogspot.com. Susan attempts to live artfully each day
and seeks beauty in simple, ordinary things.

Indulge Your Creative Side With These Other F+W Publications Titles

KALEIDOSCOPE
SUZANNE SIMANAITIS

Get up and make some art! *Kaleidoscope* delivers your creative muse directly to your workspace. Featuring interactive and energizing creativity prompts ranging from inspiring stories to personality tests, doodle exercises, purses in duct tape and a cut-and-fold shrine, this is one-stop-shopping for getting your creative juices flowing. The book showcases eye-candy artwork and projects with instruction from some of the hottest collage, mixed-media and altered artists on the Zine scene today.
ISBN-10: 1-58180-879-8 • ISBN-13: 978-1-58180-879-7 • paperback • 144 pages • Z0346

LIVING THE CREATIVE LIFE
RICË FREEMAN-ZACHERY

Living the Creative Life answers your questions about creativity: What is creativity anyway? Where do ideas come from? How do successful artists get started? How do you know when a piece is finished? Author Ricë Freeman-Zachery has compiled answers to these questions and more from 15 successful artists in a variety of mediums—from assemblage to fiber arts, beading to mixed-media collage. This in-depth guide to creativity is full of ideas and insights from inspiring artists, shedding light on what it takes to make art that you want to share with the world, and simply live a creative life.
ISBN-10: 1-58180-994-8 • ISBN-13: 9 781581 809947 • paperback with flaps • 144 pages • Z0949

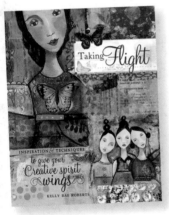

TAKING FLIGHT
KELLY RAE ROBERTS

In *Taking Flight*, you'll find overflowing inspiration—complete with a kindred spirit, in author and mixed-media artist Kelly Rae Roberts. Join her on a fearless journey into the heart of creativity as you test your wings and learn to find the sacred in the ordinary, honor your memories, speak your truth and wrap yourself in the arms of community. Along the way you'll be inspired by step-by-step techniques, thought-provoking prompts and quotes and plenty of eye candy—pages and pages of the author's endearing artwork, along with the varied works of the contributors.
ISBN-10: 1-60061-082-X • ISBN-13: 978-1-60061-082-0 • paperback • 128 pages • Z1930

A CHARMING EXCHANGE
KELLY SNELLING AND RUTH RAE

Inside *A Charming Exchange* you'll find the works and words of more than 30 artists with an array of varying creative styles and insights on collaborative art. Learn how to create 25 jewelry projects using a wide variety of techniques, from working with basic jewelry findings, beads and wire to incorporating mixed-media elements such as solder, fabric and found objects into charms and other jewelry projects. The book even offers ideas, inspiration and resources for you to start your own online swaps and collaborations.
ISBN-10: 1-60061-051-X • ISBN-13: 978-1-60061-051-6 • paperback • 128 pages • Z1653

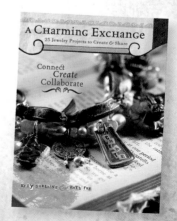